WRAPPED IN
GLORY

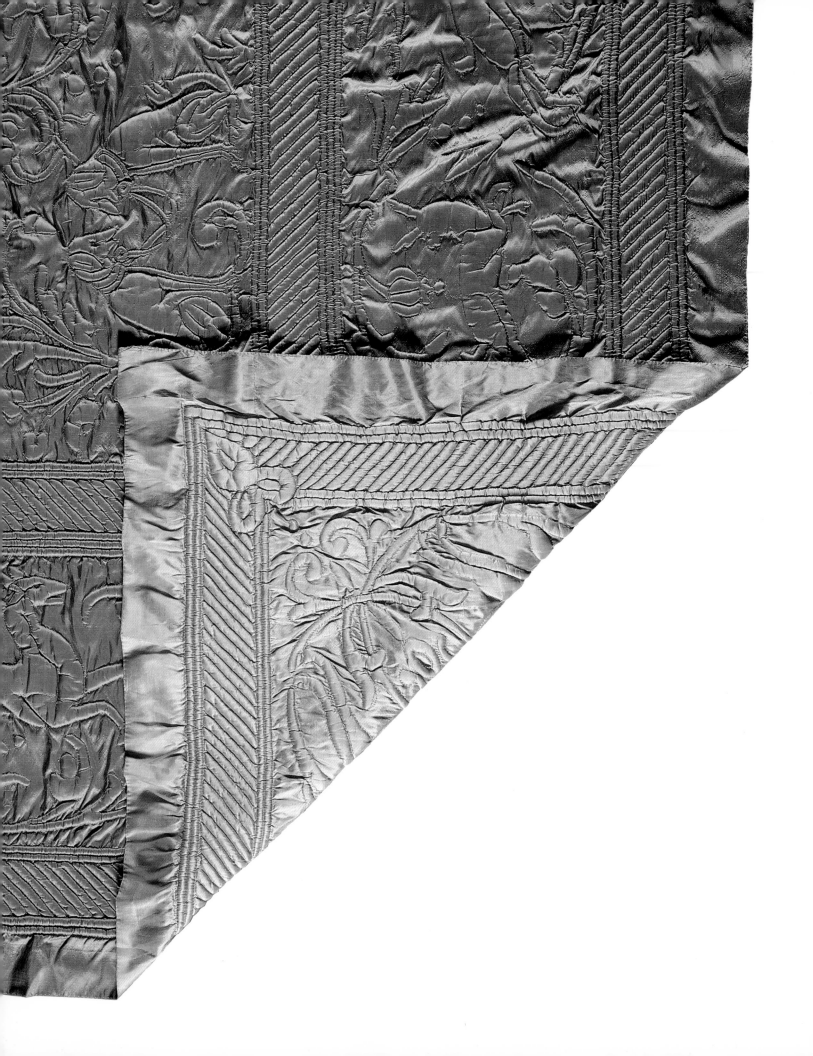

WRAPPED IN GLORY

Figurative Quilts & Bedcovers
1700 – 1900

S A N D I F O X

THAMES AND HUDSON

LOS ANGELES COUNTY MUSEUM OF ART

This book was published
in conjunction with the exhibition
*Wrapped in Glory: Figurative Quilts
& Bedcovers 1700–1900,*
organized by
the Los Angeles County Museum of Art
and presented at the museum from
October 18, 1990, through January 13, 1991.

Copublished by
the Los Angeles County Museum of Art,
5905 Wilshire Boulevard, Los Angeles, California 90036
and Thames and Hudson Inc.,
500 Fifth Avenue, New York, New York 10110.
First published in Great Britain in 1990
by Thames and Hudson Ltd., London.

Library of Congress
Cataloging-in-Publication
Data is available.
Library of Congress Catalog
Card Number 90-70394

ISBN
0-500-01499-X Thames and Hudson Inc.
(clothbound)
0-500-27617-X Thames and Hudson Ltd.
(paperback, United Kingdom edition)
0-87587-153-4 Los Angeles County Museum of Art
(paperback, museum edition)

COVER:
Attributed to Leila Butts Utter (United States), *The Leila Butts Utter Quilt* (details), dated 1898,
appliquéd and embroidered wool and cotton, Dr. and Mrs. Fred Epstein

FRONTISPIECE:
The Courting Scenes Sham b (detail), United States, late eighteenth century, appliquéd and
embroidered linen and cotton, Los Angeles County Museum of Art, Costume Council Fund and
American Quilt Research Center Acquisition Fund

TITLE PAGE:
The Hunters Quilt (detail), Goa, c. 1700, quilted silk, Los Angeles County Museum of Art,
gift of Cora Ginsburg

~ C O N T E N T S ~

Foreword
Earl A. Powell III
6

Lenders to the Exhibition
7

Preface & Acknowledgments
8

THE QUILTS & BEDCOVERS

FOREWORD

Quilts have long been a part of America's collective consciousness. We think of them as what we slept under as children and what we wrapped around us on cold nights; they evoke a sense of comfort and warmth that is almost always accompanied by sentimental remembrances. Within the past two decades, however, as many of these quilts have moved from beds and trunks to the walls of museums and galleries, we have developed a new respect for the aesthetic sensibilities of the people who made them and a new visual appreciation of those bright pieces of cotton painstakingly sewn together into seemingly endless variations of geometric or floral patterns. But there is another type of quilt, much fewer in number, on whose surfaces quiltmakers interpreted and recorded American history through the depiction of human figures in dress of the period. This exhibition brings together for the first time an important group of these extraordinary works.

We are pleased to present *Wrapped in Glory: Figurative Quilts & Bedcovers 1700–1900* as the museum's first major quilt exhibition and publication. Both are the work of Sandi Fox, associate curator in charge of the American Quilt Research Center at the museum. These quilts and bedcovers have been drawn from America's most distinguished public and private collections, and we are extremely grateful to the lenders for their participation.

Wrapped in Glory has been made possible by a gift from Helen L. Bing. From its inception this exhibition has been enhanced by her generosity and support.

Earl A. Powell III
Director
Los Angeles County Museum of Art

LENDERS TO
THE EXHIBITION

Abby Aldrich Rockefeller Folk Art Center, Williamsburg, Virginia
Atlanta Historical Society
Baltimore Museum of Art
Charleston Museum, Charleston, South Carolina
Dr. and Mrs. Fred Epstein
James and Nancy Glazer
Haggin Museum, Stockton, California
Hirschl & Adler Folk, New York
Hudson River Museum of Westchester
Mrs. Elizabeth Livingston Jaeger
Mr. and Mrs. Nelson Dorrington Jones
Joel and Kate Kopp, America Hurrah Antiques
Dr. and Mrs. John Livingston
Los Angeles County Museum of Art
Manoogian Collection
Museum of American Folk Art
Natural History Museum of Los Angeles County
New-York Historical Society, New York
New York State Historical Association, Cooperstown
Ohio Historical Society
Pioneer Village, Farmington, Utah
Shelburne Museum, Shelburne, Vermont
Shelly Zegart's Quilts, Louisville, Kentucky
Marcia and Ronald Spark
Valentine Museum

P R E F A C E &
A C K N O W L E D G M E N T S

QUILTS AND BEDCOVERS are among the most fragile artifacts of our creative past. On a small number of these textiles their makers joined painters and historians in recording observations and interpretations of the society and events that surrounded them. Particularly intriguing are those eighteenth- and nineteenth-century pieces on which human figures appear in costume of the period. *Wrapped in Glory* represents two centuries of the most extraordinary of these unique pieces.

The elegance and sophistication of the earliest of America's figurative quilts reflected what was fashionable abroad (influences illustrated by the inclusion here of two rare European examples), but as America moved increasingly toward her own national identity, new and more vigorous images began to parallel and eventually replace the elegant and refined motifs on those earlier works. The detailed figures replicate with great accuracy the history of costume from eighteenth-century European society to that of the nineteenth-century American middle class, and the surroundings in which the figures are placed parallel the historic events and images that provided the quiltmakers with their points of reference.

A remarkable number of stylistic sources and historical references are incorporated onto and encoded into these often intricate surfaces. To understand the place and circumstances in which these quilts were worked and to interpret their iconography, I have utilized a number of

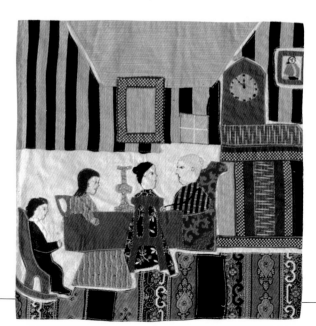

The Burdick-Childs Bedcover (detail), United States, c. 1876, appliquéd and embroidered cotton, Shelburne Museum, Shelburne, Vermont

primary sources: in many instances the quilts are of single authorship, and their provenance has been determined or supported by information drawn from legal and census records and from inventories and wills. The images themselves were often adapted or drawn directly from a broad range of popular imagery such as political cartoons, newspaper advertisements, prints, illustrations, and fashion plates. In addition to consulting books and periodicals that the quiltmakers might have read, it is from the letters, diaries, and journals that they and their contemporaries wrote that we can perhaps most clearly begin to read the messages contained in these rich surfaces.

Each of these splendid pieces was considered individually because of their unique qualities, but certain technical and thematic elements occur throughout: the flowering tree motif taken from Indian *palampores* appears as a decorative device in multiple variations, for example. The hunters worked in silk in Goa in the early eighteenth century are seemingly reprised in the romantic image of the mountain man at the end of the nineteenth century; and it is the human figures — their presence, their posture, and their personal adornment — that form the continuing thread of both exhibition and catalogue. Drawn together for the first time, these individual masterpieces compose a body of work by which the quiltmakers distinguished themselves, their country, and their craft.

Eighteenth- and nineteenth-century figurative quilts and bedcovers are both few and fragile, and I am deeply grateful to those individuals and institutions whose participation has allowed me to bring together for the first time these beautiful masterworks.

There are a number of colleagues in both those participating museums and others whose continuing personal and professional generosity has facilitated and enhanced this volume. I wish particularly to thank Barbara R. Luck of the Abby Aldrich Rockefeller Folk Art Center; Elaine Kirkland of the Atlanta Historical Society; Anita Jones of the Baltimore Museum; Ann Coleman of the Brooklyn Museum; Jan Hiester of the Charleston Museum; Linda Baumgarten and Carolyn Weekley of the Colonial Williamsburg Foundation; Gillian Moss of the Cooper-Hewitt Museum; Melissa Leventon of the Fine Arts Museums of San Francisco; John Langellier and Jim Wilke of the Gene Autry Western Heritage Museum; Laura Hardin of the Hudson River Museum; Susan Naulty of the Huntington Library; Amelia Peck of the Metropolitan Museum of Art, New York; Elizabeth Warren of the Museum of American Folk Art; Deborah Kraak of the Museum of Fine Arts, Boston; Janet Fireman of the Natural History Museum of Los Angeles County; Dilys Blum of the Philadelphia Museum of Art; Celia Oliver of the Shelburne Museum; Doris Bowman of the Smithsonian Institution; Colleen Callahan of the Valentine Museum; and Sherry McFowble and Susan Swan of the Winterthur Museum.

The names of those friends, librarians, and scholars throughout the country who have assisted with this project over the past six years are too numerous to be contained on these pages, but I wish them all to know that each contribution has been invaluable to this text. I am espe-

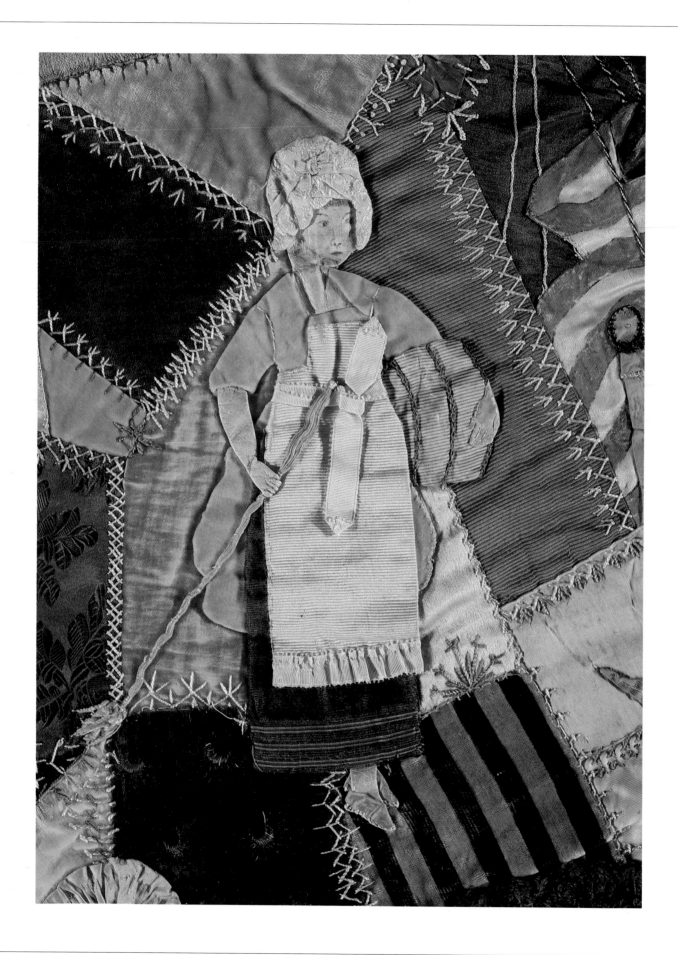

cially indebted to Alicia Annas, Tom Cuff, Nancy Druckman, Cora Ginsburg, Mary Hunt Kahlenberg, Nancy Baber McNeill, Glenna Merrill, Nancy Rexford, and Penny Stanley.

At the Los Angeles County Museum of Art, I am particularly grateful to several of my colleagues for their generous responses to questions that touched upon their area of expertise: Leslie Bowman, curator, Decorative Arts; Victor Carlson, senior curator and Bruce Davis, curator, Prints and Drawings; Philip Conisbee, curator, European Paintings and Sculpture; Michael Quick, curator, American Art; and Edward Maeder, curator, Costumes and Textiles, whom I thank for his encouragement and for his thoughtful reading of the manuscript. To assist in my selection of the fashion plates that accompany several of the entries, Sandra Rosenbaum put at my disposal the considerable resources of the Doris Stein Research Center for Costumes and Textiles, and within the museum's Art Research Library Eleanor Hartman's entire staff consistently responded with grace and good humor to my requests for source material on obscure subjects.

Made possible by the generosity of Helen L. Bing, *Wrapped in Glory: Figurative Quilts & Bedcovers 1700-1900* is the museum's first major exhibition and publication in this field. It was conceived and implemented with the early support of the museum's director, Earl A. Powell III, and of Elizabeth Algermissen, assistant director, and John Passi, head of Exhibition Programs. The care of these vulnerable textiles has been of primary importance, and the inherent difficulties in their shipping, storage, conservation, and exhibition has been a challenge well met by everyone who assumed those responsibilities, in particular Renee Montgomery, registrar, and Chandra King, assistant registrar, in meticulous arrangements for their secure and safe shipment; Catherine McLean, the museum's conservator of textiles, in preparing them for photography, for storage, and for exhibition; Art Owens and his remarkable staff of preparators in the realization of Bernard Kester's sensitive exhibition design; and Kaye Spilker, Pamela Jenkinson, Anne-Marie Wagener, and John Gebhart.

The perceptive comments and insightful suggestions of Mitch Tuchman, managing editor of the museum's publications department, have enriched every aspect of this volume. It was edited with great skill and considerable patience by Chris Keledjian. The stunning photography by Steve Oliver has captured the richness and detail of each object, and Sandy Bell has brought to the design of this book the same extraordinary aesthetic sensibilities possessed by those quiltmakers it is intended to chronicle and to celebrate. To each of them and to my husband, John, I am truly grateful.

Sandi Fox

Eudotia Sturgis Wilcox (United States), *The Storybook Quilt* (detail), c. 1895, pressed, appliquéd, and embroidered silk and velvet, Natural History Museum of Los Angeles County

THE QUILTS
& BEDCOVERS

A Note to the Reader

GREAT CARE has been taken to transcribe the inscriptions on these quilts and bedcovers accurately. The same is true for any material quoted from handwritten sources. Grammar, punctuation, and spelling are presented as they appear. There has been no attempt, however, to reproduce graphically or typographically the "look" of inscriptions or handwriting. Words and phrases underlined on the textiles and in the handwritten documents are presented in italics. Inked inscriptions, faded over time, were difficult to read and interpret; this was especially true of writing found on the *Noah's Ark Quilt* and the *Old Maid Quilt*.

A number-and-letter system has been employed to identify individual quilt blocks. Numbers refer to rows that run top to bottom and letters to rows that run left to right. Block 1a would therefore be in the upper left-hand corner. The blocks on the *Constitution Bedcover* are too numerous to identify in this way, so a diagram has been provided wherein the blocks are numbered consecutively, left to right.

This book does not contain a bibliography. Works consulted are fully cited in the notes that accompany each entry.

The *Phebe Warner Bedcover,* the *Boo-Hoo Bedcover,* the *Bible Quilt,* and the *Creation of the Animals Quilt* (entries 4, 6, 29, and 30 respectively) do not appear in the exhibition.

Caroline Jones (United States), *The Caroline Jones Quilt* (detail), c. 1885, pressed, appliquéd, and embroidered silk and velvet, Mr. and Mrs. Nelson Dorrington Jones

1

The Hunters Quilt

Goa, c. 1700
Quiltmaker unknown
Silk; quilted, stuffed, and corded
112 x 84 in. (284.5 x 213.4 cm)
Los Angeles County Museum of Art,
gift of Cora Ginsburg

THAT A three-century-old textile intended for domestic rather than public use has descended without documented authorship or provenance is not surprising; that this fragile silk quilt has survived at all indicates the high esteem in which it has been held. The appearance of human figures, flora, and fauna on this work places it stylistically in the tradition of the earliest extant examples of bed quilts, three of Sicilian origin worked at the end of the fourteenth century.[1] Quilted on linen in brown thread, the pictorial blocks and borders on those earlier pieces present an incredibly complex narrative based on the legend of Tristram. The *Hunters Quilt*, however, is the thematically simple recording of a hunt.

FIG. 1 *The Hunters Quilt* (detail)

This reversible blue and pink silk quilt was made in Goa, a district on the west coast of India that was at the time a possession of Portugal. Created for export to the European market, it bears figures (fig. 1) similar in posture and costume to the crouched hunters found on seventeenth-century Indian exports from Bengal (fig. 2), which show the influence of that area's Portuguese patrons. The Bengali needlework generally fell into two categories: quilted pictorial bedcovers worked primarily in yellow Tussar silk and embroidered pieces. Common to both categories were the use of monochromatic silk and a tightly joined series of designs that often incorporated hunting scenes of figures in European dress. These "Bengalla quilts" were known in Europe prior to the beginnings of English trade in India. The earliest known reference to their sale in London is in a report of an auction held February 25, 1618: "Then was put to sale a Bengalla quilt of 3¼ yards long and 3 yards broad to be paid for in ready money embroydered all over with pictures of men and crafts in yellow silk, Mr. Henry Garway bidding £20 for it."[2]

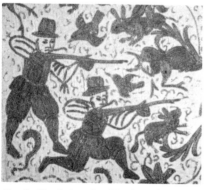

FIG. 2 Textile hanging (detail), India, seventeenth century, embroidered cotton, courtesy of the Cooper-Hewitt Museum, Smithsonian Institution/Art Resource, New York, gift of Marian Hague

Hunting scenes such as on this quilted, stuffed, and corded piece appeared frequently on needlework of the period[3] and could have been copied from any number of pattern books. Hounds pursue the hunters' prey (fig. 3) or, leashed, sit facing each other as a fox jumps through foliage above them (fig. 4); stags leap and bound (fig. 5). The hunters appear in seventeenth-century European costume: they wear doublets

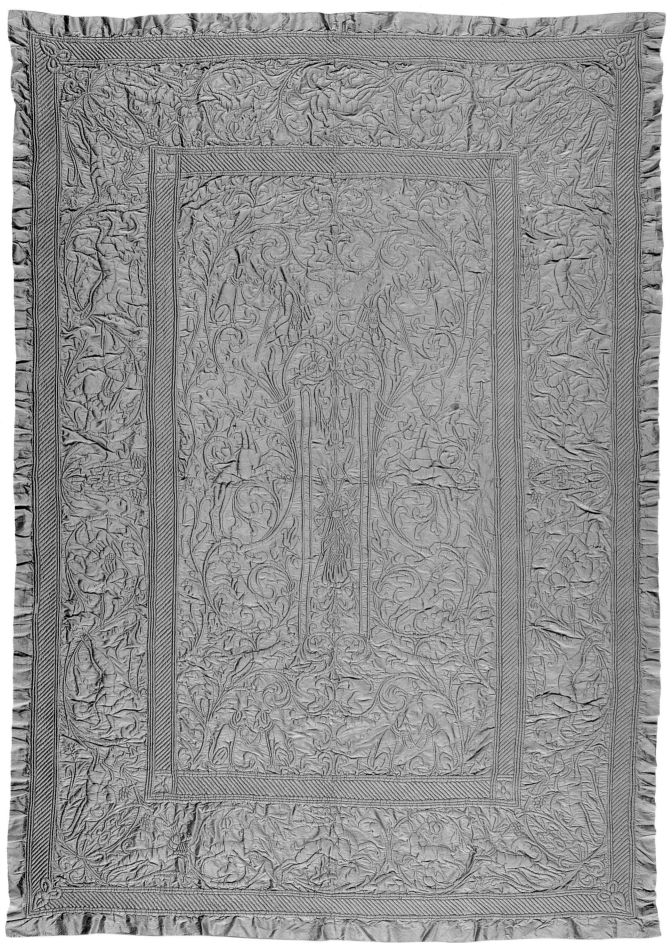

The Hunters Quilt

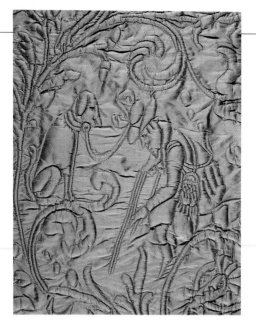

FIG. 6 *The Hunters Quilt* (detail)

with epaulets, pumpkin breeches, short boots, and stockings; and each wears a hunter's cap (some are feathered) with the brim turned up at the back. The hunters in the central panel seem to be sporting goatees (fig. 6). Some hold a spear in one hand and with the other raise a horn to their lips; the game bags are clearly quilted and hang at their sides.

Stylized leaves, flowers, and fruit, worked in scroll-like arrangements throughout the quilt, are symmetrically arranged in the central panel to enclose a trophy (fig. 7). Elaborate trophies—a gathering of objects, such as weapons and flags, that spill outward, often from behind a shield bearing a coat of arms—were popular heraldic emblems on European needlework in the seventeenth and eighteenth centuries. The trophy motif appears, for example, in a pattern book printed in Leipzig in 1619[4] and on a 1784 Gobelins tapestry (fig. 8), the latter being a depiction of the goddess Diana as a huntress, beneath whom a magnificent leaf-crowned stag's head is the central element in a trophy of bow and arrows, spears and netting. On the *Hunters Quilt* the trophy is simplified: spears are loosely bound together, fronted with a beltlike device, from which hangs a quilted hunting bag.

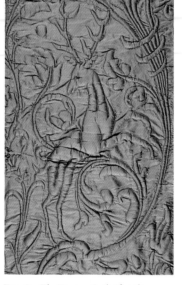

FIG. 5 *The Hunters Quilt* (detail)

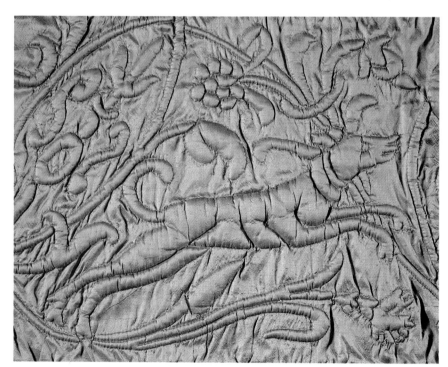

FIG. 3 *The Hunters Quilt* (detail)

FIG. 4 *The Hunters Quilt* (detail)

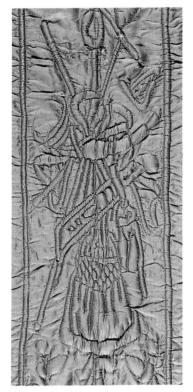

FIG. 7 *The Hunters Quilt* (detail)

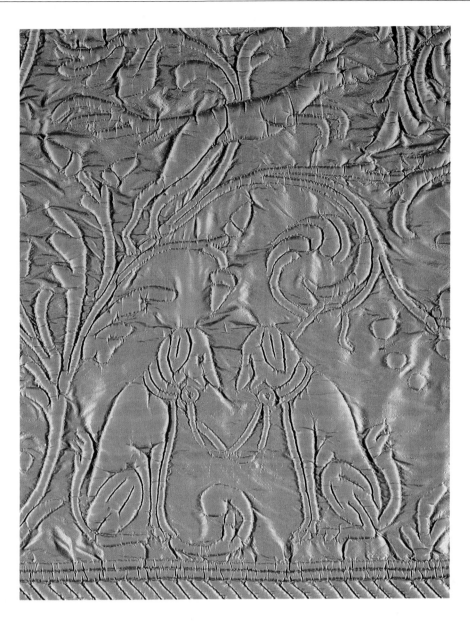

FIG. 8 Tapestry (detail), *Diana Typifying Earth,* from The Seasons and the Elements series, France, 1784, wool, the Fine Arts Museums of San Francisco, gift of Archer M. Huntington

N O T E S

1. These three pieces may have come from a common source, possibly a workshop, and were perhaps made for the wedding of Piero di Luigi Guicciardini and Laodamia Acciaiuoli in 1395. Two of the quilts were worked as a pair, one of which is now in the Victoria and Albert Museum, in London, and the other in the Museo Nazionale del Bargello, in Florence. The third is privately owned. A thorough discussion of these quilts and a transcription of the stuffed and corded inscriptions on the pair may be found in Roger Sherman Loomis, *Arthurian Legends in Medieval Art* (New York: Modern Language Association, 1938); reprint (New York: Kraus Reprint Corporation, 1966), pp. 63–65.

2. From I. O. Archives, Court Book IV, f. 135, as quoted and cited in John Irwin, "Indian Textile Trade in the Seventeenth Century (Part III): Bengal," *Journal of Indian Textile History,* no. 3 (1957): 63.

3. Similar hunters appear on a panel of bobbin lace (Milan, late seventeenth–early eighteenth century) in the collection of the Musée Historique des Tissus in Lyons, illustrated in Santina M. Levey, *Lace: A History* (London: Victoria and Albert Museum and W. S. Maney & Son, 1983), pl. 208.

4. Illustrated in Arthur Lotz, *Bibliographie der Modelbücer* (Stuttgart: Anton Hiersemann, 1963), pl. 39.

2

The Courting Scenes Bedcover and Shams

Probably English,
late eighteenth century
Quiltmaker unknown
Linen and cotton;
appliquéd and embroidered
Bedcover: 74¼ x 65⅝ in.
(188.6 x 166.7 cm)
Sham a: 17⅛ x 33⅞ in.
(43.5 x 86 cm)
Sham b: 16⅝ x 32⅞ in.
(42.2 x 83.5 cm)
Sham c: 16⅝ x 32⅞ in.
(42.2 x 83.5 cm)
Los Angeles County Museum of Art,
Costume Council Fund and American
Quilt Research Center Acquisition Fund

IN THE LATE eighteenth century an extraordinarily skilled hand created eleven needlework panels, appliquéd and richly embellished with embroidered details. Significantly, eight of those panels feature tableaux of costumed figures. For some unknown reason the work was left unfinished: on one rectangular panel some pieces of fabric are rather clumsily basted to the ground cloth, and a woman's features are incomplete. Six of the panels were eventually assembled into this top for a bedcover; three others were bordered, probably to be used as pillow shams (figs. 1–3). The rather large, uneven stitches used to assemble the bedcover and shams suggest that this work was done later by a less skilled needlewoman.

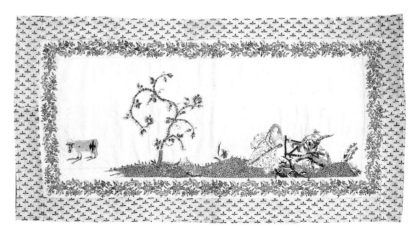

FIG. 1 *The Courting Scenes Sham* b

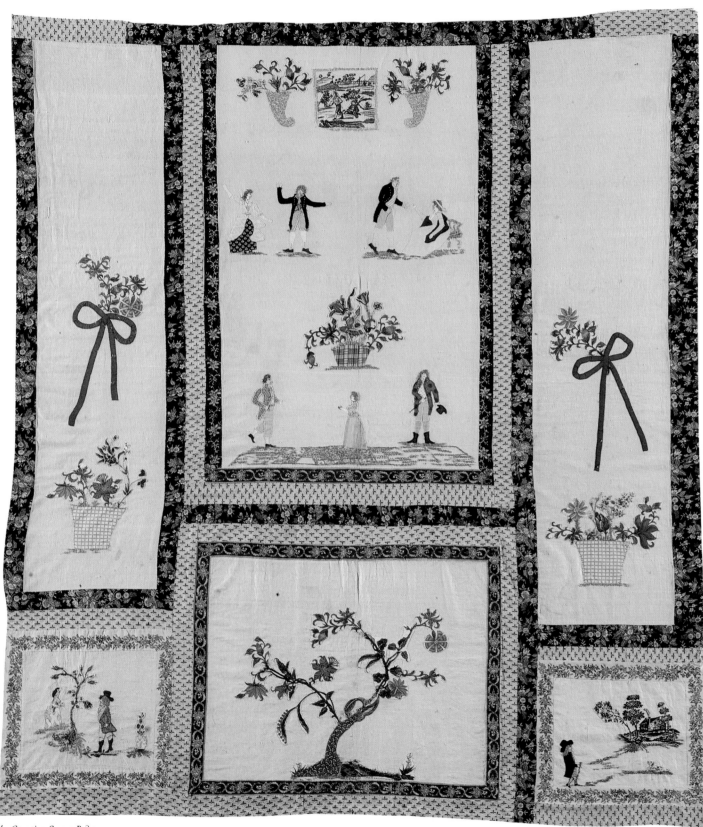

The Courting Scenes Bedcover

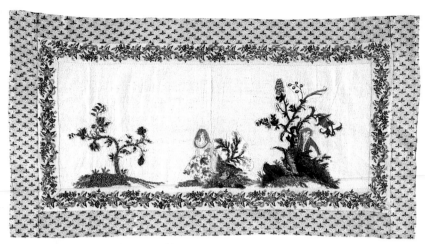

FIG. 2 *The Courting Scenes Sham* a

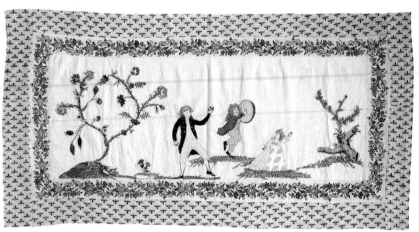

FIG. 3 *The Courting Scenes Sham* c

FIG. 4 B. Plen (United States), *Summer*, 1800, engraving, 10⅜ x 9 in. (26.4 x 22.9 cm), Henry Francis du Pont Winterthur Museum

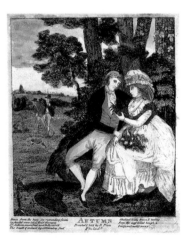

FIG. 5 B. Plen (United States), *Autumn*, 1800, engraving, 10½ x 8⅞ in. (26.7 x 22.5 cm), Henry Francis du Pont Winterthur Museum

Although the precise print source remains elusive, the designs for the shams were probably drawn from a set of courting prints similar to one printed at the turn of the century by B. Plen in Philadelphia (figs. 4–5), which was based on an English prototype published in London by Laurie and Whittle in 1794. Similar series were immensely popular both in England and America.

The pastoral, romantic scenes on the pillow shams contain figures in fashionable dress: the shepherdess (fig. 6) and the coquettish damsel (fig. 7) wear chintz; very clearly visible on the gentleman's costume are stylish sleeve ruffles or lace meant to accentuate the graceful movement of his arm (fig. 7). Eighteenth-century English society admired elegant movement and stance. The movements considered appropriate originated in seventeenth-century France, and they were as strictly prescribed by fashion as were the costumes worn. Pose and movement, though precise and deliberate, were meant to convey an ease associated with the upper class and to which the middle class aspired. They were learned from a series of etiquette and conduct manuals, and it is from illustrations in these types of books that many of the figures on the bedcover and shams were almost certainly taken. The gentleman (fig. 8) on the largest of the unfinished panels assumes the position for standing delineated in *The*

FIG. 6 *The Courting Scenes Sham* b (detail)

FIG. 8 *The Courting Scenes* (detail from unfinished panel)

Rudiments of Genteel Behavior, by F. Nivelon (1737) (fig. 9): "The Arms must fall easy, not close to the Sides, and the Bend of the Elbow, at its due Distance, will permit the right Hand to place itself in the Waistcoat easy and genteel." On the central panel a figure with expressively stitched facial features (fig. 10) seems to satisfy Nivelon's requirement that in "Walking and Saluting passing by...the Person must be erect, not inclining backwards, the advanc'd Knee must be strait, the Step moderate, and the whole Body and Limbs disengag'd, and free to move gracefully." Dance movements similar to those found on one of the pillow shams (fig. 3) were illustrated in profusion in such manuals as Rameau's *The Dancing-Master* (fig. 11). On the same sham the young girl

FIG. 9 Illustration of a "standing position" from F. Nivelon, *The Rudiments of Genteel Behavior* (London, 1737), the Huntington Library, San Marino, California

FIG. 7 *The Courting Scenes Sham* a (detail)

21

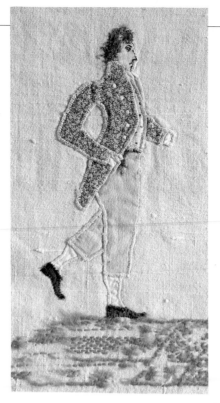

FIG. 10 *The Courting Scenes Bedcover* (detail)

holds her arms in an "S" curve (a fashionable pose of the period), as does the woman dancing on the bedcover's central panel (fig. 12).

The attention to the smallest detail of dress, particularly on the male figures, is extraordinary. On the bedcover a gentleman (fig. 13) holds his hat in a stylish manner that would allow others to see its lining. He wears blue and white striped stockings on his fashionably turned-out legs. Close inspection reveals that the dancing gentleman on the central panel (fig. 12) is wearing a pair of clock stockings (cf. fig. 14).

In this elegant array of bedcover and shams, edges still unfinished, we see certain thematic and technical elements representative of American figurative quilts in the nineteenth century, in particular the depiction of figures in fashionable dress and also the use of the bright printed and painted calicoes, which would ultimately become the quiltmaker's greatest delight.

Hand-painted and resist-dyed cottons were first imported into Europe in the seventeenth century through the East India Company. Into a marketplace of silks, worsteds, velvets, and brocades came remarkable cotton textiles characterized by a freshness and vitality of design and by bright colors, colors that retained their brilliance even

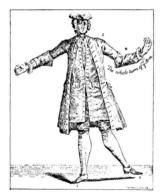

Fig. 14. Preparatory Position for the Execution of a Pirouette

FIG. 11 From Rameau, *The Dancing-Master*, trans. from the French by J. Essex (London, 1728), private collection

FIG. 12 *The Courting Scenes Bedcover* (detail)

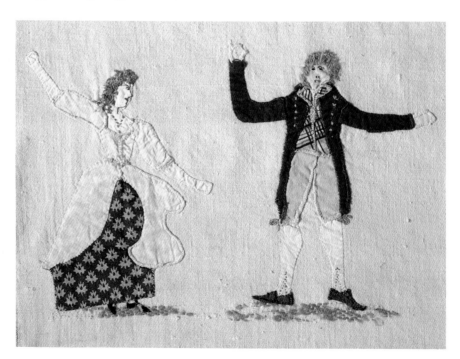

when washed. By 1698 London silk weavers felt the effects of an increasing demand for the Indian goods. In addition to the troublesome importation of Bengal-wrought silks, the recorded imports of calicoes for that year reached 247,214 pieces; they would increase to 853,034 the following year and by 1700 to 951,109 pieces.[1] "On a sudden," said a late seventeenth-century pamphleteer, "we saw all our women rich and poor, cloath'd in Callico, printed and painted; the gayer and the more tawdry the better."[2] Painted calico was what the London lady wanted, and it was painted calico she would have.

In 1700, following a series of riots,[3] Parliament passed a bill that prohibited the use of all imported calicoes, whether painted, dyed, printed, or stained. Some initial gains seem to have been achieved by the weavers as a result of this bill; but the Act of 1700 had not provided for penalties against those who wore calico, and it did not apply to calico of English manufacture. The wealthy were quite prepared to pay dearly for smuggled goods, and once the previously unknown process of mordant dyeing employed by the Indians had been learned, factories opened in France and England. Women simply refused to "dress by law or clothe by Act of Parliament...they claim English liberty as well as the men, and as they expect to do what they please, and say what they please, so they will wear what they please."[4]

It was, as we have seen on the bedcover and shams, not only the ladies who found delight in fabric and fashion. Men participated fully in the prevailing preoccupation with personal adornment. Coats and vests, in particular, were made of rich fabrics, usually elaborately embroidered. And just as some women indicated they wished to wear their best calico to their graves, so too did Alexander Pope in *Moral Essays:* "Let a charming chintz and Brussels lace / Wrap my cold limbs and shade my lifeless face."

FIG. 13 *The Courting Scenes Bedcover* (detail)

FIG. 14 Stocking, England, c. 1750, silk, length: 24½ in. (62.2 cm), Los Angeles County Museum of Art, gift of Cora Ginsburg

NOTES

1. Bal Krishna, *Commercial Relations between India and England, 1601–1757* (1919), pp. 257–59, as quoted and cited in Alfred Plummer, *The London Weaver's Company, 1600–1970* (London: Routledge & Kegan Paul, 1972), p. 293.

2. Plummer, *London Weaver's Company,* p. 292.

3. In January 1697, following a march by four to five thousand weavers and their wives, a mob attacked the East India House, and the following day, smaller numbers of weavers entered several London shops to tear up the dreaded goods. Two months later, on March 22, the weavers attacked the home of a member of Parliament who was also a deputy governor of the East India Company. The mob was fired upon and two weavers were killed. Ibid., pp. 293–94.

4. Daniel Defoe, *A Plan of English Commerce* (1726), p. 253, as quoted and cited in Plummer, *London Weaver's Company,* p. 306.

3

The Flowering Tree Quilt

United States (possibly Hillsborough
Plantation, King and Queen County,
Virginia), first quarter of the
nineteenth century
Possibly made by Frances Baylor Hill
Cotton and linen; appliquéd,
embroidered, quilted, and stuffed
92 x 81 in. (233.7 x 205.7 cm)
Valentine Museum,
gift of Mrs. Edward J. Mosley, Jr.

Fig. 1 *The Flowering Tree Quilt*
(detail)

As INDICATED in letters from the London firm of Pomeroy and
Streatfield to New York dry-goods dealer James Beekman, the available
supply of chintz[1] and calico was often insufficient to meet the burgeon-
ing American demand:

> Aug. 20, 1756
> Our disappointment of an East India sale in March last which we
> always used to have, and out of which we were always supplied with
> Callicoes to print in the summer season, hath rendered it impossible
> to conform so regularly to Your order for quantity...had no chocalate
> ground callicoes, have sent but 13 small spots and shells instead of 24
> You ordered.

> Oct. 11, 1757
> We have taken particular care in the choice of Your printed callicoes,
> but You must be sensible of the impossibility of complying wholly
> with Your orders and as that commodity hath been very scarce, and
> dearer than formerly we have not compleated Your whole order....
> Our East India Company not having had any sale, for twelve months
> have put it out of our power to supplie You with the quantity of East
> India goods you wrote for and have been obliged to reduce the
> orders of all our friends for that commodity.[2]

In spite of the inconsistent supply and the substantial cost of these
textiles, they continued to be imported through the end of the eighteenth
century and well into the nineteenth, and a variety of the block- and
roller-printed fabrics were used on this flowering tree quilt, thought to
have been worked at Hillsborough Plantation, King and Queen County,
Virginia. The color and design of these beautiful printed and painted
cottons inspired the sophisticated design and style of construction that
was to characterize classic Southern quilts until roughly 1840.

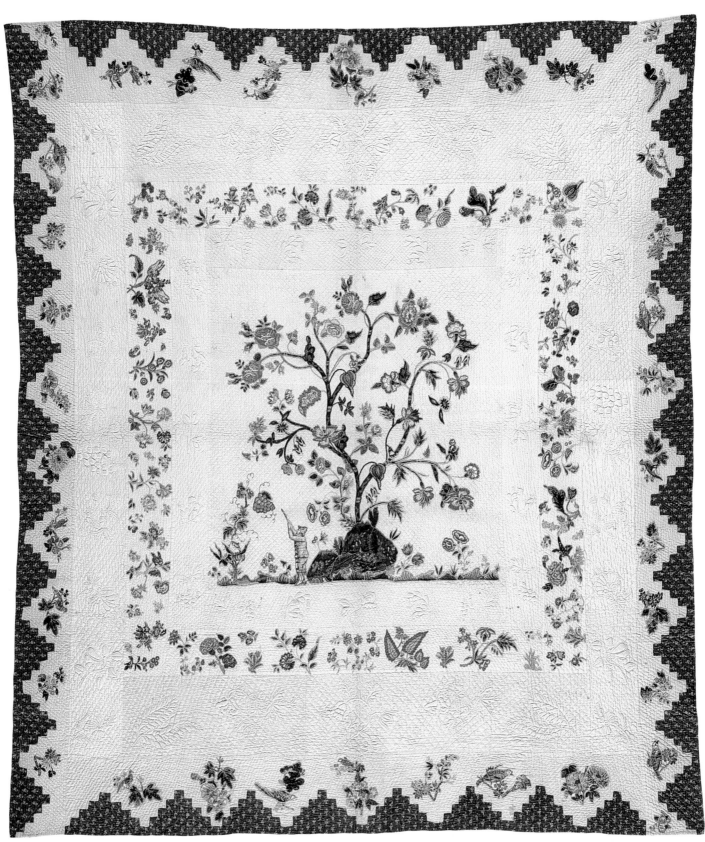

The Flowering Tree Quilt

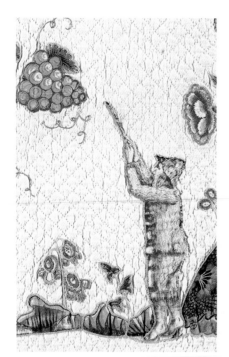

FIG. 2 *The Flowering Tree Quilt* (detail)

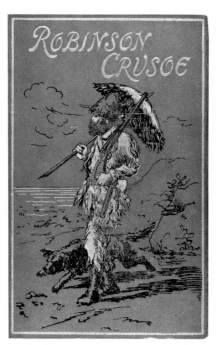

FIG. 3 Cover, Daniel Defoe, *The Life and Surprising Adventures of Robinson Crusoe of York, Mariner* (New York: A. L. Burt, no date), private collection

The technique used on this quilt is known as *broderie perse*; it is deceptively simple when compared to the elegant results of its application (fig. 1). The quiltmaker cut individual printed images (such as leaves and petals, butterflies and branches) from segments of chintz. These were then arranged on a plain background fabric, sometimes as single images or forming large, floral, central medallions or, as we see on this quilt, as surface designs intended to replicate in great detail the flowering tree motif of Indian *palampores*. The tree was frequently constructed of motifs drawn from various pieces of chintz fabrics, often remnants from which sufficient small pieces of petals and leaves could be sewn together to form a large flower where none existed. These acquired motifs were attached with a blind whipping stitch or with decorative stitches (such as buttonhole, feather, or chain) in colored floss or yarn. Theories as to the origins of the broderie perse technique are neither consistent nor confirmed. When government policy or personal economics put the precious goods beyond the quiltmaker's grasp, she had at hand a method by which she might construct from her piece-bag a surface pattern of substantial dimension. An additional inducement might have been that the resulting work could offer a visual approximation of the more time-consuming crewel-embroidered bedcovers. Whatever the reason, by the time any necessity for such careful and creative use of bits of fabric had passed, the technique's continuing popularity was assured by the quiltmaker's pleasure in the work and in the results of her effort.

This quilt is sometimes referred to as the "Robinson Crusoe Quilt," and although no additional pieces of a pictorial toile of that subject have been found, the figure to the left of the hillock (fig. 2) would indeed seem to be that of Daniel Defoe's popular hero. Illustrations from the book (fig. 3) and descriptions in the text correspond to the costume the barefoot figure wears: "I have mentioned that I saved the skins of all the creatures that I killed....The first thing I made of these was a great cap for my head, with the hair on the outside to shoot off the rain; and this I performed so well, that after, I made me a suit of clothes wholly of these skins—that is to say, a waistcoat, and breeches."[3]

Figures cut from a pictorial toile of one subject often appeared on quilts or bedcovers in a completely different context, and that may be the case in this instance. Drawing upon biblical iconography, this piece invites comparison with the subject matter of Gerard David's *The Rest on the Flight into Egypt*, circa 1510 (fig. 4), which represents the third day of the journey, when the infant Jesus caused a palm tree to bend down to provide fruit for the Virgin Mary. On the quilt a bunch of grapes combine with other cut-and-appliquéd elements to form a tree; the figure on the quilt reaches up with a stick (rather than a gun or the umbrella we most often associate with Crusoe), and in the David painting, the gesture is the same although Joseph is gathering chestnuts.[4]

Although this type of quilt is usually of individual authorship, an inspection of the needlework on the quilt indicates that it was possibly the work of more than one quiltmaker, and a 1797 journal[5] kept by young Frances Baylor Hill confirms that quiltmaking was a well-attended and often-cooperative activity at Hillsborough. During the last

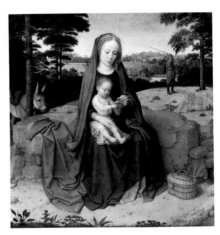

FIG. 4 Gerard David (Bruges, c. 1460–1523), *The Rest on the Flight into Egypt*, c. 1510, oil on wood, 17⁷⁄₁₆ x 17¹⁄₁₆ in. (44.3 x 43.3 cm), National Gallery of Art, Washington, D.C., Andrew W. Mellon Collection

week of July alone her entries document a flurry of activity:

> Monday: Aunt Temple very busy fiscing her bedquilt in the fram
> Tuesday: help'd to make gingerbread and Biscuit — wash'd & iron'd 3 pieces of muslin and quilt'd a little in the evening.
> Wednesday: Aunt Temple and my-self went to work on the quilt by times, we had Cousin P Gwathmey Camm Garlick, Nancy and Becky Aylett, Mrs & Miss Polly Turner, Miss Caty Pollard & Mrs Simons to help us, we quilt'd a great deal and was very merry The Ladies all went away at night but Camm & Cuz Polly, we had Sam Garlick to plague us, at night John Hill came, we also had the Miss Temples to help us and staid all night.
> Thursday: Miss Caty Pollard came back to help us again, we did not do so much to day as we did yesterday, Cousin Nancy very sick not able to quilt a stitch, we had a number of fine water mellons & Peach's a plenty of Bisquit and Cake fine eating and merry quilting.
> Fryday: Mrs. Garlick & Sally came had no other company, we spent the day agreable eating drinking and quilting, Cousin John Hill, Sam Garlick, & Cousin Ben Temple draw'd on the quilt...
> Saturday: Aunt Gwathmey came to breakfast, we got the quilt out early in the day and then the girls all went to making edging.

Hillsborough stands high on a bluff, and the ladies who came for peaches, melons, and biscuits could look from the quilting frame across the wide lawn, through rows of crepe myrtle, down to the Mattaponi River. The diary that Frances kept was eventually wrapped in a newspaper circa 1850[6] and passed down in her family, as was this quilt, a remembrance of those gentle days.

N O T E S

1. It is probable that chintz had arrived in the colonies by the end of the seventeenth century. Margarita Van Varick arrived in New York in 1685, and in her will, written ten years later, items bequeathed to both sons and daughters included "a pss. of Chints and remnants of chints...one Chintt petticoat, one callico wastcote, one Chint ditto...seven chints mantells," as quoted in Alice Baldwin Beer, *Trade Goods* (Washington, D.C.: Smithsonian Institution Press, 1970), p. 35.

2. *Beekman Mercantile Papers*, vol. 2, ed. Philip L. White (New York: New-York Historical Society, 1956), pp. 630–35.

3. Daniel Defoe, *The Life and Surprising Adventures of Robinson Crusoe of York, Mariner* (New York: A. L. Burt, no date), pp. 104–5.

4. John Oliver Hand and Martha Wolff, *Early Netherlandish Painting* (New York: Cambridge University Press, 1987), p. 64.

5. *The Diary of Frances Baylor Hill (1797)*, ed. William K. Bottorff and Roy C. Flannagan, printed in *Early American Literature Newsletter* 2, no. 3 (Winter 1967).

6. Ibid., editors' introduction, p. 4.

4

The Phebe Warner Bedcover

United States, c. 1800
Made by a member of the Warner family
Linen and cotton; appliquéd and
embroidered
101½ x 90 in. (257.8 x 228.6 cm)
The Metropolitan Museum of Art, gift of
Catherine E. Cotheal, 1938

WITHIN THE Warner family of New York a rich body of needlework took form in the early years of the nineteenth century. The pieces are not yet fully documented as to specific identification and attribution, but the Warner name is associated with some of America's most sophisticated figurative appliqué.

A textile scene (fig. 1) with a tradition of ownership in the Warner family was probably intended to be used as the central field of a quilt or bedcover. Bits of branches were cut from an English arborescent chintz to form the tree on which large flowers bloom and in which a peacock and a pheasant rest. The figures are constructed of bits of fabric and embroidery rather than cut from preexisting printed images. Mary (garbed in calico) and the Holy Infant are led toward the tree by Joseph, here using his staff for support. Below the tree the shepherd tends his flock on a landscape of plain and printed cotton.

FIG. 1 Textile panel, United States, c. 1805–10, appliquéd cotton, 40⅝ x 40¾ in. (103.2 x 103.5 cm), Henry Francis du Pont Winterthur Museum

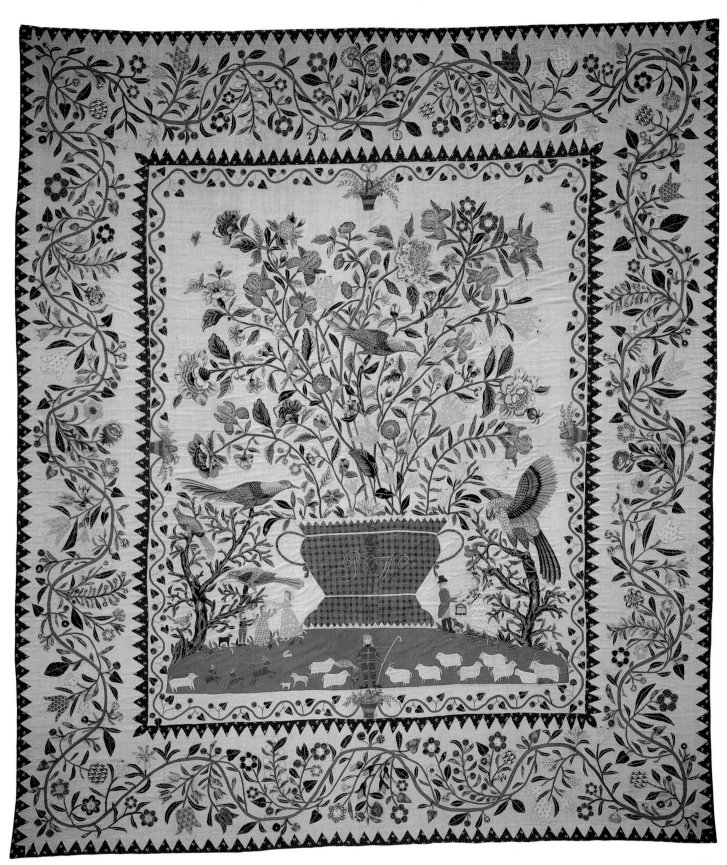

The Phebe Warner Bedcover

FIG. 2 *The Phebe Warner Bedcover* (detail)

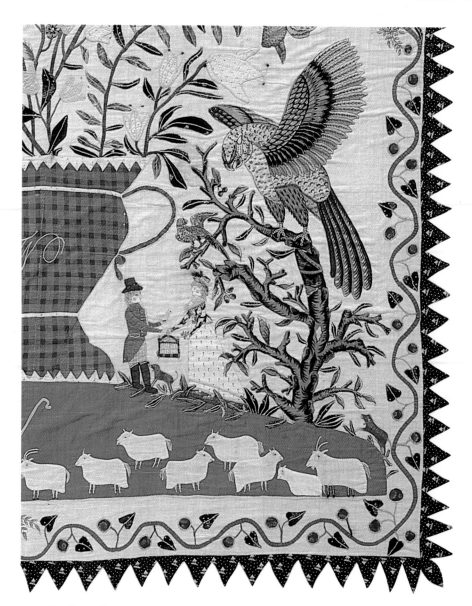

Similar adornments are found on the *Phebe Warner Bedcover*. Another shepherd (a crook in his right hand, a sheaf of wheat in his left) looks out at us from a field, amid sheep and dogs, a squirrel and three stags. He stands beneath another flowering tree, one suggested by slender stalks that spring from a massive urn. The urn bears the maiden initials of Phebe Warner Cotheal, P. W., in flowing, embroidered script; family tradition holds that the piece was constructed prior to Phebe's marriage to Henry Cotheal in New York City in 1803.[1] The duplication of several specific birds, buds, flowers, and leaves suggests that a limited number of chintz fabrics were cut for use on the bedcover (the yellow and white tulips are cut from fabric used also for two of the costumes). Iris appear in profusion.[2] An English block print circa 1780[3] provided the quilt-maker with the following elements: two of the birds perched in the gnarled tree to the left of the urn; certain of the flowers and branches; and in the tree on the right, the fierce beaked bird that menaces a man handing a small yellow bird to a woman holding a cage. An additional

group of figures to the left includes a small male figure with a bow and arrow and two young girls exchanging a bird and a bough.

Simplistic vines that encircle the central field bear only the repeating motif of a leaf and berry. This minimal design differs sharply from that of the wide, outer border, which contains a large, meandering vine bearing a variety of botanical images: leaf and berry have burst into large blooms and lush foliage. In contrast to the repetition of the red and green fabrics on the inner border, the outer is characterized by a rich variety of multicolored calicoes.

Fashion plates of the period are a primary source of comparative material for dating costumes on quilts: we can confirm the circa 1800 date assigned to this bedcover by the presence of the caraco jacket worn by the woman holding the birdcage (fig. 2). Additionally, these plates often illustrate certain finishing elements common to both dress and quilts. The same narrow handwoven tape, for example, that binds many late eighteenth- and early nineteenth-century quilts was also in more common use as ties on the quiltmaker's dresses or undergarments. As with many elements of a quilt's construction, the selection of the style to be used in the final binding of its raw edges was most often drawn from aspects of fashionable dress. On Phebe's bedcover continuous rows of triangles contain the substantial outer border. It is a border or binding treatment that embellishes many of the most sophisticated quilts of this period, and in N. Heideloff's *Gallery of Fashion* for 1796 and 1797 we find several ladies' dresses featuring Vandyke scollops[4] (fig. 3). It is probable that the quiltmaker transferred this refined element from the hem of her gown to the border of her bedcover.

FIG. 3 From *Gallery of Fashion*, vol. 3 (London: N. Heideloff, August 1796), Los Angeles County Museum of Art

NOTES

1. Although tradition has attributed this remarkable bedcover to Phebe's mother, Ann Walgrave Warner, important research being conducted by Amelia Peck, assistant curator, Department of Decorative Arts at the Metropolitan Museum of Art, New York, may soon require a reattribution.

A "sister" piece, the *Sarah Furman Warner Bedcover*, also circa 1800, was made for Phebe's first cousin. Although both bedcovers share a number of technical similarities, the subject matter of Sarah's bedcover (unfortunately almost completely destroyed by fire at the Henry Ford Museum) is that of a village scene with buildings and a large number of promenading figures. The *Ann Warner Quilt* (see p. 46) is a third quilt produced within the Warner family.

2. Vijay Krishna, in "Flowers in Indian Textile Design," *Journal of Indian Textile History* 7 (1967): 2, points out that in spite of the iris's popularity in the West, the flower did not often appear in fabric of European origin but is a familiar motif in India and used in large numbers on Mughal textiles and architecture.

3. A fragment of this textile is illustrated in Florence H. Pettit, *America's Printed & Painted Fabrics 1600–1900* (New York: Hastings House, 1970), opposite p. 65.

4. This border treatment is commonly called "dog's tooth," perhaps because of its obvious resemblance to canine teeth, though it could refer to "dogtooth," an architectural ornament on early English Gothic. However, specific evidence of either terminology having been applied to late eighteenth- or early nineteenth-century quilts has not yet been found. Perhaps the more appropriate appellation would be "Vandyke scollops," since that phrase is specifically used in reference to the pattern's appearance on costume of the late eighteenth century: the text opposite Heideloff's 1796 illustration refers to the "round gown of fine calico; short push-up sleeves; the whole trimmed with a gold coloured chintz border, in Vandyke scollops." The effect is achieved not by the piecing together of triangles but by the application of what is referred to as a Portuguese hem.

5

The Rachel De Puy Quilt

United States (Pennsylvania), dated 1805
Made by, for, or with Rachel De Puy
(1788–1816)
Cotton; quilted, corded, and stuffed
109 x 101 in. (276.9 x 256.4 cm)
Los Angeles County Museum of Art,
American Quilt Research Center
Acquisition Fund, partial gift of
Phyllis Haders

AT THE CLOSE of the eighteenth century and the beginning of the nineteenth there was a significant change in the lives of many well-to-do American women. Affluent Philadelphia women, for example, were encouraged and expected to move beyond the management of their households into the intellectual life of the city. Their education generally included reading and languages. They wrote letters and diaries revealing a remarkable diversity of interests, including those political. Several Philadelphia women during this time established themselves as professional artists, perhaps most notably those within the Peale family of distinguished painters.

During this enlightened period women, of course, continued to do needlework, whether it was plain sewing or fancy. It was at this time that a masterpiece quilt was created by, for, or with Rachel De Puy,[1] who was born in the early years of Philadelphia's Federal period. This quilt, carefully inscribed and dated "R. De Puy 1805" (fig. 1), reflects a thematic simplicity and a technical sophistication that were characteristic of the time. Even if family history did not already attest to the substantial economic position of the De Puys, the work itself gives ample indication of the comfortable domestic circumstances under which it was made: this

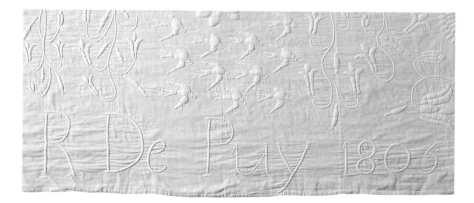

FIG. 1 *The Rachel De Puy Quilt* (detail)

The Rachel De Puy Quilt

FIG. 2 *The Rachel De Puy Quilt* (detail)

FIG. 3 *The Rachel De Puy Quilt* (detail)

elegant object is the product of leisure time and ample space, commodities seldom available in 1805 to other than those of the privileged class.

The quiltmaker selected the flowering tree as her central design. Both the placement of the individual motifs and the elaborate borders replicate Indian *palampores;* but instead of the bright colors and patterns typical of those textiles, it is the absence of color that distinguishes this piece and reflects the fashionable Federal preference for the classical purity of a white surface. Another factor in the choice of an all-white surface may have been a concern that printed fabric would distract an observer's eye from the praiseworthiness of the stitches, whose size and evenness were often the criteria by which the quiltmaker's work, and therefore the quiltmaker herself, would be judged.

To enhance the dimensional quality of the work, its creator chose to use a technique called *Marseilles quilting.* In this method two pieces of fabric are basted together without a batt or filling, and the entire decorative pattern is then "quilted" with a small running stitch through both layers. The quiltmaker then carefully separates threads on the back fabric and, within the confines of her stitched outlines, carefully inserts cotton batting or cording. Shape and shadow are thus given to those elements she wishes to project (fig. 2).

Throughout the nineteenth century quiltmakers shared with the extraordinary craftsmen of their time a common vocabulary of design; for example, the quilt is embellished with two large pineapples (fig. 3), a popular motif worked by men primarily in glass, silver, and wood. America had adopted the exotic fruit as a symbol of hospitality, and tradition suggests a pineapple was often speared onto the front gate of the house of a captain returned from a sea voyage. The motif seems entirely appropriate to the Indian origins of the quilt's design: the Portuguese introduced the pineapple into India in the sixteenth century, and it was there that many travelers were first introduced to it.

Another important motif drawn from American decorative arts is the series of deep swags that form the quilt's three wide borders. French and English wallpapers were among exports to the colonies, but the coveted rolls of paper were often beyond the financial reach of a city dweller and beyond the physical reach of a rural housewife. An itinerant craftsman could offer an acceptable alternative by extracting some of the wallpapers' most desirable elements (such as an elaborate swag border) and applying them to white plastered walls with paint, brush, and stencil patterns. As with many elements of European import, the designs were simplified and adapted to American preference and practicality. Quiltmakers, instead of paper, paint, plaster, and wood, employed cotton and a simple running stitch. Swag borders appear on large numbers of quilts throughout the nineteenth century, held here by narrow ribbons but often with bell or tassel. Swags, pineapples, feather plumes—these would also have been seen on the white, plaster-ornamented mantels that were an important decorative element in Philadelphia homes during the time the De Puy quilt was created.

The quilt's central scene is one of pastoral serenity, an intricately stitched interpretation of the virtues of a simple, rural existence (fig. 4).

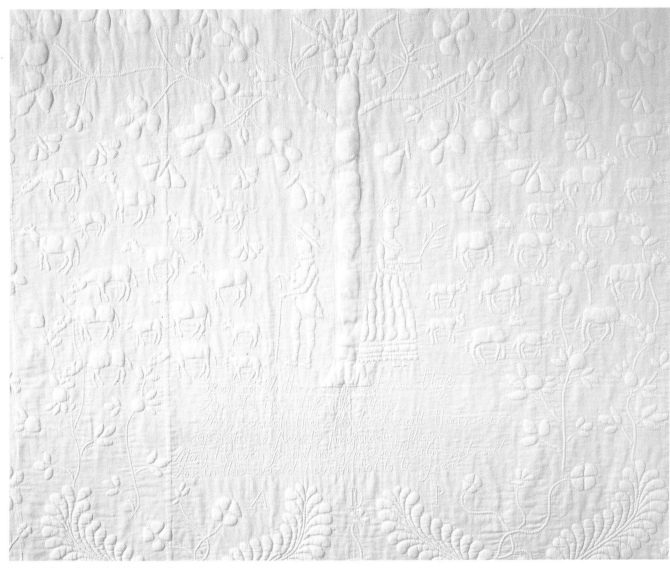

FIG. 4 *The Rachel De Puy Quilt* (detail)

In small, corded script the following appears: "If on earth there is found true bliss / Sure it's in a life like this / They watch their flocks 'tis all their care / Of natures sweets profusely share / May heaven grant me som such calm retreat / For in this world i wish not to be great." Philadelphia at the end of the eighteenth century reflected the by-then fashionable rural influences of seventeenth- and eighteenth-century farmers and their descendants, farmers such as Rachel's great-great-great grandfather, Nicholas Depui, who had come to America from Flanders in October 1662 in that great wave of Huguenots seeking safe haven from religious persecution.

The idyllic scene on the De Puy quilt is in the tradition of those pastoral themes worked on English and American needlework. Beneath the flowering tree and above the paean to rural existence stand a rather fashionably garbed shepherd and shepherdess. Wearing coat and breeches, he carries a crook and smokes a clay pipe. Her hair (or wig) is done in the classically inspired ringlets of the period; she carries a leafy

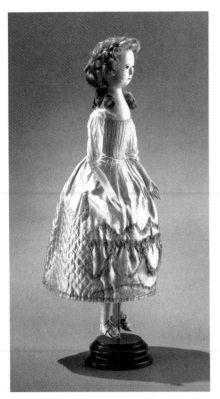

FIG. 6 Doll, France or England, c. 1770-74, height: 22 in. (55.9 cm), Colonial Williamsburg Foundation

FIG. 7 Tradesman's card, England, c. 1764, 9⅝ x 5⅞ in. (24.5 x 14.9 cm), the Huntington Library, San Marino, California

FIG. 8 Abigail Trowbridge, petticoat, England or Colonial America, 1750, silk quilted to wool, Colonial Williamsburg Foundation

spray. The flock they tend is large, as is the flock of birds soaring above the tree. They are aided by a dog, distinguishable from the sheep primarily by its small, upturned tail. The sheep graze peacefully, nibbling here and there on the small, delicately stuffed flowers that flourish in the fields and, indeed, throughout the quilt. "True bliss" was surely the life envisioned for Rachel as a bride, a betrothal perhaps suggested by the pair of entwined hearts (fig. 5) in each lower corner. The date on which she married the Reverend Jacob M. Field is uncertain, but on July 17, 1816, only eleven years after this splendid quilt was completed, Rachel died, childless.[2]

The simple quilted petticoat worn by Rachel's shepherdess recalls that garment's functional origins, but by the middle of the eighteenth century its practical use as a warm undergarment had in some circles yielded to more aesthetic considerations. As the fashions changed, or perhaps as petticoats changed the fashion, women's dresses opened in the front to reveal elaborately and decoratively quilted petticoats.

Fashionable dress in America was dictated by that which was fashionable in England and France, and news of the frequent changes in styles reached America as swiftly as personal correspondence or the latest fashion journals could be delivered by ship. Eagerly anticipated letters from friends and family abroad would have alerted American women to the petticoat's metamorphosis. These detailed missives often contained patterns and drawings as well as bits of the latest trimmings. The most extravagant method for conveying such information was through the exchange of fashion dolls. The exquisite doll pictured here is only midway through her *toilette* (fig. 6). The sleeves of her linen shift are visible beneath her boned stays. She wears two cotton underpetticoats. A third petticoat, of silk, is elaborately quilted and embellished,

FIG. 9 Petticoat (detail), Colonial America, mid-eighteenth century, quilted linsey-woolsey, Los Angeles County Museum of Art, Costume Council Fund

FIG. 5 *The Rachel De Puy Quilt* (detail)

and over it she will wear a stomacher and a gown with skirt drawn up *à la polonaise.*[3]

English tradesmen's cards of the period (fig. 7) identify commercial shops as a primary source for quilted petticoats, though many of course were worked as personal creative projects. Such is surely the case with the petticoat (fig. 8) signed and dated "Abigail Trowbridge 1750," on which, in more elegant attire than Rachel De Puy's shepherdess, a quilted lady wears a quilted petticoat *on* a quilted petticoat. This work, which may be American or English, shows figures once again beneath a flowering tree. The animals that roam its border and climb its tree bear great similarity to others worked on what we are beginning to consider a quite distinctive, if still small, group of American quilted petticoats. On one we find various animals — horses, squirrels, unicorns, a fox (figs. 9–10) — that inhabit a world of pomegranates and berries, of winged insects, tulips, and running vines, worked traditionally on the lower third of a woolen petticoat, meant to please the woman who wore it and those who saw it.

NOTES

1. Although Rachel's name appears most prominently on her quilt, and although family history has attributed it to her hands, three additional initials, "A D P," are worked beneath the corded inscription. They may be those of Anne De Puy, Rachel's aunt. Although Rachel was only seventeen, the fine work on this quilt is not beyond the capacity of a girl of that age and of that time. It is certainly not unusual, however, to find a quilt of extraordinary quality made by a loving mother or fond aunt.

2. The quilt descended through Rachel's sister, who married John Stroud, son of Colonel Jacob Stroud (who founded Stroudsburg, Pennsylvania). I am indebted to its most recent familial owners, who shared with me the genealogical information and family history contained in this entry.

3. This doll is illustrated in its three other stages of dress in Linda Baumgarten, *Eighteenth-Century Clothing at Williamsburg* (Williamsburg, Virginia: Colonial Williamsburg Foundation, 1986), p. 14. In addition to its fine text, this important publication contains photographs of several objects from Williamsburg's extensive collection of eighteenth-century clothing, including several quilted petticoats and a trio of clock stockings.

FIG. 10 Petticoat (detail), Colonial America, mid-eighteenth century, quilted linsey-woolsey, Los Angeles County Museum of Art, Costume Council Fund

6

The Boo-Hoo Bedcover

United States (Windsor, Connecticut),
c. 1813
Made by Mary Beebe (Mrs. Elisha)
Strong (1759–1834)
Linen; embroidered
86¼ x 78 ¾ in. (219.1 x 200 cm)
(includes 6¾ in. netting on either side)
Private collection

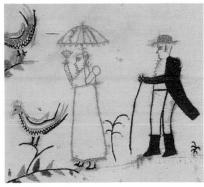

FIG. 1 *The Boo-Hoo Bedcover* (detail)

THIS BEDCOVER, pictured here without the frayed and tattered wide strips of netting that remain tenuously attached to either side, features in blue, brown, and rust threads floral and geometric shapes similar to those applied to early nineteenth-century New England embroidered woolen blankets. Five couples are depicted, perhaps illustrating stages of romantic love and married life. At the top right a young man offers a small token to a young woman holding a leafy bough, and in the last scene a man walks with a cane behind a still-fashionable, older woman who holds a parasol high above her head (fig. 1). The dresses on the piece are circa 1813: the waistline has risen considerably, and the shape is almost tubular.

Another surviving piece by Mrs. Strong, a quilt cut for a four-poster bed, features a checked-leaf motif that also appears on her bedcover. In addition, similar human figures are worked in blue silk thread on a closely quilted linen ground (fig. 2). The design includes another woman with a parasol; she stands with a man and two children between flower and fruit trees. In another small bower there is an angel with two chil-

FIG. 2 Mary Beebe Strong (United States, 1759–1834), quilt (detail), c. 1800, embroidered and quilted linen, private collection

38

The Boo-Hoo Bedcover

dren. Near the bottom of the quilt four men in knee breeches aim guns at a dragon outlined but never embroidered. Extant American quilts and bedcovers from the first quarter of the nineteenth century are relatively few in number, figurative quilts even more so. Establishing that authorship and provenance is the same for both these pieces allows us to assume that the motifs they share are peculiar to this quiltmaker and/or provide a basis for the identification of certain regional characteristics, should other comparable pieces be discovered in the future.

On the bottom corners of her bedcover and also on her quilt, Mrs. Strong embroidered variations of a motif found on the corners of eighteenth- and nineteenth-century rose blankets, produced in England and exported to America (the 1797 inventory of Richmond Hill, Aaron Burr's home in New York City, lists five rose blankets[1]). These woolen blankets are described in the 1839 *Workwoman's Guide* as "generally sold in pairs, or two woven together. These, for beds must be cut, in which case, the edges are sewed over in a very wide kind of button-hole stitch, with red, or other coloured wool, also a kind of circle or star is often worked in the corner with various coloured wool."

An earlier embroidered piece (fig. 3), worked in the closing years of the eighteenth century by Mrs. Sallie Kasinger Williams of Waynesboro, Tennessee, features motifs interestingly similar to those found on Mrs.

Fig. 3 Sallie Kasinger Williams (United States), bedcover, c. 1792, embroidered linen, 94 x 81 in. (238.8 x 205.7 cm), Los Angeles County Museum of Art, gift of Barbara Johnson

Strong's bedcover. In the center of three joined panels of homespun linen, Mrs. Williams stitched in pink and blue floss a large pinwheel-like design similar to two found on Mrs. Strong's bedcover. Fanciful winged beasts encircle the central motif on the Williams bedcover and populate the outer borders; a fantastic creature also hovers near the courting couple on the Strong bedcover (fig. 4). This creature establishes the bedcover's earliest possible date. The image is copied from a political cartoon (fig. 5) designed and engraved by Amos Doolittle. The cartoon "The Hornet and Peacock Or, John Bull in Distress, Entered according to act of Congress the 27th day of March 1813 by A. Doolittle of the State of Connecticut" is a satirical comment on an event of the War of 1812, during which British vessels sought to deny American ships an Atlantic crossing. On February 24, 1813, the American ship *Hornet* sank the British *Peacock*, which Doolittle faithfully illustrates. In the foreground of the cartoon, however, Great Britain is represented as a creature part bull, part peacock, being stung through the neck by a giant hornet saying "Free Trade & Sailor's rights!!! you old Rascal!!!" to which John Bull responds "Boo-o-o-o-hoo!!!" Caricatures such as this were an effective means of recording the nation's history and placing it into the hands of the common man quickly: Doolittle's cartoon was printed only a month after the battle. The incident proved to be a

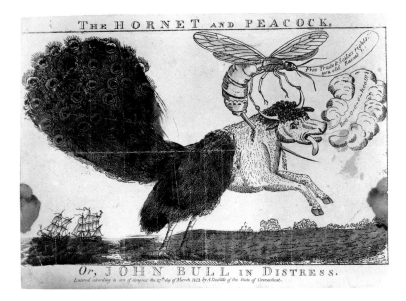

FIG. 5 Amos Doolittle (United States, 1754–1832), *The Hornet and Peacock, Or, John Bull in Distress*, 1813, etching, 7½ x 10¼ in. (19.1 x 26 cm), the Huntington Library, San Marino, California

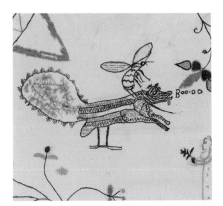

FIG. 4 *The Boo-Hoo Bedcover* (detail)

particularly popular satirical subject: Doolittle himself produced a second cartoon on the topic;[2] William Charles engraved "The Cock fight — or Another Sting for the Pride of John Bull" beneath an image of George III, who, observing a hornet delivering a mortal sting to a peacock, remarks "Aye! What! What! What! Brother Jonathan's Hornet killed my Peacock!!! In fifteen minutes too! not possible — Fine bird — well fed — I fear he was too fond of showing his tail.";[3] and the incident was also treated in verse, "O, Johnny Bull, my joe, John, your / *Peacocks* keep at home, / And ne'er let British seamen on a *Frolic* / hither come, / For we've *Hornets* and we've *Wasps*, / John, who as you doubtless know, / Carry stingers in their tails, O, Johnny / Bull my joe."[4]

 And on at least one occasion the victory was recorded on the refined and elegant surface of a New England bedcover.

N O T E S

1. Florence M. Montgomery, *Textiles in America 1650–1870* (New York: W. W. Norton & Co., 1984), p. 170. The American Quilt Research Center at the Los Angeles County Museum of Art has a very early specimen of this motif, gift of Joel and Kate Kopp.

2. An 1813 letter from Amos Doolittle to a prospective purchaser is quoted in William Murrell, *A History of American Graphic Humor*, vol. 1 (New York: Whitney Museum of American Art, 1933), p. 61:

 Sir,
 Although a stranger to you, I take the liberty of sending you a Caricature Print, entitled "Brother Jonathan administering a Salutary Cordial to John Bull." Although many caricatures extant are of no use, and some of them have an immoral effect, I flatter myself that this will not answer that description. At the present time, it is believed, it will have a tendency to inspire our countrymen with confidence in themselves, and eradicate any terrors that they may feel as respects the enemy they have to combat.

3. This cartoon, in the collection of the Historical Society of Pennsylvania, is illustrated in *Philadelphia: Three Centuries of American Art*, exh. cat. (Philadelphia: Philadelphia Museum of Art, 1976), p. 228.

4. "Brother Jonathan's Epistle to Johnny Bull," in B. J. Lossing, *Pictorial Field-Book of the War of 1812* (New York, 1869), p. 698, n. 2, as quoted and cited in *Philadelphia: Three Centuries of American Art*, pp. 228–29.

7

The Salley Fulcher Bedcover

United States (Virginia), dated 1818
Made by Sarah ("Salley") Wisdom
Fulcher (1796–1873)
Cotton; embroidered
106 x 87½ in. (269.2 x 222.3 cm)
The Abby Aldrich Rockefeller Folk Art
Center, Williamsburg, Virginia

FAMILY TRADITION holds that Sarah ("Salley") Wisdom, born in 1796, "seeded, carded, spun, wove and embroidered" this splendid all-white bedcover during the War of 1812 and finished it the day peace was declared; that Alexander Fulcher served in the war and that the bedcover was dedicated to him; and that the work bears the date 1818 as the year of their marriage.[1] Official records, however, establish the wedding date as January 2, 1812;[2] and the treaty signed at Ghent on Christmas Eve, 1814, brought an end to the war four years before this bedcover was dated.

Though the circumstances under which this bedcover was made remain in doubt, one thing is certain: Salley's superior craftsmanship is everywhere apparent. The tabby-woven white cotton is embroidered in white cotton in a great variety of stitches, including French knots, bullion, satin, seed, stem, and Roumanian couching. Candlewicking, or cut stitches, form the hair of the lady at the far left and frame the face of the primary female figure.

The human figures within the scalloped oval medallion (itself surrounded by intertwining vines) appear in quite detailed costume (fig. 1). The woman holds sheaves of wheat, and what may be a handkerchief or a reticule[3] hangs at her side. Her white cotton day dress is in a style that slightly predates the bedcover. The elaborate whitework embroidery on the dress was a popular embellishment from 1795 to 1815.

On an 1817 fashion plate from the *Journal des dames et des modes* (fig. 2) a female figure's tiny feet are in the same fashionable position as the feet of Salley's central figure. She carries her handkerchief at her side. The bodice of her dress is, as with Salley's ruff-ornamented bodice, only a few inches in depth, but there is a considerable widening and a decorative elaboration at the bottom of the skirt. The costume of the gentleman at her side is almost identical to that of the primary male figure on the bedcover: in addition to a top hat and tail coat, each man wears a linen stock collar wrapped around the neck over the shirt collar and tied with a decorative bow at the front; vertical linen ruffles are attached to the

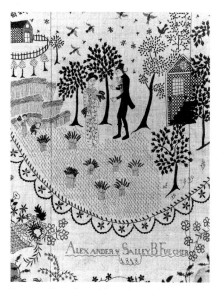

FIG. 1 *The Salley Fulcher Bedcover* (detail, backlit)

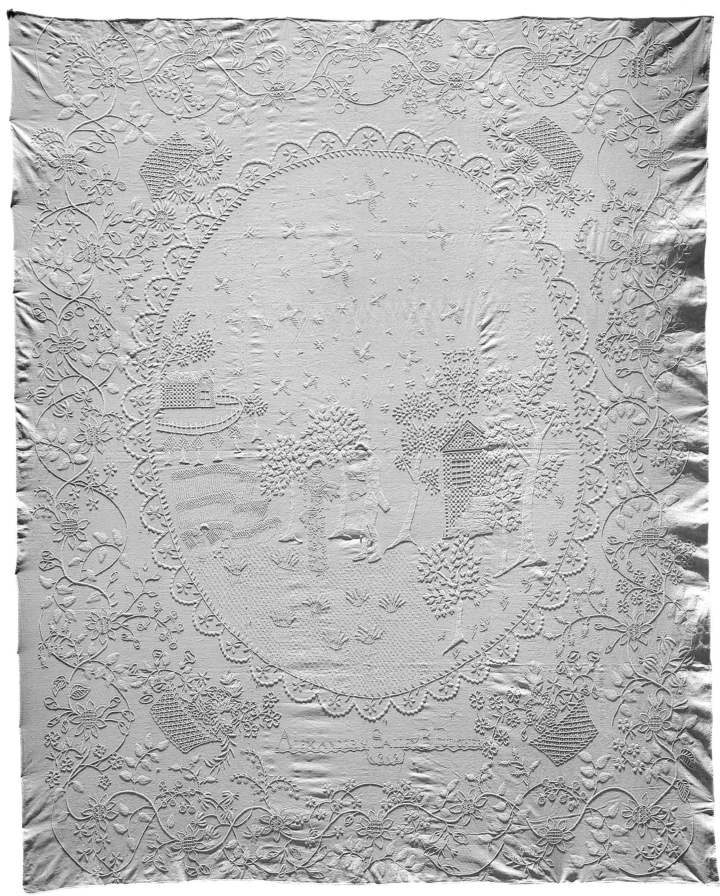

The Salley Fulcher Bedcover

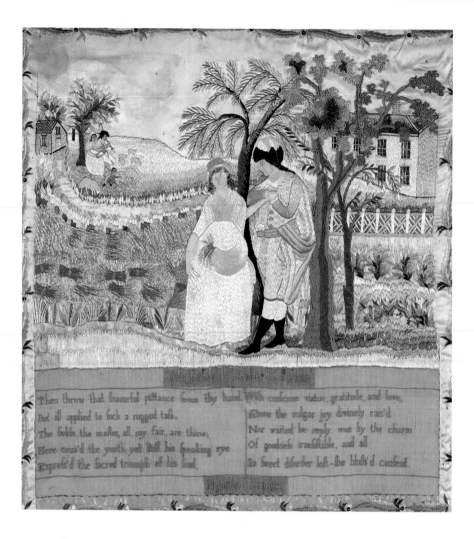

center front of the shirt. At the top of his turned-down boots, the French gentleman wears decorative ribbons; on this Virginia bedcover, the fashion seems to have been for small tassels.

At the time this piece was worked, engravings were considered an appropriate point of visual reference for painters and students. That prints were a source of design for needlework is evident on a number of silk pictorial embroideries worked in the fashionable, young ladies' academies primarily in the first quarter of the century.[4] The designs were usually drawn or copied on the silk by a teacher who then supervised the needlework; at this time technical proficiency in needlework was more highly regarded than originality of design.

The figures on this bedcover and the setting in which they are placed almost certainly derive from a print source. The source for the theme of Salley Wisdom Fulcher's bedcover was in all probability identical to that which inspired Mary Abner's fine needlework sampler (fig. 3), also Virginia, circa 1800: the story of Palemon and Lavinia from "Autumn," part of an immensely popular eighteenth-century poem cycle, *The Seasons*, by Scottish-born English poet James Thomson (1700–48).[5] Thomson, whose work celebrated nature and an agrarian existence, was a forerunner of the romanticism of the early nineteenth century. His Palemon

and Lavinia episode is a tale of harvest, based on the Old Testament story of Ruth and Boaz.

The existence of a second Palemon and Lavinia schoolgirl embroidery from Virginia, executed by Drusilla de la Fayette Tatein in 1802, and two thematically related pieces worked at the Moravian School in Lititz, Pennsylvania, in 1816 and 1817 suggest a possibly extensive use of the subject in American needlework during that period.[6] A specific print from which the design for these embroideries might have been taken has not yet been found. The rural vignette on Salley's bedcover is surely also drawn from a similar source. As the daughter of a well-to-do Richmond, Virginia, planter and thus a young lady of social privilege, Salley probably had access to imported prints, if not in a classroom then quite possibly in her home. The romantic story of Palemon and Lavinia might have seemed particularly appropriate to her rural existence, the legend on the piece now recording the tale to be that of "Alexander and Salley Fulcher 1818."

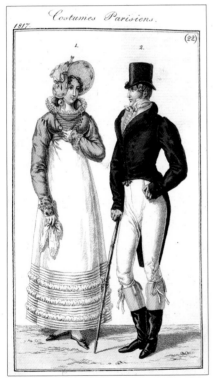

FIG. 2 From *Journal des dames et des modes* (May 25, 1817): opposite 568, Los Angeles County Museum of Art

NOTES

1. This information comes from the archives of the Abby Aldrich Rockefeller Folk Art Center.

2. Spotsylvania County, Virginia, *Marriage Register* (1812), p. 32.

3. At the beginning of the nineteenth century women adopted a version of the dress of classical antiquity, white and high-waisted, of a fabric so sheer that it could not bear the weight of a pocket, thus necessitating the carrying of a reticule or small handbag.

4. In *American Needlework Treasures* (New York: E. P. Dutton, 1987) Betty Ring illustrates several examples from her own important collection of silk embroideries with the print sources from which the designs were drawn. An aquatint engraving of *Mount Vernon in Virginia* inspired a number of needlework pieces such as Mrs. Ring's *The tribute of/an AFFECTIONATE daughter in Me/mory of the Ho/nle JOSEPH ISHAM, Obit/Octr 31st 1810*, p. 89. The same engraving was the model for a watercolor painted by Susan Whitcomb in 1842 at Brandon, Vermont (illustrated in Jean Lipman, "Print to Primitive," *Antiques* [July 1946]: 41).

5. Wylie Sipher, *Enlightened England: An Anthology of Eighteenth-century Literature* (New York: W. W. Norton & Co., 1947), p. 394.

6. I am extremely grateful to Barbara R. Luck, curator, the Abby Aldrich Rockefeller Folk Art Center, for suggesting to me the possibility of the bedcover's thematic source being that of Palemon and Lavinia. Information regarding the related schoolgirl embroideries appears in Sotheby's exhibition catalogue for Wednesday, June 21, 1989.

8

The Ann Warner Quilt

United States, dated 1822
Made by or for Ann Maria Warner
(1794–1873)
Cotton; pieced, appliquéd, quilted,
and embroidered
103 x 105½ in. (261.6 x 268 cm)
The New-York Historical Society,
New York, gift of
Mrs. Bayard Verplanck, 1945

FIG. 1 *The Ann Warner Quilt* (detail)

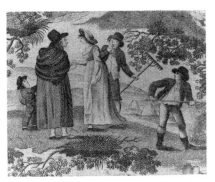

FIG. 2 Furnishing fabric (detail), England, c. 1805–10, printed cotton, Los Angeles County Museum of Art, gift of Mrs. Henry Salvatori

THE SMALL, cross-stitched alphabets worked on American samplers were decorative exercises for the eventual marking of household linens. They also provided one of the earliest methods by which inscriptions, usually initials and/or dates, were entered on American quilts. Each of the four corner blocks of this dramatic quilt are pieced in the *LeMoyne Star* pattern, and on the one at the top right-hand corner, cross-stitches set out "AMW 1822." The quilt is presumed to have belonged to Ann Maria Warner; however, since it is yet another piece that has descended through the Warner family (see the *Phebe Warner Bedcover*, p. 28), the authorship of the work cannot be absolutely established.

The origin and the original name of any particular pattern is almost impossible to ascertain; but that the geometric, pieced pattern on this quilt was in use in the early nineteenth century can be confirmed by the existence of dated pieces, such as this quilt and one dated 1828 in the collection of the Los Angeles County Museum of Art. The traditional and continuing name for this pattern is *Irish Chain*; that it was in use at the time this quilt was worked is suggested by its mention in popular literature, such as the short story "The Quilting Party," in which T. S. Arthur writes, "Our young ladies of the present generation know little of the mysteries of 'Irish chain,' 'rising star,' 'block work,' or 'Job's trouble,' and would be as likely to mistake a set of quilting frames for clothes poles as for anything else."[1]

The alternating white blocks the pattern creates have been embellished with appliquéd and embroidered figures and flowers (fig. 1). Symmetrically placed throughout the quilt are a series of rural scenes cut from a single, polychrome, figurative, cotton print. These show a cottage, groups of figures, and a young woman beneath a tree; the woman holds a sheaf of wheat, as did figures on the *Phebe Warner* and *Salley Fulcher* bedcovers (ill. p. 29 and p. 43). Pastoral and rural scenes were especially popular as furnishing fabrics during the first quarter of the nineteenth century. In contrast to the richly colored illustrations on this Warner quilt, many such scenes were printed in monochrome (fig. 2) and by metal rollers, thereby producing a much less expensive product than was available in the previous century.

The remaining blocks are imaginatively filled with appliquéd and embroidered images of flowers and birds, some cut whole from chintz and applied in the *broderie perse* technique and others inventively constructed from a variety of pieces of printed cottons. The individual elements of the flowering tree are worked here as single elegant entries, some — such as the tulip and the iris — intriguingly similar to those found on the piece so splendidly worked for Phebe Warner.

NOTE

1. *Godey's Lady's Book* 39 (September 1849): 185.

9

The Trade and Commerce Bedcover

United States (Stockton, New Jersey),
c. 1830
Probably made by Hannah Stockton
Cotton; appliquéd and embroidered
105 x 89 ¼ in. (266.7 x 226.7 cm)
New York State Historical Association,
Cooperstown

As REFLECTED in American folk art circa 1830, the artistic tastes of America's growing middle class were centered not on the romantic images of a European past but on the more vigorous images of America's present. An intense national interest in trade, commerce, and individual entrepreneurship may have inspired a quiltmaker thought to be Hannah Stockton to appliqué and embroider this bedcover illustrating the water-front activities of a bustling port town. If it was indeed Hannah who created this piece, then the locale depicted may be one near Stockton, New Jersey, where she was born and where she lived prior to moving to Germantown, Pennsylvania, after her marriage into the Stiles family.

The central panel around which the three narrative borders are constructed once again affirms the flowering tree as a continuing decorative motif. Winged cherubs are barely discernible within the gnarled trunk. Nine immense exotic birds perch on its branches, six cut from chintz as complete images and three on the right side inventively assembled from other bits of printed cloth. When the chintz remnants yielded an insufficient number of leaves, substitutes were cut and shaped from the printed cotton that also provided the wide, rolling waves.

An inner border teems with maritime activity. During the Victorian age sailors became increasingly popular as romantic figures through images projected by Gilbert and Sullivan, Joseph Conrad, Staffordshire pottery, and ultimately through drawing-room paintings and mass-produced prints.[1] Here, however, the quiltmaker portrays them engaged in less heroic, more commonplace activities (figs. 1–2).

Rural and urban costume are well represented on American figurative quilts throughout the nineteenth century, but this work is particularly significant in its illustration of the clothing worn by laborers, clothing seldom described in letters and diaries or in the literature of the period. A wagon driver appears twice, and he wears a large, brown, worker's smock (figs. 3–4).

All the figures are constructed of plain and printed fabric primarily from the first three decades of the nine-

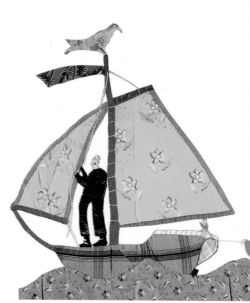

Fig. 1 *The Trade and Commerce Bedcover* (detail)

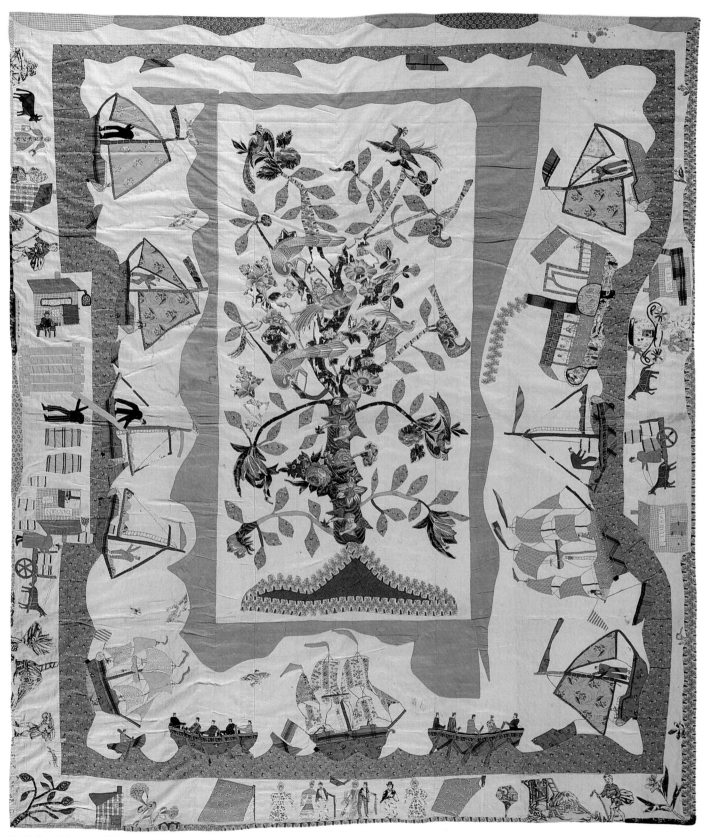

The Trade and Commerce Bedcover

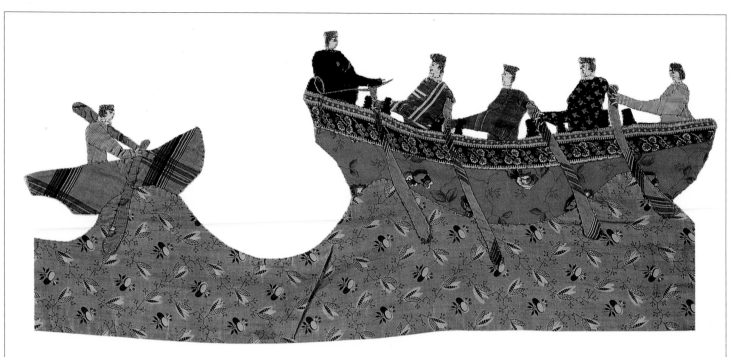

FIG. 2 *The Trade and Commerce Bedcover* (detail)

teenth century, but two are printed figures, their burdens and surroundings cut from an unidentified print quite possibly from the mid-eighteenth century. A rather coarse, indigo blue woodblock print depicts tobacco growing in the colonies. One man (fig. 5) carries tobacco leaves under his arm: grasping a staff he walks, eyes downcast, past a small stone hut with thatched roof and small leaded-glass windows. The second carries the crop on his back. He moves toward a palm tree that is ingeniously constructed from bits of tobacco leaves and a rake obviously printed elsewhere on the original bit of fabric.

Five ladies and gentlemen view the panorama from the covered deck of a steamboat (fig. 6), and although they are barely more than one-and-a-half inches in size, their costumes have been so finely worked in single threads that they are detailed and datable. Several couples promenade on the lower border of the bedcover. A man sits, stein in hand, in front of the grocery store (fig. 7); another, amid tiny embroidered bottles in the tavern, raises his glass in toast (fig. 4). A fashionably attired milkmaid

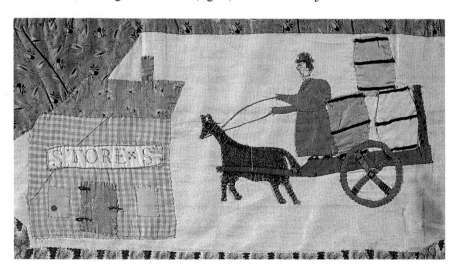

FIG. 3 *The Trade and Commerce Bedcover* (detail)

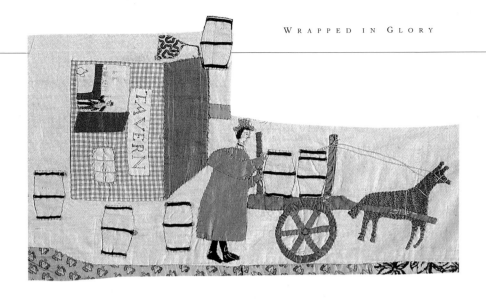

FIG. 4 *The Trade and Commerce Bedcover* (detail)

FIG. 5 *The Trade and Commerce Bedcover* (detail)

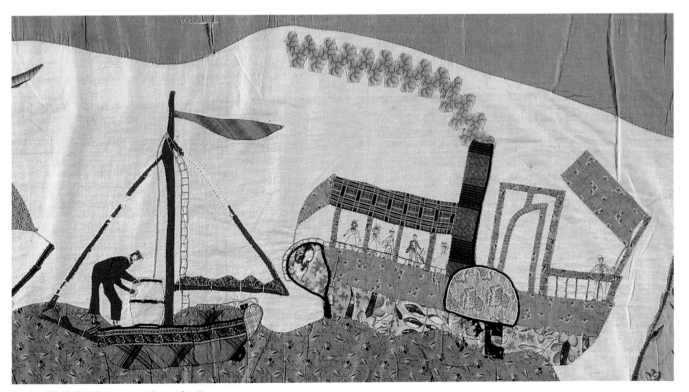

FIG. 6 *The Trade and Commerce Bedcover* (detail)

FIG. 7 *The Trade and Commerce Bedcover*
(detail)

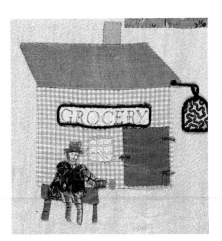

stands beside a cow, her stool and bucket in her hands (fig. 8).

On the right side of the bedcover two ladies have alighted from their carriage (fig. 9). Their expressive faces, as on the other appliquéd figures, have been stitched on fine cotton, then cut out and appliquéd to the ground. Although the figures are only four inches tall, their costumes are worked in elaborate and accessorized detail. The silhouettes of these small figures show clearly that the straight, clinging classical line introduced following the French Revolution has disappeared, the column replaced by a series of triangles. The full-bottomed skirts attach to lowered waists, which in turn widen to immense balloonlike sleeves, the entire ensemble completed by enormous hats with towering crowns and huge brims that have lifted to accommodate more elaborate hairstyles and streaming, wide ribbons (cf. fig. 10). The skirts on these ladies fall fashionably to a point only slightly below their ankles, and we can see their tiny, flat shoes. They each carry a fashionable reticule, or purse, and between them, a basket of fruit. Their posture and costume speak of a new confidence.

NOTE

1. David Marcombe, *The Victorian Sailor* (England: Shire Publications, 1985), pp. 5–7.

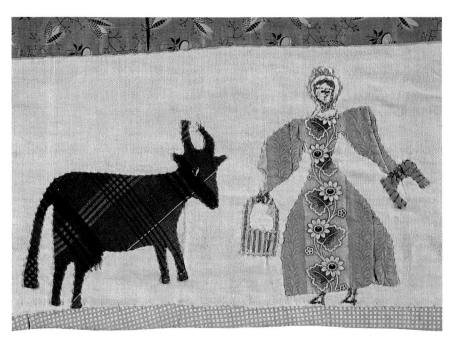

FIG. 8 *The Trade and Commerce Bedcover*
(detail)

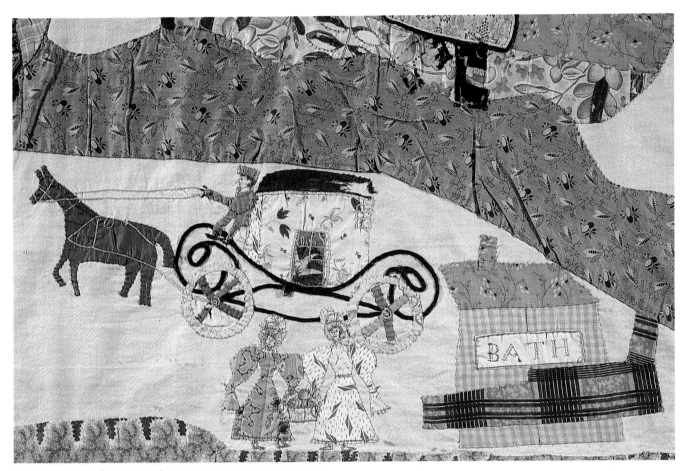

FIG. 9 *The Trade and Commerce Bedcover*
(detail)

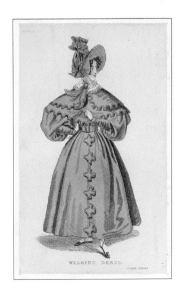

FIG. 10 Fashion plate, England, c. 1830, Los
Angeles County Museum of Art

10

The Charleston Battery Scene

United States (Charleston, South
Carolina), c. 1840
Probably made by Martha Cannon Webb
Cotton; appliquéd and embroidered
17 x 202¼ in. (43.2 x 513.7 cm)
The Charleston Museum, Charleston,
South Carolina

T HE LEGACY of American quiltmakers does not always take the form
of completed objects. These unfinished segments, for example, preserve a
remarkably rich record of Charleston, South Carolina, circa 1840. By
comparing what is depicted on these segments with similar images pro-
duced contemporaneously in other media (i.e., works written, printed,
painted, or photographed), we can begin to identify, date, and interpret
those images created with needle and thread.

Records in the Charleston Museum provide a basis upon which
analysis of the object can commence:

> Appliquéd panel, originally a quilt "done by an elderly lady" of the
> Logan family in Charleston circa 1800. Subsequently "Cousin Pattie"
> snipped out bits for her friends. Finally, another cousin rescued the
> remnants and painstakingly sewed them on this panel. Given to the
> Charleston Museum September 7, 1977, by Alice Logan, in memory
> of many generations of Logans who have served the town, the pro-
> vince and the country.

Contrary to the written record, physical evidence suggests the panels
were never actually joined to form a quilt; certain of the images, for
example, are only basted. The quiltmaker may have intended that these
narrow panels be joined, perhaps to another undiscovered or uncom-
pleted panel, to form a quilt top or to serve as borders. Segments were
indeed cut out and later restored, seemingly to their original positions on
the panels. The use of certain fabrics suggests a later date than 1800.

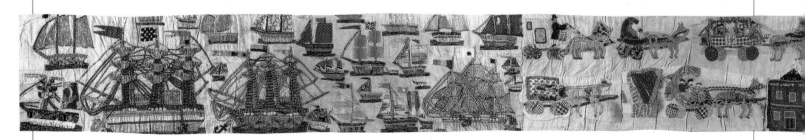

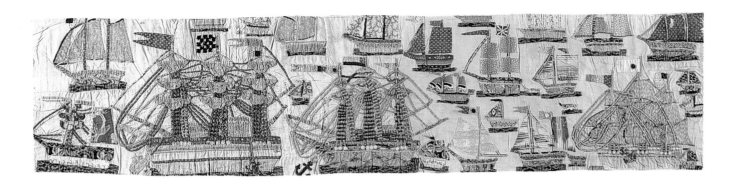

The Charleston Battery Scene

FIG. 2 From the *Courier* (Charleston, South Carolina, February 18, 1835)

FIG. 1 *The Charleston Battery Scene* (detail)

Additional clues to the identity of the quiltmaker may be found in a handwritten document, "A Record of the Logan Family of The State of South Carolina in North America Written by William Logan The Eldest Male Descendant Living Anno Domini 1841":

In 1802, upon the death of his grandfather, William Logan purchased his plantation in St. James (Episcopal Parish) in Goose Creek. He named it Maryville after his wife, Mary Doughty, daughter of John Webb Esq. of Charleston. William had been admitted to the bar in 1797, at the age of 21, but he now gave up the practice of law and became a planter. Mary Doughty Webb died in 1818 and William Logan again married on the 11th November 1819 in the 43 yr of his age and 36th of hers Mi(p) Martha Cannon Webb eldest daughter of Mr. Wm. Webb and cousin to his first wife. She [Martha] had been her cousin's constant companion and on our marriage [the marriage of Mary and William] came to live with us and continued to do so until the death of her cousin, the children looked upon her as a sister and mother. Possessing all those endearing qualities and amiableness of disposition and temper her cousin so fully possessed, she could not do otherwise than make up the loss we met with as far as permitted. I am happy today we have both journeyed on for upwards of twenty years in the enjoyment of every domestic happiness (except riches) and an affectionate daughter and son to add to the leisure of our declining lives.[1]

Martha Cannon Webb Logan died on March 12, 1843, and the unfinished work depicting Charleston was eventually passed to her granddaughter Martha Webb ("Patty") Logan. Patty (the daughter of Martha's son, the Reverend Edward Charles ["Ned"] Logan) married Arthur Lawrence Eubank and lived on a farm northwest of Traveler's Rest, near Greensville, South Carolina. She had no children, and in her later years when relatives came to call, she would often give them family treasures. To a niece, Alice Logan Wright, she gave these cotton panels depicting early Charleston. All we have learned from records in the Charleston Museum and from William Logan's testimony would lead us to believe that this work was made by either Mary Doughty Webb Logan or Martha Cannon Webb Logan; however, the presence of a richly detailed urn (fig. 1) strongly suggests that the *Charleston Battery Scene* was not done by Mary Logan. She died in 1818, and the urn was almost surely based on one featured in an advertisement (fig. 2) in the Charleston *Courier* of February 18, 1835, the work of South Carolina silversmith John Ewan (1786–1852), who practiced his craft in Charleston from circa 1823 until the time of his death.[2]

The subject matter of ships and buildings and the narrow, elongated shape into which the panels have been assembled is in the tradition of the earliest of Charleston's marine art, particularly a 1737 watercolor of the harbor painted by Bishop Roberts from across the Cooper River (fig. 3) (which was in turn engraved in London by W. H. Toms [fig. 4]) and a 1774 oil painting by Thomas Leitch, which also illustrates recognizable structures on Charleston's waterfront. The watercolor, the print,

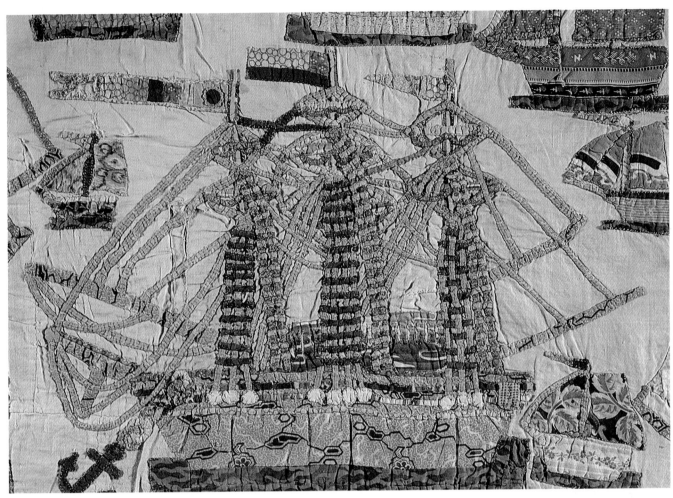

FIG. 5 *The Charleston Battery Scene* (detail)

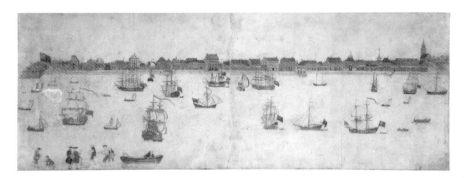

FIG. 3 Bishop Roberts (United States), *View of Charleston, South Carolina*, c. 1735–39, watercolor on paper, 15 x 43⅜ in. (38.1 x 110.2 cm), Colonial Williamsburg Foundation

FIG. 4 W. H. Toms (England, 1700–50?), *The Prospect of Charles Town*, 1749, line engraving, 19¾ x 55½ in. (50.2 x 141 cm), Colonial Williamsburg Foundation

FIG. 6 *The Charleston Battery Scene* (detail)

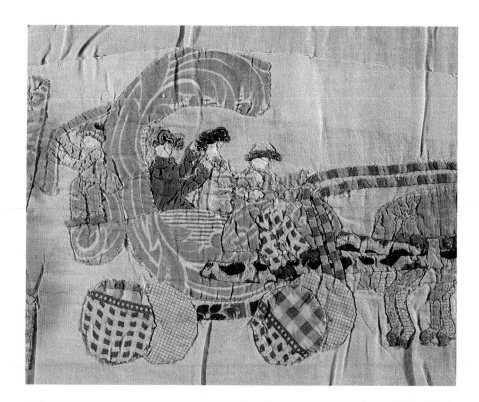

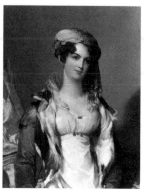

FIG. 7 Thomas Sully (United States, 1783–1872), *Mrs. Robert Gilmore*, 1823, oil on canvas, 36⅛ x 28¼ in. (91.8 x 71.8 cm), the Gibbes Museum of Art/Carolina Art Association

and the painted canvas all depict the harbor teeming with a variety of sailing vessels, and so too do these panels, on which the ships are worked in exquisite dimensional details (fig. 5).

Two panels feature conveyances (fig. 6) of the type that Mrs. St. Julien Ravenel, a prolific chronicler of the romantic Charleston of her girlhood, describes in the following passage:

> The coaches, though ugly in shape, were very ornamental in colour and gilding; round-bodied, hung high on C-springs, with high box draped with hammer cloth, on which sat an important coachman. Behind was a foot-board on which stood a footman, who clung for dear life to bands which depended from the back, and sprang down to unfold the flight of steps, down which his mistress carefully, with hand on his sleeve, descended to the ground....Some of the coaches were wide enough to accommodate three persons on a seat, and they must have been at least four feet from the ground. A few of these unwieldy vehicles were in occasional use as late as 1840–1845. The writer remembers one—a survival—which to her youthful imagination was the prototype of Cinderella's pumpkin. It was round and bright yellow, with a great quantity of gilding, lined with brown velvet.[3]

Riding in the quilt's carriages are the elegant, turbaned ladies of Charleston (cf. fig. 7).

The eighteen houses that appear on the panels provide a record of Charleston's great architectural heritage. Not all the houses are grand, but each of them is worked in specific architectural and decorative details. In some instances the desired effect is achieved through the skill-

ful manipulation of embroidery stitches, but more often it is through the imaginative choice of textiles (many in the rainbow hues typical of that city's dwellings); the fabric forming the surface of one house, for example, is an ombré overlaid with a honeycomb maze suggesting bricks, and the fabric on the surface of another suggests climbing vines.

Several of the more modest structures are clustered along the top of the last panel. Here one of Charleston's most distinctive forms of architecture, the "single house," is depicted. To take advantage of cooling sea breezes, these houses were built sideways on the plot, their gable ends facing the street, from which one entered through a narrow piazza or veranda. It is in this neighborhood that a goat appears (fig. 8): as late as 1893 goats were treasured family pets in Charleston and could be seen pulling children's wagons along West Point Mill Causeway as families relaxed on the promenade.[4]

Although the panels have been dubbed the *Charleston Battery Scene,* at least some of the houses seem to represent those at other locations, par-

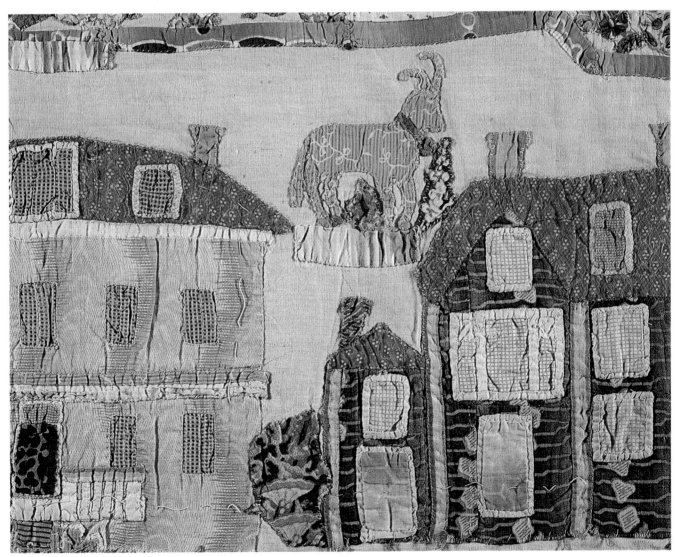

Fig. 8 *The Charleston Battery Scene* (detail)

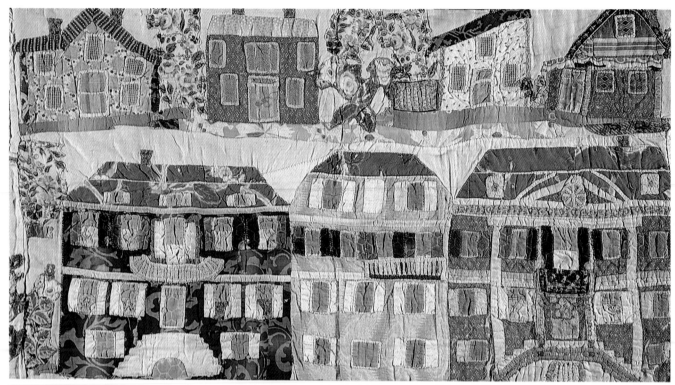

FIG. 9 *The Charleston Battery Scene* (detail)

ticularly the house in the lower right-hand corner, which undoubtedly depicts one of Charleston's most historic, the Pinckney Mansion (fig. 9):

> The lot occupied the whole square from Market to Guignard Street, on the Western side of East Bay. The house stood in the center, facing east to the water, and the ground across the street, down to the water's edge, also belonging to the family, was never built upon, but kept for open air and for the view....It was of small, dark English brick, with stone copings, and stood on a basement containing kitchens and offices. It had, besides the basements, two stories, with high slated roof, in which were wine and lumber rooms....This house differed from those of later date in Carolina, by having the kitchen and office in the basement—an almost unknown thing there in after years—and in the absence of extensive piazzas. In front there was only a high flight of stone steps with a small canopied porch....A vegetable garden was at the back, and grass plats with flower beds filled the southern part of the lot, one of the largest in the town.[5]

In addition to its occasional appearance in marine views of Charleston and its depiction on these remarkable panels, the image of that great house is also recorded in Mathew Brady's 1865 photographs of the Pinckney Mansion in ruins (fig. 10); it is from these that we can most authoritatively identify the building's cotton facade. As with much of Charleston, the destruction of the house came not from Union bombardment but from one of the many conflagrations that swept through the city, the Great Fire of December 11–12, 1861. Following the fall of Port Royal, hundreds of refugees from the plantations gathered in the city,

FIG. 10 Mathew Brady (United States, 1823?–96), *Pinckney Mansion*, 1865, albumen silver print, the National Archives

and during a cold front a small fire built for cooking and warmth ignited a nearby building. The fire could not be stopped, and by the next morning one-third of the city lay in ruins.

Around the splendid houses on this work, various chintzes form trees and shrubs, reminders of Charleston's magnificent gardens. It is appropriate that gardens should be represented so prominently on this work: in 1772, at age seventy, Martha Logan wrote what is said to be the first horticultural book to be published in America, *Directions for Managing a Kitchen Garden every month of the year Done by a Lady*,[6] and she would surely have been one of the Logans in whose memory Alice Logan chose to donate this work to the Charleston Museum.

N O T E S

1. This text was generously provided by members of the Logan family.

2. E. Milby, *South Carolina Silversmiths 1690–1860* (Charleston, South Carolina: Charleston Museum, 1942), pp. 54–57.

3. Mrs. St. Julien Ravenel, *Charleston: The Place and the People* (New York: Macmillan, 1906), p. 393.

4. Alice F. Levkoff, *Charleston Come Hell or High Water* (Charleston, South Carolina: Alice F. Levkoff and Patti F. Whitelaw, 1976), p. 58.

5. Alice R. Huger Smith and D. E. Huger Smith, *The Dwelling Houses of Charleston South Carolina* (New York: Diadem Books, 1917), pp. 371–72. According to Harlan Greene (personal communication, 1986) the bottom-left house on the third panel is probably the Laurens House, which is known to have been in the same East Bay area as the Pinckney Mansion.

6. Ann Leighton, *American Gardens in the Eighteenth Century* (Amherst: University of Massachusetts Press, 1986), p. 211.

11

The Anson Baldwin Quilt

United States (Yonkers, New York),
dated 1847
Made for Anson Baldwin by the Ladies
of St. John's Church
Cotton; pieced, appliquéd, embroidered,
and quilted; ink
104¾ x 101¼ in. (266.1 x 257.2 cm)
The Hudson River Museum of
Westchester, gift of
Miss Martha Baldwin, 1947

ALTHOUGH THE early Dutch settlers in the area had originally been members of the Holland Reform Church, it was the Church of England that formed the religious roots of Yonkers, New York, and it was in St. John's Episcopal Church (fig. 1) that the most prominent of Yonkers's early families continued to worship.[1] Among these were the families of Anson F. Baldwin and William C. Waring, who in 1838 formed a partnership for the manufacture of wool hats, beginning an industry that would remain prominent in Yonkers throughout the rest of the century.

The Ladies of St. John's were drawn together by religion, society, and kinship, and in addition to their philanthropic efforts on behalf of Yonkers's children and its poor, they met as a sewing circle, frequently at the Anson Baldwin home. On one of those occasions, noticing that an inordinate amount of attention seemed to be focused on St. John's popular minister, the Reverend Henry Lemuel Storrs, their genial host remarked in jest that "all the molasses goes into the minister's jug."[2] The ladies thereupon resolved that each member would work and inscribe a block to be assembled into a quilt for presentation to Mr. Baldwin as tangible assurance of their affection and regard.

The central panel of the resulting quilt represents a farm scene (fig. 2). Beneath the house we see a barrel or cask, perhaps the source of the molasses. The sky is filled with stars and a crescent moon and with a fanciful bird, flowers, and butterflies that hover over a woman drawing water from the well. From the outstretched hand of one woman (hair tightly drawn back in a bun) kernels of corn, suggested by small, yellow satin stitches, drop to the waiting chickens. Another woman stands with a broom, addressing a man with freckles. Her hair is white, and she wears a blue-ribboned cap, suggesting an older woman; beneath her feet pigs feed in a trough. All the men wear bright printed or plaid trousers tucked into high boots. The activities portrayed are commonplace, but a

The Anson Baldwin Quilt

FIG. 3 Portrait of Joanna Bashford from J. Thomas Scharf, *History of Westchester County, New York*, vol. 2 (Philadelphia: L. E. Preston & Co., 1886), p. 143, private collection

stylistic significance may be observed in the manner in which the features of the figures are rendered. On several, most particularly the figure second from the left, there seems to be a deliberate attempt at caricature. There is an exaggeration of features that results in a similarity to physiognomic "drawings," an admired form of popular imagery during the period in which the quilt was made.

The pieced and appliquéd blocks surrounding the central panel bear the names of women who were born and/or married into the most prominent Yonkers families: Gates, Paddock, Vark, and Waring among them.[3] For the most part, it was in the names of their fathers, husbands, and sons that the community's history was recorded, but one young signatory, Miss Joanna Bashford, entered into the financial history of this community in a visible if passive way: her father was on the board of directors of a newly formed bank, and it was Joanna's portrait (fig. 3) that appeared on the bank's bills until it became a national institution.[4] Invariably, however, what each of the ladies may have accomplished as individuals was generally acknowledged only within the records that pertained to women's spheres. Their collective accomplishment is likewise documented here on this quilt in script and embroidered in tiny, red stitches (fig. 4): "Anson Baldwin Esq / Presented by the Ladies / Yonkers October 1847."

Other images and inscriptions have, until now, gone unnoticed. An inspection of the quilt's backing under optimum lighting conditions revealed faded blue lines that, when photographically enhanced in the conservation laboratory of the Los Angeles County Museum of Art, proved to be the manufacturer's mark, faded and turned inward toward the quilt's batting. It reads at the base "Waltham Bleach," encircled by elaborate scrolling; in the middle "Ogden Superfine Sea Island"; and at the top the image of an Indian with bow and arrow (figs. 5–7).

The appliquéd block that appears to the right of the quilt's commemorative inscription includes images of a worsted hat, beehives, and a large molasses jug, some of its contents now being poured into Mr. Bald-

FIG. 2 *The Anson Baldwin Quilt* (detail)

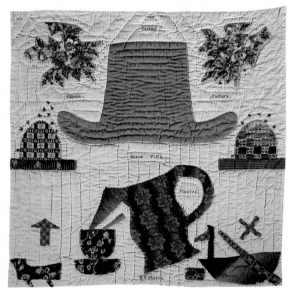

FIG. 8 *The Anson Baldwin Quilt* (detail)

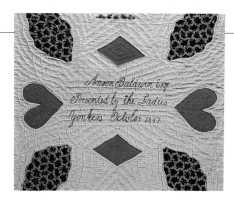

Fig. 4 *The Anson Baldwin Quilt* (detail)

Fig. 5 *The Anson Baldwin Quilt* (detail, reverse)

Fig. 6 *The Anson Baldwin Quilt* (detail, reverse)

Fig. 7 *The Anson Baldwin Quilt* (detail, reverse)

win's cup (fig. 8). The following cross-stitched inscriptions are entered as well: "Yonkers"; "Phoenix Factory"; "Buena Vista"; "lasses"; and "E. K. Storrs." The elements on this and other of the blocks would seem to support the oral history provided by Mr. Baldwin's granddaughter, and the appliquéd hat and the cross-stitched inscriptions may at least partially resolve the questions that have surrounded another Yonkers quilt, the *Hat and Heart Quilt* (see p. 66).

NOTES

1. J. Thomas Scharf, *History of Westchester County, New York*, vol. 2 (Philadelphia: L. E. Preston & Co., 1886), p. 58.

2. From the typescript of the oral *History of the Baldwin Quilt*, given to the Hudson River Museum in July 1947 by Miss Martha P. Baldwin, Anson Baldwin's granddaughter.

3. The following names appear on the quilt:

Jane Bashford	Fanny Meyer
Joanna Bashford	Sarah E. Meyer
Ann R. Bowitt	Elizabeth Paddock
Amanda Brown	George Paddock
Lizzie Burch	Lioneena Paddock
Elizabeth [Caufest?]	M. A. Paddock
E. F. Y. [Codenglen?]	Mrs. Matilda Paddock
Al[etta?] R. Cooper	Susan Emily Paddock
Luanna Dann	Walter H. Paddock
S. Dann	L. E. M. Prowitt
Mrs. Amos Gates	Mrs. Jane Smith
Mrs. M. H. Gates	E. K. Storrs
Mrs. H. A. G. Groshon	Mrs. Esther Storrs
Mary Elizabeth Groshon	Joanna Vark
Caroline Jones	Judge Vark
Mrs. Albert Keeler	Catherine Waring
Mrs. Harriet M. McMaster	Mrs. Wm. Waring

4. Joanna's father, John Bashford, kept a hotel. "It afforded something in the way of neighborhood sociability. It kept the people in touch with the outside world. In addition to its transient visitors it was the meeting place of local politicians, public gatherings and such like. For a number of years Bashford's hotel and his Sloop Landing played a very important part in the everyday life of our little village." Henry Collins Brown, *Old Yonkers* (New York: Valentine's Manual Press, 1922), p. 73.

"A long, two-story house of reddish brown color, but with no accompanying signpost or proprietor's name in sight and with no external indications that it was an inn. It stood near the Hudson at the mouth of the Nepperhan, whose water ran clear as the water of a mountain brook. Broad verandas, also two stories high, covered its whole front. The building was handsomely shaded by several large willows, and the high wooded bluff, towards which the house almost faced, looked down on it from the opposite side of the creek, while the gardens and the open ground, and the fields behind the house all combined to give the place the air of an ample, quiet rural home by the waterside." Charles Allison, *The History of Yonkers* (New York: W. B. Ketcham, 1896), p. 160.

It was in this setting that Joanna and her sister Jane may well have worked a portion of their blocks, or entertained at their turn, the ladies of the sewing circle of St. John's.

12

The Hat and Heart Quilt

United States (Yonkers, New York),
c. 1847
Probably made for Anson Baldwin
by E. (Esther?) K. Storrs
Cotton and wool; appliquéd,
embroidered, and quilted; ink
35 x 33 in. (88.9 x 83.8 cm)
The Baltimore Museum of Art,
gift of Irwin and Linda Berman,
St. Simons Island, Georgia

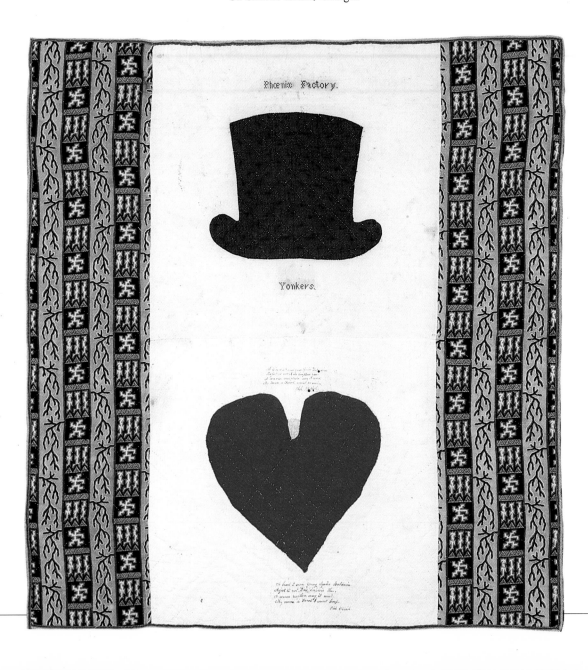

FIG. 1 Portrait of Louis Antoine Godey (1804–77), c. 1845, engraving from an unidentified source, Los Angeles County Museum of Art

FIG. 2 *The Anson Baldwin Quilt* (detail)

FIG. 3 *The Hat and Heart Quilt* (detail)

THE *Hat and Heart Quilt* has become one of this country's most often published textile pieces, but its maker and provenance, its meaning, and the circumstances under which it was worked have long been in question. Comparison with one of the blocks on the *Anson Baldwin Quilt* (p. 62, fig. 8) will perhaps allow us to begin to resolve these issues.

By the nineteenth century the top hat (in style since the 1780s) dominated the fashion in men's hats, and by the middle of the century it was the principal choice of men of every class[1] (fig. 1). It appears here appliquéd on a plain cotton ground. The worsted hat and a heart are bordered on two sides by whole-cloth panels. Below the heart, in ink: "A heart I send, Young Squire Baldwin / Reject it not, I do implore you. / A warm reception may it meet. / My name a Secret I must keep. / Old Maid." And above, a slight variation in faded ink: "A heart I send *You* Squire Baldwin / Reject it not I do implore you / A warm reception may it meet / My name a Secret must remain. / Old Maid." Above and below that woolen top hat small cross-stitches reveal pattern idiosyncracies (figs. 2–3) also common to the block on the *Anson Baldwin Quilt* worked by E. K. Storrs: this small valentine may in fact have been worked not by an old maid, but by the minister's wife.

Earlier attempts to identify and interpret this piece usually centered on searching for a hat factory by the name of Phoenix, but none has emerged in Yonkers. Mr. Baldwin and his partner had begun a business on the site of the sixth fall of the Saw-Mill River, but it burned in 1844, and they rebuilt on the fifth fall, the next below their old site.[2] Could *this* not be the Phoenix Factory, risen from the ashes of the old?

NOTES

1. Michael Harrison, *The History of the Hat* (London: Herbert Jenkins, 1960), p. 156.

2. J. Thomas Scharf, *History of Westchester County, New York*, vol. 2 (Philadelphia: L. E. Preston & Co., 1886), p. 95.

13

The Baltimore Album Quilt

United States (Baltimore, Maryland),
c. 1850
Quiltmaker unknown
Cotton; appliquéd, embroidered,
painted, and quilted; ink and watercolors
101¼ x 103¼ in. (257.2 x 262.3 cm)
Hirschl & Adler Folk, New York

Names, dates, and sentimental remembrances of the kind inscribed on the pages of nineteenth-century autograph albums were, by the 1840s, being similarly recorded on quilt blocks. The quilt assembled from these blocks was almost always intended as a presentation piece, to be given to such individuals as brides, ministers, or departing friends. In terms of both style and execution the album quilt came to full flower in Baltimore, Maryland, between 1846 and 1852. This particular piece is the quintessence of the Baltimore album quilt and of American appliqué.

Baltimore quiltmakers applied a number of innovative techniques to the abundance of plain and printed fabrics available in that prosperous port town. Predominant on Baltimore album quilts are a variety of floral motifs that developed from simpler forms (for example, the wreath we see at the bottom left-hand corner) into a complex and multicolored layering of fabrics. At their most splendid the flowers are arranged in sprays, in wreaths both open and closed, and gathered together in great bunches held by, or arranged in, a number of elaborate baskets and bowls. The blossoms burst from various cornucopias: the ringed example on this quilt (block 5b) appears on several other of the most elegant Baltimore album quilts.

Many of the images on these Baltimore quilts are replications of designs found in the city's decorative arts. The flower-filled baskets, bowls, and cornucopias on this quilt, for example, are similar to those found on theorems, on carved and painted furniture, and on the edges of some of the city's pottery and china. One of many decorative patriotic images typical of the period, the American eagle (fig. 1) in the center of the quilt is another motif typically found on the classic Baltimore album quilts. Its head droops downward; a shield is clasped in its beak; a flag streams from the tassel-topped standard held in the bird's claws; and above the tassels hangs a liberty cap (for more on the liberty cap, see p. 95) worked in the same appliquéd-rings technique used to create the cornucopia.

Although figurative blocks are not often found on Baltimore album

Fig. 1 *The Baltimore Album Quilt* (detail)

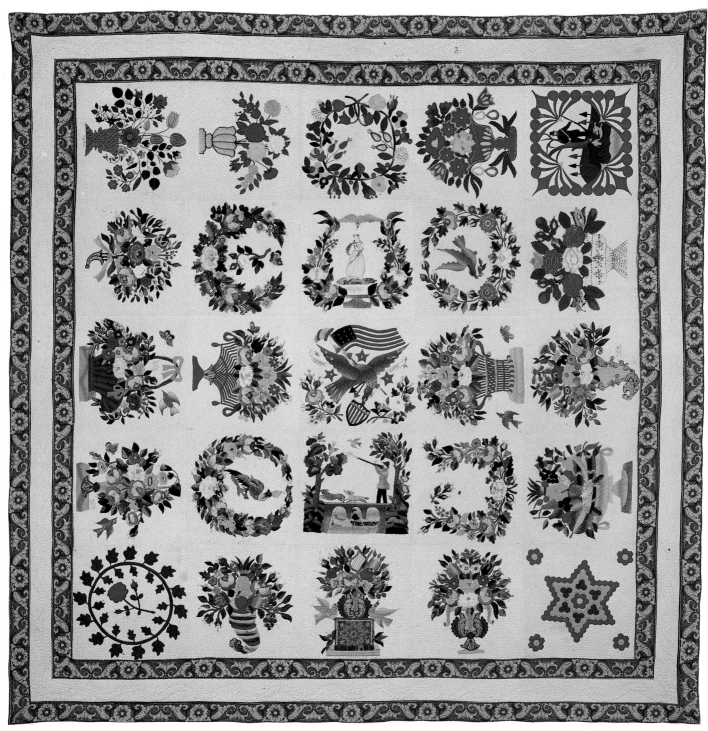

The Baltimore Album Quilt

FIG. 4 *The Baltimore Album Quilt* (detail)

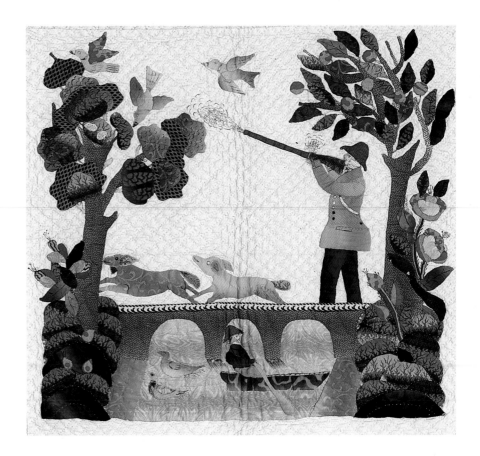

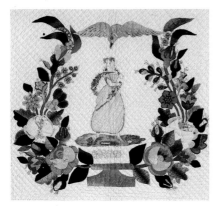

FIG. 2 *The Baltimore Album Quilt* (detail)

quilts, this piece features three. A delicate Queen of the May is framed in a lyre-shaped wreath (fig. 2). Rendered in watercolors, she stands beneath a large, hovering bird, a festoon of flowers wrapped around her. Bird, festoon, and costume may have been inspired by the popular stipple engraving by Edward Savage, *Liberty, in the Form of the Goddess of Youth; Giving Support to the Bald Eagle* (1796). Another figurative block (top right-hand corner) features a hunter[1] beside a tree; two ducks (or geese?) lay at his feet, a third is in the jaws of his hunting dog (fig. 3). In a block below the eagle another hunter has fired his gun (an inked puff of smoke has erupted from the barrel), and one of three birds falls into a tree (fig. 4); a second man rows his boat in the blue moiré water beneath the bridge.[2]

Hunting scenes appeared also as whole-cloth images on furnishing fabrics in England and America, enjoying particular popularity in the 1820s. On an earlier bedcover, circa 1825–35 (fig. 5), two top-hatted figures and their dogs, cut from a printed textile, move through a chintz forest, and from one gun we see a puff of smoke that later appears in ink on the Baltimore scene. The hunters, trees, and prey of the later work are relatively proportional; on the earlier bedcover, huge pheasants seem unconcerned about the Lilliputian hunters who stalk them through the foliage constructed of exotic blooms and palm trees cut from an arborescent chintz.

The specific circumstances surrounding the construction of this particular quilt are unknown, but it is probable that, as with most of the

classic Baltimore album quilts, it was made within the sphere of Baltimore Methodism. Evidence of the strong Methodist affiliations of the women who made these quilts and the men and women who received and treasured them is presented in the catalogue that accompanied the Baltimore Museum of Art's landmark exhibition of these objects; in it Dena Katzenberg points out that although only 10 percent of Baltimore's 1840s population belonged to Methodist congregations, eighteen of the twenty-four exhibited quilts carry Methodist names, and seven of the quilts were made for ministers or class leaders.[3] But confirmation of individual authorship of either quilts or individual blocks remains elusive. Five names have been entered on this masterpiece: Emily Hilliard, Elizabeth Morrison, Agnes Rankin, E. M. Pettit, and M. C. Galloway. Each may indeed have made the block on which her name appears or may have merely signed an already prepared "page" in this extraordinary album.

FIG. 3 *The Baltimore Album Quilt* (detail)

NOTES

1. The figure on this block is stylistically identical to two figures found on a block on a Baltimore album quilt made for Samuel Williams. Both blocks are signed E. M. Pettit.

2. This landscape appears in almost identical design and workmanship on at least one other quilt, this made circa 1852 for Miss Isabella Battee on the occasion of her marriage.

3. Dena Katzenberg, *Baltimore Album Quilts*, exh. cat. (Baltimore, Maryland: Baltimore Museum of Art, 1981), p. 59.

FIG. 5 Bedcover (detail), United States, c. 1825–35, appliquéd cotton, Philadelphia Museum of Art, Mary Richardson Fund

14

The Marriage Quilt

United States (vicinity of Staunton,
Virginia), c. 1865
Quiltmaker unknown
Cotton; appliquéd, embroidered, and
quilted
94 x 92½ in. (238.8 x 235 cm)
The Atlanta Historical Society

A SUBSTANTIAL knowledge of textiles, particularly of printed cottons, is of course an invaluable asset in dating a quilt. One cannot, however, determine with certainty when a quilt was made simply by identifying and dating the fabric used in its construction. Such an approach can only tell us that the quilt could not have been made prior to the date of the last-manufactured fabric found on the quilt. That newest fabric is itself difficult to identify when the quilt is composed of an extraordinarily large number of small pieces of fabric, such as is assuredly the case of the *Marriage Quilt*.

The style of this quilt is not unlike many others of the mid-nineteenth century: nine large, appliquéd blocks are separated by strips of fabric anchored with circular motifs; the central field is enclosed within wide borders of meandering vines bearing a variety of identifiable leaves. American quiltmakers have traditionally used symmetrical floral designs (often based on the traditional German cut-paper technique *scherenschnitte*) to fill the surfaces of their blocks. In some patterns the crossed stems reach only into the four corners; more often, however, leaves and flowers extend to corners and sides. Variations of both types appear on seven of this quilt's blocks. Many of the additional elements within these blocks occur on other quilts made circa 1845–65: for example, the crescent-shaped leaves opening to reveal a pomegranatelike motif and the fleurs-de-lis, which also appear in multiple variations on many classic Baltimore album quilts.

The fabric and forms of these seven blocks, though they may engender in us a profound respect for the creative and technical abilities of the quiltmaker, provide little additional information regarding the quilt's provenance; however, in the two remaining blocks the quiltmaker incorporated motifs that enable us more precisely to place the quilt within the flow of America's social history. Although the motifs in the lower right-hand block (fig. 1) are embellished with embroidered tendrils and appliquéd leaves and flowers, they are clearly depictions of the square and compasses. Although the symbol was occasionally incorporated into the imagery of other fraternal organizations, it is one primarily and most prominently associated with Freemasonry.

FIG. 1 *The Marriage Quilt* (detail)

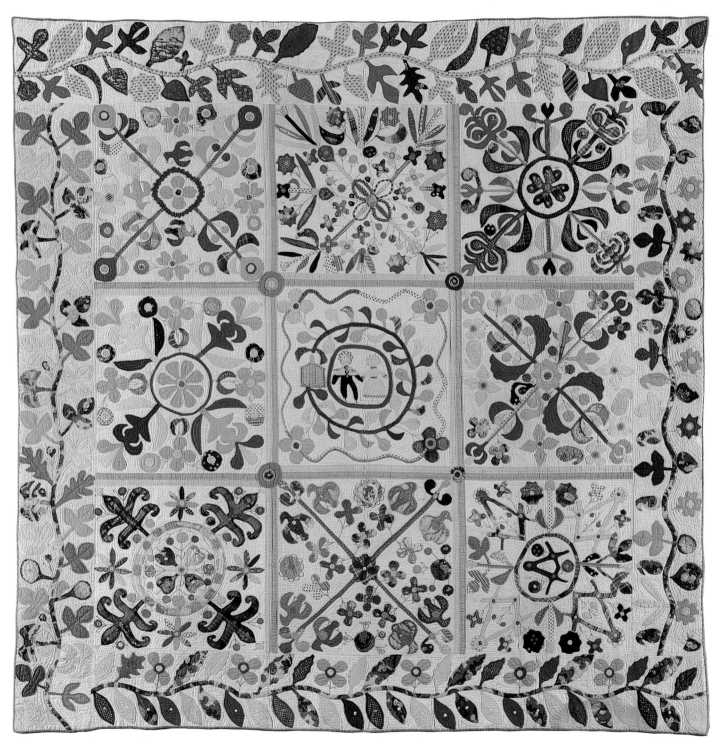

The Marriage Quilt

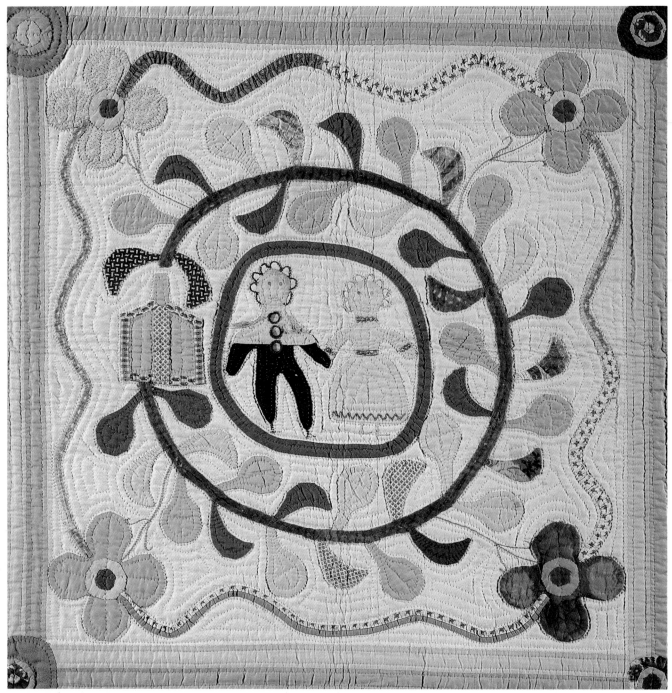

Fig. 2 *The Marriage Quilt* (detail)

In the central block (fig. 2) two figures are framed within an appliquéd wreath, the left side of which is interrupted by an image that may be a building with a chimney. This wreath in turn is surrounded by an undulating ribbonlike frame, bare save for the four simple floral shapes that hold its corners. The figures themselves are extremely stylized but certain characteristics of the woman's dress suggest fashion of the 1860s rather than the 1840–50 date previously assigned to the quilt. The waistline of the 1840s was much lower; the trim at the waistline, neck, cuffs, and hem is much closer to the embellishments of the 1860s; the sleeves appear quite full at the elbow, suggestive of the military-shaped sleeves of 1863–64. The man's shoulders and chest are covered by what is in all probability some form of fraternal regalia, given the presence on the quilt of the square and compasses motif. The shawl or collar bears three large buttons or badges on its front and, on its shoulders, yellow epaulets. The records of the Atlantic Historical Society place the quilt's provenance in the vicinity of Staunton, Virginia; coincidentally, the Staunton Lodge was one of the earliest Masonic lodges in the United States, chartered on October 10, 1786.

If some of the quilt's images are indeed fraternal, then the dating of the quilt should take into consideration periods of regional and national feelings against America's secret societies. In 1826 William Morgan, a debt-ridden Royal Arch Mason of Batavia, New York, intended to publish a book describing for the public at large secret Masonic rituals; his disappearance before the work could be printed was widely believed to be the result of actions by the Batavia Masons. This episode, and increasing religious and political opposition,[1] led to a wave of anti-Masonic sentiment. Many lodges closed, and Masonic symbolism all but disappeared from American decorative arts. Freemasonry and the use of its symbols as decorative motifs did not regain popularity until the second half of the nineteenth century, particularly the post-Civil War period.[2] Secret societies flourished in Victorian-era Staunton, among them the Odd Fellows, the Red Men, and the Good Templars. The Staunton Masonic Lodge, by 1884, had a membership of 187: "The roll includes the names of most of the leading business and professional men in the city and vicinity. The Lodge has lately built a fine three-story brick hall on Main Street...and the lodge-room is a model in every regard."[3] Supported by the presence of the stylized 1860s woman's costume, it seems reasonable to assume that the quilt was worked sometime during the late 1860s when Freemasonry's respectability and visibility had been restored.

NOTES

1. Roger Butterfield, *The American Past* (New York: Simon and Schuster, 1976), p. 94. The Anti-Mason Party actually carried Vermont in the 1832 election.

2. Barbara Franco, *Masonic Symbols in American Decorative Arts* (Lexington, Massachusetts: Scottish Rite Masonic Museum of Our National Heritage, 1976), pp. 38–39.

3. Alpheus A. Townsend and John Cornman, *Representative Enterprises, Manufacturing and Commercial of the South and Southwest Valley of Virginia* (Staunton, Virginia: Valley Virginian Power Press, 1884), p. xviii.

15

The Asylum Quilt

United States (Catonsville, Maryland),
c. 1850
Quiltmaker unknown
Cotton; appliquéd, embroidered, and
quilted
89 x 79 in. (226.1 x 200.7 cm)
Manoogian Collection

THE *Asylum Quilt* is an extraordinary and enigmatic recording of bright, colorful images that suggest dark meanings. Tradition ties this quilt to the third oldest mental institution in the United States, the Spring Grove State Hospital in Catonsville, Maryland, established in 1797 as the Public Hospital of Baltimore. In addition to treating the insane, the institution attended to the medical needs of mariners, the indigent, and, in times of war, the wounded. In 1816 it was incorporated as the Maryland Hospital. By 1839 patients other than the insane had been moved elsewhere; the wards, nevertheless, became increasingly crowded, and in 1852 a commission selected 136 acres known as Spring Grove on which to build a new, larger hospital.[1] It has been held that this quilt was raffled to assist in the construction of the new facility. However, it may well have been during an earlier phase of the project, when the property was being purchased with funds raised primarily through public subscription, that the quilt was won by Dr. John Smith of Boonsboro, Maryland.

The oral tradition that accompanies this piece attributes it to a young adult who entered the asylum pregnant out of wedlock and who eventually died there. Records pertaining to the institution's patients, even those long dead, are cloaked in confidentiality, thus precluding research methodology that might have decoded the messages seemingly contained in this work.

Authorship aside, the quilt seems indeed to have been created in the shadow of Baltimore, and the care with which the floral motifs are constructed and appliquéd is in the tradition of the work done by that city's ladies on their album quilts (see the *Baltimore Album Quilt,* p. 68). The quilt's central field is composed of ninety-six diamonds bearing images of flora and fauna both exotic and amusing and of a wide variety of human figures. Although the figures themselves are often portrayed in a state of movement and activity, this central area is so compartmentalized and orderly the figures appear as if held in a state of suspended

The Asylum Quilt (detail)

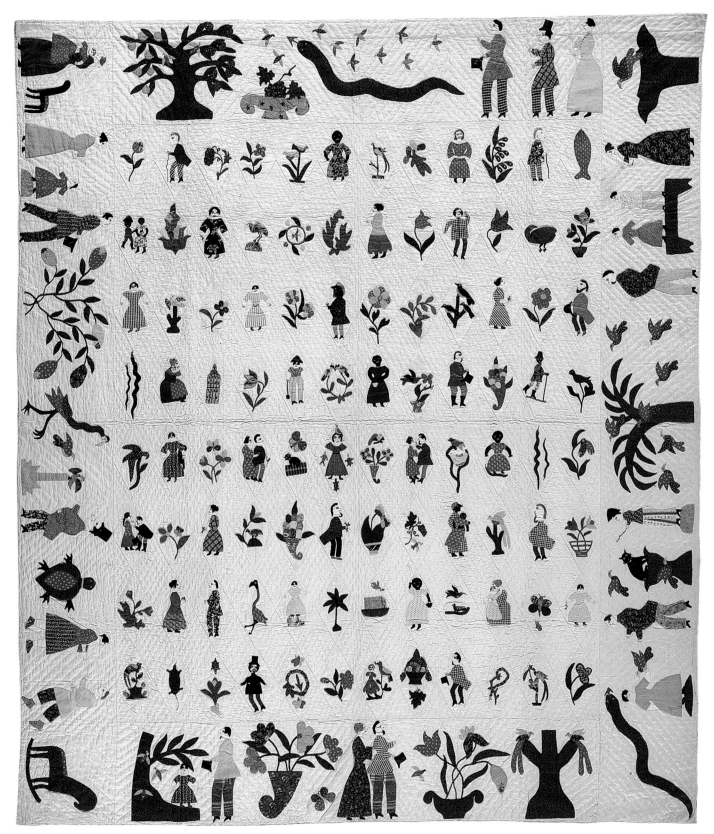

The Asylum Quilt

FIG. 1 *The Asylum Quilt* (detail)

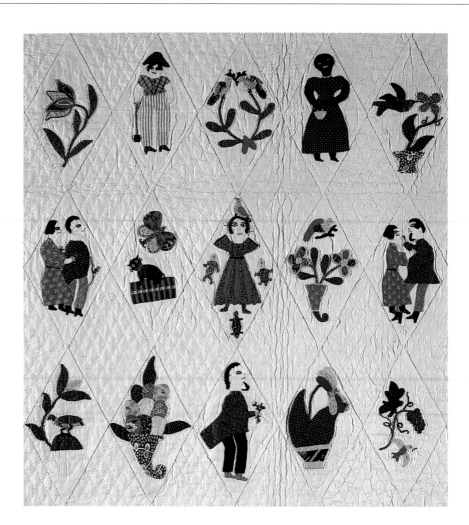

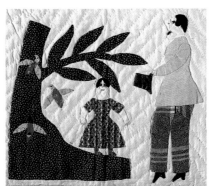

FIG. 2 *The Asylum Quilt* (detail)

tension. In the center of the quilt a young girl (purportedly the quilt-maker) stands wide-eyed, surrounded by reptiles, and with a bird perched on her head (fig. 1). Above her right shoulder is the figure of a young boy;[2] quarreling couples are to her left and right. The wide border holds an undecipherable story of agitation and rage: on many of the figures, bulging eyes and flared nostrils are quite clearly defined. Snakes undulate across the quilt. The border seems to have no specific narrative beginning or end; it is simply a stream of urgent and inexplicable activity around some apparently tragic testament (fig. 2). In a representative tableau (fig. 3), at the quilt's top left-hand corner, a woman holds an infant wearing a coral necklace and stands with her back turned to a scene of discord, from which she is separated only by an empty chair. Beyond this a woman reaches out toward the departing figure of a man, and a child stands between them with arms outstretched in an imploring gesture.

 Throughout the quilt, but particularly observable in the four borders, the figures are worked in fine detail: hands and fingers (and ears, where visible) are individually formed of tight embroidery stitches. The dresses on the women in figure 4 show details of costumes of the late 1840s: the sleeves are a form referred to as "bell" or "pagoda" sleeves; the dress has a slight fullness in the back; the skirts are even across the

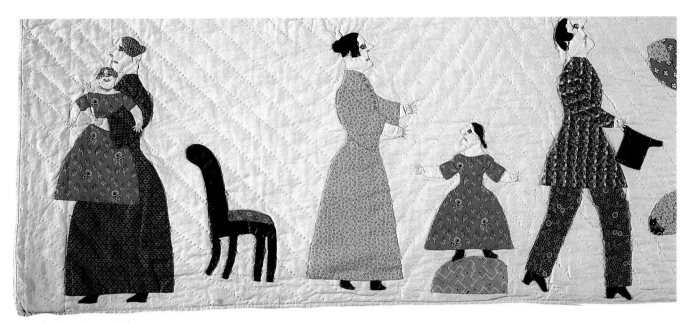

FIG. 3 *The Asylum Quilt* (detail)

FIG. 4 From *The Cyclopaedia of the British Costumes from the Metropolitan Repository of Fashions* 5, no. 10 (London: Walker, 1847), Los Angeles County Museum of Art

THE QUILTING PARTY.

FIG. 5 From *Godey's Lady's Book* (September 1849), Los Angeles County Museum of Art

bottom, thus of a period prior to the introduction of the full-fledged crinoline. Throughout the border men wear coat and trousers in a cut and of fabrics nearly identical to those illustrated in *The Cyclopaedia of the British Costumes from the Metropolitan Repository of Fashions,* which pictures London fashions for the winter season of 1847 (fig. 4): "Sleeves are cut in a loose fit and made without cuffs….Materials worn are brown and drab velveteens, also fancy tweeds in very large checks or broad stripes, as represented on the figures."[3] Both men and women are presented in a variety of hairstyles of the period. Several of the gentlemen sport goatees. Many of the women have their hair parted in the center and drawn back into a knot, with an early form of sausage curls at the sides, a style illustrated in *Godey's Lady's Book* for September 1849 (fig. 5).

NOTES

1. Construction of the new hospital began in 1853 but was interrupted by a lack of funds and by the Civil War and was not completed until 1872. Information on Spring Grove Hospital's complex history has been drawn from *The Beacon* (published in 1933 as a "yearbook" for the hospital's nursing students) and *The History of Spring Grove State Hospital 1797–1947,* copies of which were kindly provided to the author by Lloyd Stewart, Ph.D. I am particularly grateful to Morgan Anderson, the person who first brought this quilt to my attention many years ago, for his extraordinary generosity in sharing with me his personal research on the quilt's provenance.

2. The boy's costume is referred to as a skeleton suit. Prior to this period the shirt and pants would have been of the same color. Here, however, the suit consists of a tan plaid shirt buttoned at the waist to pink-and-white-striped long pants, appropriate to the period in which this quilt was worked.

3. *The Cyclopaedia of the British Costumes from the Metropolitan Repository of Fashions* 5, no. 10 (London: Walker, 1847), p. 39.

16

The Crystal Palace Quilt

United States, c. 1851
Quiltmaker unknown
Cotton; quilted
81 x 78 in. (205.7 x 198.1 cm)
Shelburne Museum, Shelburne, Vermont

PERHAPS NO EVENT during Queen Victoria's reign more completely captured the public imagination than did the Great Exhibition of 1851. Two days after the opening ceremonies on May 1 the *Illustrated London News* observed that "the pens of all the 'ready writers' of Great Britain, and no small number of those of continental Europe and America, are engaged upon this one theme." Prince Albert's grand preparations for the "Great Exhibition of the Industry of All Nations — 1851" caught the fancy of all of England, especially that of the new middle class, created by the Industrial Revolution and now swept up in the national mood of prosperity. It is the architectural wonder of that exhibition, the Crystal Palace, that is celebrated on the surface of this whole-cloth quilt.

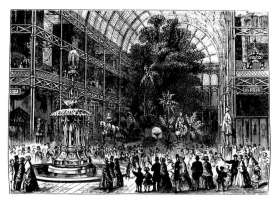

FIG. 1 Interior of the Crystal Palace, 1851, from William Nichols, *The Beloved Prince: A Memoir of His Royal Highness the Prince Consort* (London: Wesleyan Conference Center, 1880), p. 133, private collection

For the design of the principal building almost fourteen thousand applications had been received and rejected before Joseph Paxton submitted an architectural design quickly sketched on a piece of blotting paper.[1] It was around Paxton's design for a revolutionary building of iron and glass that the pessimists then rallied. The Astronomer Royal merely predicted general disaster, but others were quite specific: the glass roof would be porous, and the droppings of the Park's fifty million sparrows would ruin everything beneath it, or it would drip with condensation, saturating all the goods; the reflection of the sun's rays would ignite the building's contents. There was also a question among some as to whether or not it would even stand up until May, for who could predict the effect of hail or wind or the weight of nineteen acres of snow? Indeed, Paxton had no academic qualifications as an architect or as an engineer, and to pose the question of whether or not the "footsteps of the multitudes would set up vibrations which must shake it down"[2] was perhaps not unreasonable. But the opposition had not reckoned with Joseph Paxton's public popularity nor with the confidence this modest man inspired. Self-educated and industrious, Paxton was everything the nineteenth-century Englishman admired. More than six million visitors entered his remarkable building.

As print illustrations (fig. 1) and the vignettes (fig. 2) on this quilt

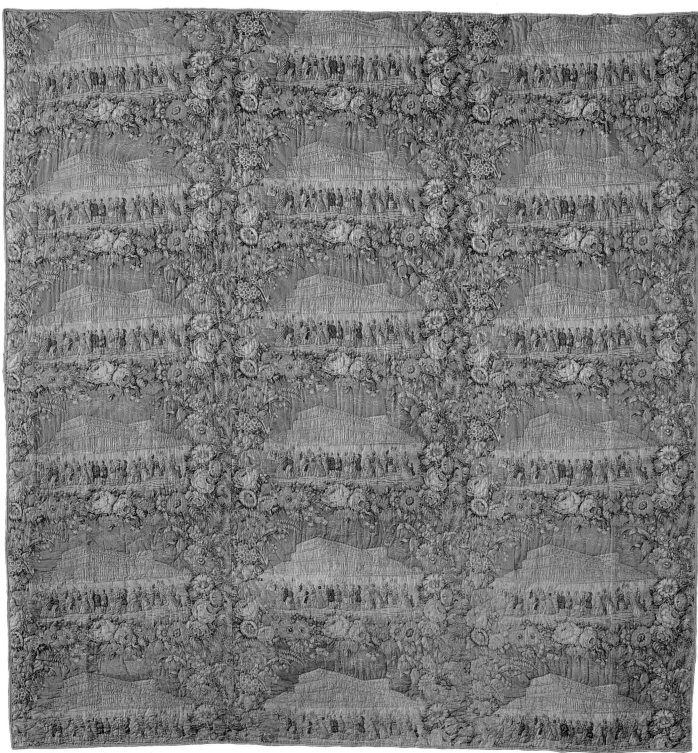

The Crystal Palace Quilt

confirm, most of the women who strolled among the one hundred thousand objects presented by seventeen thousand exhibitors from all over the world were wearing the large skirts and wide sleeves of the period, styles that made a coat an impractical outer garment and the wearing of shawls by all classes a continuing and fashionable alternative. Since her coronation, Queen Victoria had almost always chosen textiles of British manufacture for the dresses in which she made her public appearances, hoping to reverse the declining fortunes of the British textile industry through the example of royal patronage; the manufacture of shawls was symbolic of the type of British industry she and Prince Albert hoped the exhibition would promote and preserve.

Not until 1767 was the shawl referred to in print as an article of European dress, but as happened with printed calicoes, the Indian export almost immediately became an integral part of a fashionable wardrobe. The shawl industry in Britain was established between 1775 and 1785, in Norwich and Edinburgh. A 1795 circular addressed "To the Promoters of Female Industry," by a Norwich shawl manufacturer under Royal patronage, urged the gentry to inspect his inventory: "The very near affinity of the above Articles to the real Indian shawls, the very great improvement they receive by Washing (superior to the printed ones) & the thousands of Young Females it gives constant employment to, will, he presumes to be a particular recommendation."

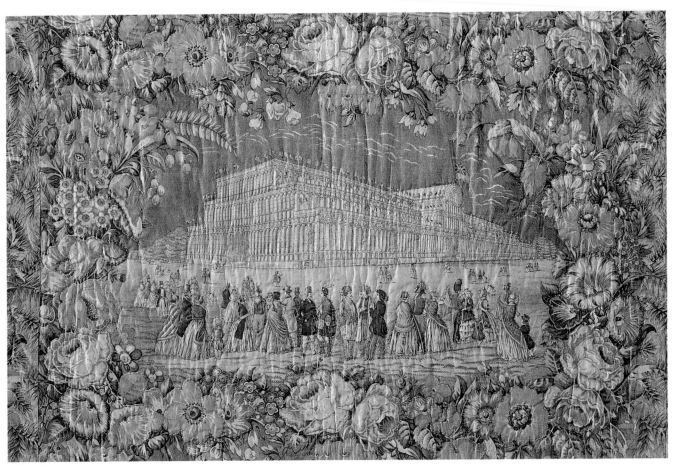

Fig. 2 *The Crystal Palace Quilt* (detail)

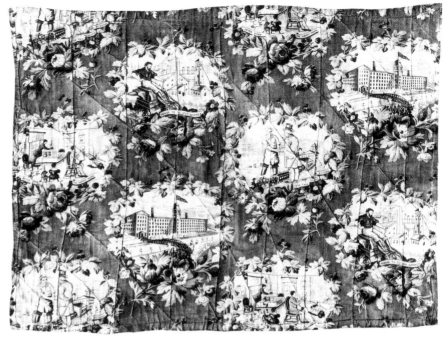

FIG. 3 Doll quilt, United States, c. 1875, quilted cotton, 16¾ x 22¾ in. (42.5 x 57.8 cm), the Baltimore Museum of Art, gift of Dena S. Katzenberg

Catalogues, books, and pamphlets on the exhibition found an enthusiastic American market, and the image of the Crystal Palace appeared on a variety of surfaces and souvenirs, including the commemorative fabric used on this quilt. A variety of Industrial Age images were extremely popular at the time, and a later printed textile, *Honor to the Working Class*, was used by another quiltmaker to construct a doll quilt (fig. 3), one appropriately quilted on a sewing machine. Its floral wreaths, similar to those surrounding the Crystal Palace, contained illustrations of "Labor Is Honorable," "Honor to the Iron Worker," "The Two Powers in Accord," and "After Work the Happy Home."

In this portrait of Queen Victoria and her seven oldest children (fig. 4), painted in 1854, we see in the distance the Crystal Palace. The queen ruled over an entire age, but the object the Prince of Wales holds here in his hands represents Albert's triumph rather than Victoria's: the blueprints of the Crystal Palace.

NOTES

1. Christopher Hobhouse, *1851 and the Crystal Palace* (London: John Murray, 1950), p. 54.

2. Cecil Woodham-Smith, *Queen Victoria* (New York: Dell Publishing Co., 1974), p. 404.

FIG. 4 John Calcott Horsley, R. A. (England, 1817–1903), *A Portrait Group of Queen Victoria with Her Children*, c. 1851, oil on canvas, 47 x 33 in. (119.4 x 83.8 cm), the FORBES Magazine Collection, New York

17

The Noah's Ark Quilt

United States (Woodville, Jefferson
County, New York), dated 1853
Made by Mrs. L. J. Converse (signed)
Cotton; appliquéd and quilted;
ink and paint
87 x 81 in. (221 x 205.7 cm)
Joel and Kate Kopp,
America Hurrah Antiques

IN 1841 Lutheria Converse joined the Congregational Church in Woodville, New York, and a dozen years later it was in all probability she who produced this remarkable religious narrative signed "Mrs. L. J. Converse."[1] A fierce, swooping eagle, pictured at the top of her quilt, clasps in its beak a banderole bearing the words "Onward Our Country." But beneath this patriotic exhortation, in ink, the quiltmaker proclaims the dominant theme of her quilt to be "A Representation of the Ark, Noah and Family with a Collection of the Beasts, Birds and Insects."

The scene that dominates the central field, surrounded with three borders of appliquéd and painted leaves and buds, illustrates what the quiltmaker inscribed beneath it: "We read— / To the day, Noah entered into the Ark, / they did eat, drink, and were given in marriage neit- / her his preaching or preparation interrupted their business or pleasures. So shall also the coming of the Son / of man be. Matthew 24[:]39 / By / Mrs L- Converse. / 1853 / Woodville Jefferson Co / NY."

The inscriptions are all in ink, as are the ominous clouds overhead. The characters in this tableau, as well as many of the beasts, birds, and insects, are constructed of fabric appliqué and in some instances feature inked details. Noah and his family are solemn and silent as they walk toward the ark, but the figures below are both active and verbal. Their attributes and comments are contained in cartoonlike clouds above their heads.

LEFT
A man, "Scoffer" (fig. 1), observes from high in a tree the unfolding events: "Ho-Ha boys I've got a good-place." To the left of the tree (top to bottom), "Dina" says, "Bless mes Noah and de sons hav started." "Morality," still at work behind a team of horses and a plow,

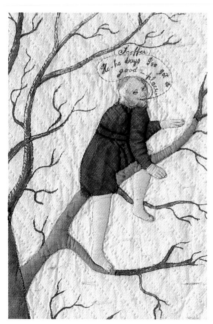

FIG. 1 *The Noah's Ark Quilt* (detail)

84

The Noah's Ark Quilt

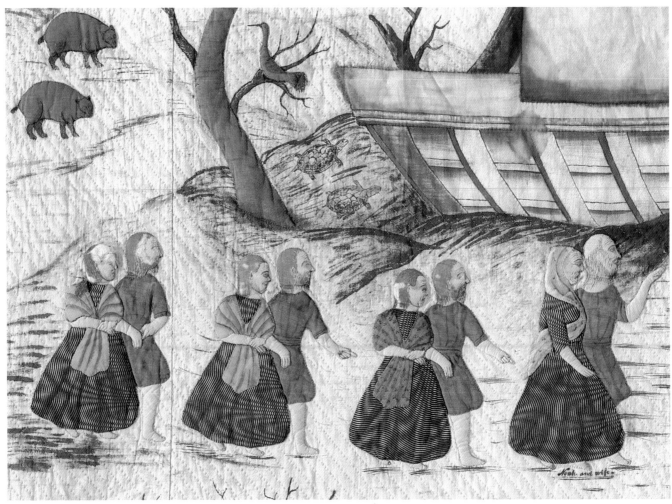

FIG. 2 *The Noah's Ark Quilt* (detail)

says, "Halow-Sam. you cripple, Why don't you take Dina and go
into the ark?" to which "Sam," one-legged and on crutches,
responds, "Oh neber mind, broder, dare be black blood enough in
Ham to preserve de color."

MIDDLE
Four figures, the only ones wearing bright colors, join hands in a
dance (fig. 2). The inscriptions read (left to right): "1st. By George,
the women are all out." "2d I guess they'l bring a rain." "3d Halow!
There gose Noah Shem Ham & Japheth." "4th. And the old woman
& dauters."

RIGHT
"Unbelief" pauses part-way up the tree trunk to announce, "This is
hard uphill work, but you'll see my head above water." To the right
of this tree (top to bottom): "Self Consolation," smoking a pipe, says,
"I think by the clouds thar's more wind than rain." "Malting between
two opinions," leaning on a cane, answers, "Oh dear; I do'nt know
what to think the clouds look dreadful." "Infidelity" leans on two
canes and opines, "I'm parfectly disgusted, setch operations —
pretending a flood."

Though most of the clothes that appear on the quilt are suggestive of the simple, loom-tailored garments of biblical times, the quiltmaker has coiffed, dressed, and shod Noah's wife and daughters-in-law in a contemporary fashion (fig. 3). An inscription beneath their feet identifies Noah and his wife; Noah is balding, and his wife, rather than wearing her shawl, as do her daughters-in-law, in the style of the period, drapes it over her head and crosses it over her bosom. This was the fashion of the previous decade and just what one would expect on the older woman.

NOTE

1. The 1850 federal census for the town of Ellisburg, New York (village of Woodville), shows only two Converse families living in the area, both of them prominent within the community. At that time Lydia Converse and her husband, Thomas, lived with their youngest son, James, who had bought the homestead farm, 235 acres north of the north fork of Sandy Creek (from *History of Jefferson County, New York* [L. H. Everts & Co., 1878], p. 377). James was a successful farmer, and it is plausible that his aging mother would have had the leisure time necessary to work such a quilt, but it is less likely that three years later at the age of sixty-eight she would have had the keen eyesight and steady hand required for the tiny inked drawings that are the core of this quilt.

Rufus Converse, thirty-two, lived in close proximity. Both James, twenty-four, and Rufus were born in Oneida, New York, and were probably brothers. Rufus's wife was Lutheria Converse and, listing herself as L. Converse in the 1855 state census, she would have been thirty-two years of age at the time the last diagonal quilting stitches were applied to this quilt, suggesting it is more likely to have been the work of her hands.

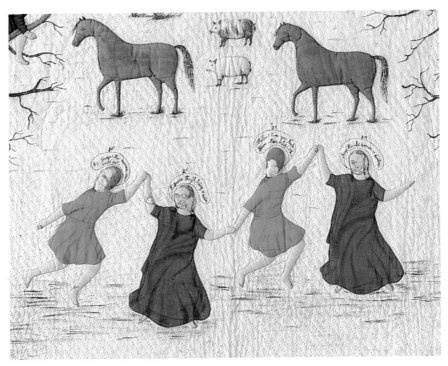

FIG. 3 *The Noah's Ark Quilt* (detail)

18

The Maria Hanks Quilt

United States (Charleston, Coles County,
Illinois), dated 1857
Made by Maria Gregg Hanks
(1835–1914)
Cotton; appliquéd, embroidered, quilted,
padded, stuffed, and corded; paint and
human hair
78½ x 67 in. (199.4 x 170.2 cm)
Los Angeles County Museum of Art,
gift of Virginia Stephens Gold

O N THIS QUILT of remarkable delicacy, appliquéd and embroidered birds feast on berries and currants; nests of eggs are placed beneath running vines. The entire quilted surface is one of random, intermingled floral images: blooms and buds, leaves and tendrils. Almost hidden within this suggested garden, the quilter has left her name: "Maria Hanks" (fig. 1).[1]

Two elements dominate opposite corners of this enigmatic quilt. On one corner an appliquéd and embroidered inscription reads, "Maria C Hanks. Charlston. Coles County. Ill. 1857" (fig. 2). But Maria had already left her signature on the quilt in those small, white, running stitches. Does the "C" stand for her still unconfirmed middle name, or is it a badly cut "G" representing her maiden name? A small, human figure, the haunting presence on the lower-right corner of the piece (fig. 3), can perhaps tell us more about the quilt and about Maria. She is worked in exquisite detail. Her face is padded, painted, and embroidered; her hair is human hair. Her embellished costume is appropriate to the

FIG. 1 *The Maria Hanks Quilt* (detail)

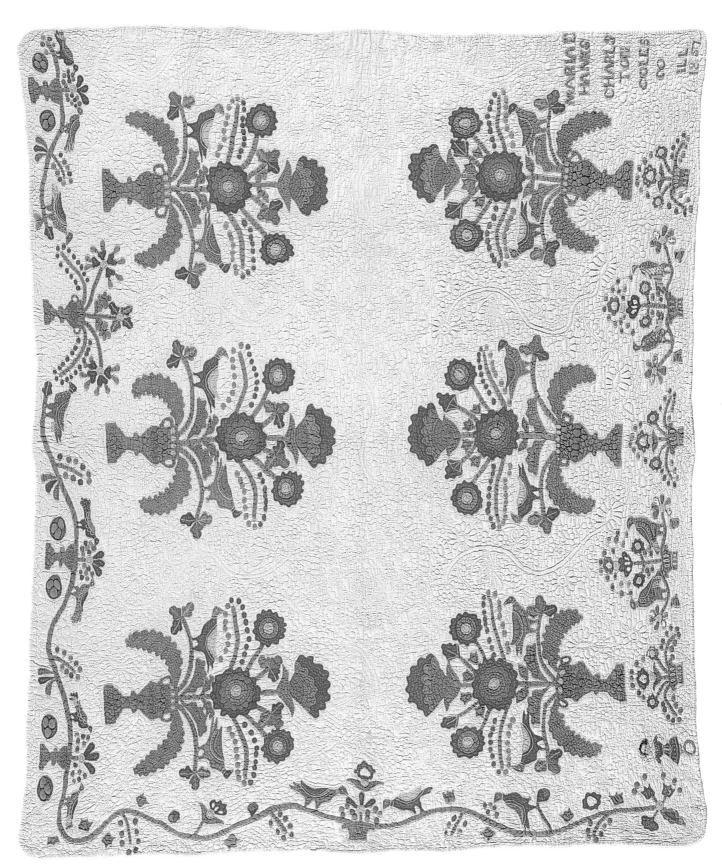

The Maria Hanks Quilt

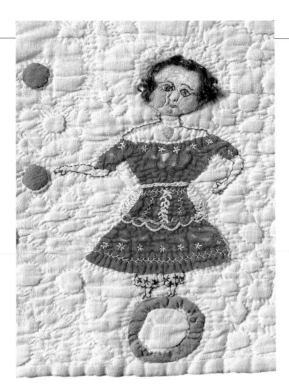

period: her shoulders are bare, and pantalets with an embroidered approximation of *broderie anglaise* are clearly visible. Her hand reaches tentatively toward small flowers. She stands upon what seems to be a hoop, a childhood toy often seen in nineteenth-century portraits of children (fig. 4). The figure and inscription appear as jarring intrusions on the quilt's surface, suggesting that they were perhaps not part of the quiltmaker's original concept.

Boxes discovered in an attic in 1975 were found to contain Hanks family records and mementoes from the 1810s commingled with some that date well into the second half of the twentieth century. Their contents were sorted in the hope that the earlier documents might yield information concerning the figure or the inscription; public records had revealed none. In one box a handwritten page was found listing not only Maria's children living, and those dead in infancy, but one other: in 1857, to John Elsberry and Maria Hanks, a daughter, stillborn. Public records indicate nine children, but John and Maria Hanks's obituaries list ten. John's, surely drawn from information provided by Maria, notes that two children died in infancy. Harmon's birth was recorded, and he died young, but what of the other, never mentioned, never named? She is perhaps remembered and recorded on this quilt alone. Fifteen years after having seen that fragile page, perhaps in Maria's hand, the author believes, as she did then, that this quilt is a unique example of America's mourning arts.

Certain of the quilt's elements parallel the classic symbols of those schoolgirl mourning embroideries, worked primarily in young ladies' academies, and usually based on print sources or engravings. A landscaped garden usually contains an urn, a plinth, a tree (usually a weeping willow), and one or more mourners. On this piece the silk is replaced with cotton; the garden is a floral field suggested by quilted stitches; the urn (of primary importance) symbolizes the spirit of the one for whom the others mourn, and it is present here in multiple numbers,

but instead of ashes these urns hold bright fruit and flowers, symbols of life itself. These motifs are, however, no different than those often present on other appliquéd quilts and as such cannot be confirmed as intentional imagery to support either the quilt's origin or its intent.

But we do know that the year this quilt was completed, Maria Hanks gave birth to a stillborn daughter. The green and yellow inscription may be the one that would more traditionally have been entered on the plinth. In a period when gravestones across the country bore grim reminders of infant mortality, here, perhaps, such personal sorrow was inscribed on softer stuff.

Regarding the figure itself, hair would be more usually worked in colored floss, but Maria has couched bits of human hair, a traditional material used in needleworked expressions of mourning and often encased in a locket similar to that which the figure wears at her neck. Although all other aspects of her clothing are rendered with specific details, her feet are bare, and she wears a red dress, both devices sometimes used in formal portraiture to indicate the image is one of a child deceased.[2] Rather than on a hoop, is she poised on the symbol for eternity? It is not the image of an infant, but it is perhaps the dear, bright girl her grieving mother knew she would have grown to be.

FIG. 4 Joseph Goodhue Chandler (United States, 1813–80), *Fannie and Ella Graves of Conway, Mass. and Henry Street, New York*, 1854, oil on canvas, 50¼ x 40 in. (127.6 x 101.6 cm), Hirschl & Adler Folk, New York

NOTES

1. Public records indicate that Maria Gregg was born on January 17, 1835, in Coles County, Illinois, to Quaker parents, and that she was wed on March 20, 1853, to John Elsberry Hanks, back (with some success) from the California gold fields. His grandmother Sarah Hanks (whose maiden name had remained unchanged when she married her first husband, James Hanks) was sister to Nancy Hanks Lincoln, and John's father, William, was first cousin to Abraham Lincoln. President Lincoln was of less than heroic stature to many of the people of Coles County, where his parents had lived since 1837; and in Charleston, the county seat, political sympathies were rather evenly divided during the Civil War. Family tradition assigns to Maria a sympathy with the Union cause and possible participation in the Underground Railroad, but if those were indeed her loyalties, they ran counter to those of her husband.

Southerners, mostly from Kentucky and Tennessee, had settled the eastern parts of Coles County, and although most had not been slaveholders, many had brought with them an abiding dislike for abolitionists, which was ingrained in descendants such as John Elsberry Hanks. On March 28, 1864, "Berry" Hanks participated in the only Civil War "battle" to be fought in Illinois. Referred to as the Charleston Riot, it was fought at the courthouse where Abraham Lincoln had practiced law in the 1840s and early 1850s. Tensions and physical confrontations had increased between soldiers on leave and a group belonging to the Copperheads, one of the secret organizations of Peace Democrats that opposed the draft and sought an immediate armistice. That March day, when "Berry" and several of his cousins entered Charleston, they had shotguns beneath the hay in their wagons and pistols in their pockets. In a few moments, and in a scene of utter confusion, soldiers and civilians lay dead or wounded, and Maria's husband had fled into hiding (Charles H. Coleman and Paul H. Spence, "The Charleston Riot, March 28, 1864," *Journal of the Illinois State Historical Society* 33, no. 1 [March 1940]; reprinted in *Eastern Illinois University Bulletin*, no. 257 [July 1965]: 78–112). A poster published by the men of the 54th regiment, Illinois Volunteers offered a one thousand dollar reward for the apprehension of the eight men responsible for the death of five soldiers. Among those described was J. Elsberry Hanks, 5' 8", age thirty-five, farmer. In addition to the reward offered by the regiment, the citizens of Coles County placed an additional hundred dollars on John's head, the reward to be given dead or alive. He was eventually reunited with Maria and their children and remembered as "a well-to-do and much respected citizen, that has always been interested in all such public matters as pertain to the good of the community in which he has lived" (*The History of Edgar County, Illinois* [Chicago: Wm. Le Baron, Jr., & Co., 1879], p. 670).

2. I am grateful to Michael Quick, curator of American art, Los Angeles County Museum of Art, for bringing the significance of the red dress to my attention.

19

The Ackerman Quilt

United States (vicinity of Saddle River,
New Jersey), dated 1859
Quiltmaker unknown
Cotton; appliquéd, embroidered, pieced,
quilted, and padded; ink
96 x 72 in. (243.8 x 182.9 cm)
James and Nancy Glazer

THE OCCASION or occurrence that prompted the making of this New Jersey quilt is no doubt connected with the eleven names and one set of initials[1] entered on the twelve blocks:

1a.	M.A.Y.	3a.	Peter H. Winter
1b.	Aleta Jane Holstede	3b.	Elisa Cooper
1c.	Catharine Depew	3c.	John J. Mowerson
2a.	William A. Ackerman 1859	4a.	Laweesa Winter
2b.	Catharine Ackerman 1859	4b.	William Pulis
2c.	John Mowrefson	4c.	Maria M. Mowrefson

They were bound together by friendship, by faith (most were members of the Saddle River Reformed Church, and three of the couples were married there), and as census records confirm, by family.

John Mowrefson and Maria Durie were married on December 2, 1820. When he joined the Saddle River Church the following year, Mowrefson was a prosperous farmer and, like so many of his neighbors, would have sold his produce to markets in Paterson, Jersey City, and New York City. New Jersey was then truly a garden state, and the quilt includes several appliquéd examples of the harvests of its fields and orchards.[2] He and Maria both died in 1873 and were buried at Saddle River. His personal estate was inventoried to be worth $19,152.20, and his will (made in 1867) provided Maria with living quarters, firewood, furniture, the use of a garden, and income from the interest on $4,000. The farm, originally given to Mowrefson by his father, was to be devised to his son, John, upon the payment of $3,000. Each of his four daughters were bequeathed the sum of $2,500.[3]

The name of his third daughter, Catharine, and her husband, William Ackerman, are the only two names on this quilt followed by inscribed dates, both 1859, which would have been the year of their fifteenth wedding anniversary (they were married on December 21, 1844). Though it is assumed that the quilt descended through the Ackerman family, it would be only conjecture to suggest it was made in commemoration of that presumably happy occasion.

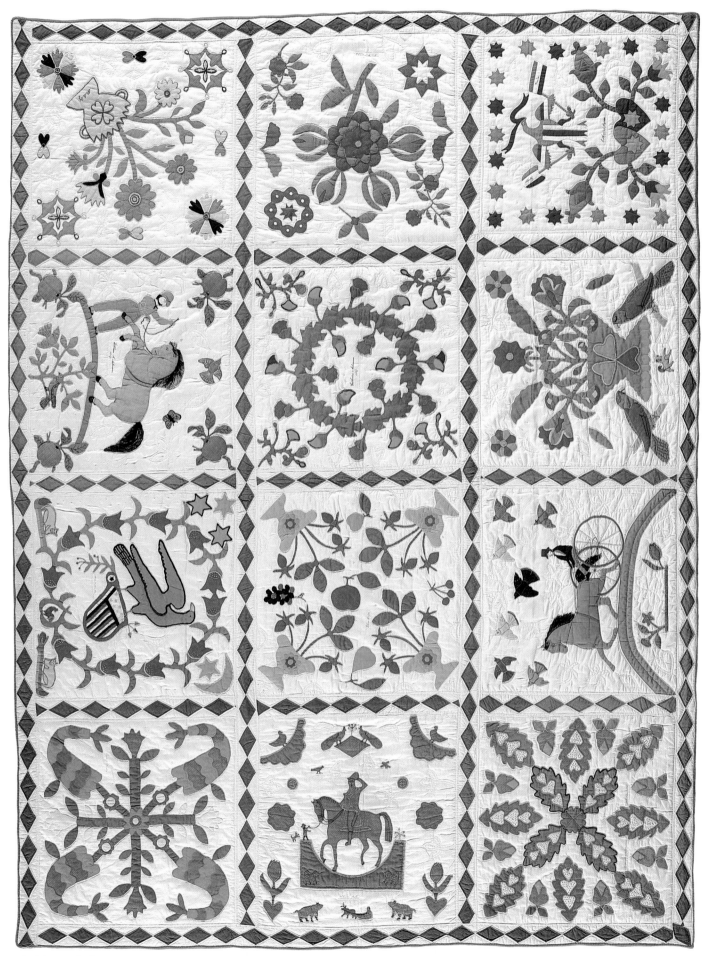

The Ackerman Quilt

FIG. 1 *The Ackerman Quilt* (detail)

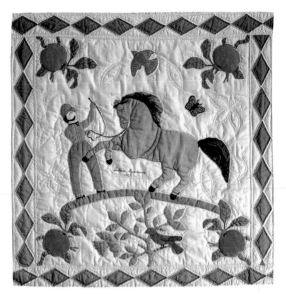

The families represented on this piece seem to have lived in close proximity to each other. Mowerson and Depew are early Rockland County, New York, names; Rockland County borders Bergen County, New Jersey, and many families settled on both sides of the border. William James Pulis was born in Campgaw, only about five miles from Saddle River and a relatively short ride by horse and wagon.[4]

Saddle River had a large number of horse farms, and three of the brothers-in-law have their names inscribed on those blocks that feature horses: John J. Mowerson (3c), William Pulis (4b), and William Ackerman (2a, fig. 1). It is interesting to note that, according to family tradition, Blind Peter Ackerman delivered mail on horseback and raised and raced fine horses.[5] Diverse interactions of horse and rider (such as travel, hunting, herding, racing, dressage, and military operations) were illustrated on a number of American quilts. Three years before the Ackerman quilt was dated, Virginia Ivey quilted, corded, and stuffed a masterpiece inscribed "1856 A Representation of the Fair Ground near Russellville Kentucky" (fig. 2). This elegant and refined all-white quilt features a central medallion and a wide fringe. The static figures on this piece contrast with the more vigorous, kinetic images on the *Ackerman Quilt.* The buggies are motionless, several horses stand saddled but at rest. Even when a rider is

FIG. 2 Virginia Ivey (United States), quilt (detail), 1856, quilted cotton, Smithsonian Institution

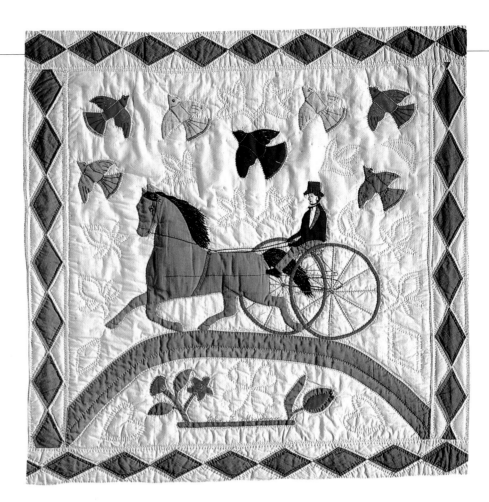

FIG. 3 *The Ackerman Quilt* (detail)

astride the horse, there is no suggestion of movement such as that indicated by the purposeful strides of the horse on the John Mowerson block of the New Jersey quilt (fig. 3).

The patriotic images that appear on the *Ackerman Quilt* were worked in the tense political climate of impending civil war and are similar to those found on other appliquéd quilts of the period. An eagle appears in two of the twelve blocks: on the one signed by Catharine Depew (fig. 4) the bird holds a banderole in its beak and grasps in its talons standards bearing a flag inscribed "Union" and a banner inscribed "Liberty"; on the Peter H. Winter block (3a) the eagle stands atop a shield, its intended fierceness tempered somewhat by the cats and rooster that rest beneath the wreath of tulips that surrounds it. Hung on crossed poles on block 4a are stylized adaptations of the liberty cap, reminders of our revolutionary beginnings when long poles were erected in town squares to symbolize the liberty tree under which the Sons of Liberty met and from whose branches representations of the British government were often hung in effigy. Miss Liberty often appears on printed fabric holding a liberty pole and cap, the latter a type of Phrygian cap worn in classical times by liberated slaves and worn in a similar context during the French Revolution (fig. 5).

The mounted figure on the bottom of the quilt (fig. 6) is dressed in a military uniform. Rather than commemorating a specific patriotic incident, however, the block may well record a more modest event. During this period P. T. Barnum wintered his circus in New Jersey, and the

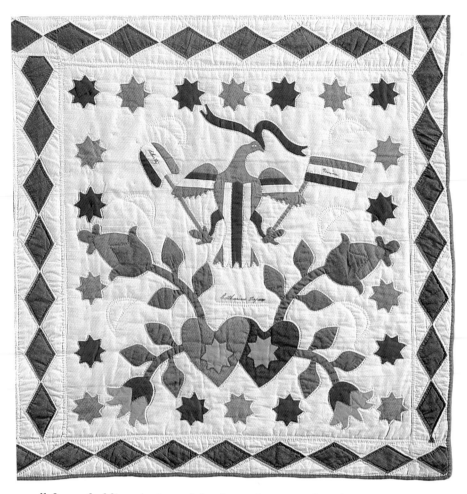

FIG. 4 *The Ackerman Quilt* (detail)

FIG. 5 From A. E. Gibelin, *De l'Origine et de la forme du bonnet de la liberté* (Paris, 1796), Los Angeles County Museum of Art

small figure holding the horse's lead may be Tom Thumb, who is said to have met General Grant at that time.[6]

The personal histories that many Americans wished to chronicle in cloth were those that expressed their pride of individual accomplishment, achieved often in the face of considerable adversity. It had been to secure for himself and his family the promise and plenty recorded on this quilt that David Ackerman and his wife, Elisabeth (Lysbet) de Villiers, sailed with their six children from Holland to New Amsterdam aboard the *D'Vos* (The Fox). Arriving on August 31, 1662, he was dead a few months later, and on April 26, 1663, Lysbet was called upon by the Orphan Masters of New Amsterdam to submit an inventory of David's property. She reported only a few household goods and was told she need not appear again until she remarried, "provided she did her duty by her children."[7] David's journey had founded the Ackerman family in America, and two hundred years later this quilt recorded the harvest of that great adventure.

N O T E S

1. The initials "M. A. Y." may be those of Matilda Yeury, who married Andrew Horn in July 1862. The genealogical information on the families and individuals whose names appear on this quilt has been gathered from the following sources: *New Jersey Census Records* (1850); *The Kakiat Patent in Bergen County New Jersey*, published privately by Howard I. Durie; the *D.A.D. Newsletter, David Ackerman Descendants — 1662*; and personal communication with Katharine P. Randall, Bergen County Historical Society, River Edge, New Jersey, June 17, 1989.

2. There is a dated and inscribed quilt in the collection of the Bergen County Historical Society on which is entered, "Betsy Haring made this quilt while in her 57th year of age 1859," although the costume on, and other aspects of, the quilt point to a date of ten years later. Workmanship and motifs suggest a possible connection with the Ackerman quilt, but research has failed to uncover any information on Betsy. The flowers she worked are identifiable, and she paid particular attention to detail: one block holds two baskets of fruit — one for strawberries and one for blackberries — and she has very carefully rendered the difference in the distinct shapes used in that geographical area for each type of berry. The *Betsy Haring Quilt* is illustrated in *The Tree of Life: Selections from Bergen County Folk Art* (New Jersey: Bergen County Historical Society, 1983). I am grateful to Kevin Wright, curator of Steuben House, River Edge, New Jersey, for providing on-site observations of the quilt.

3. Howard I. Durie, *The Durie Family: Jean Durier of the Huguenot Colony in Bergen County, New Jersey* (privately published, 1985), p. 9.

4. Personal communication with Marion Snedecor, membership genealogist of the David Ackerman Descendants — 1662, June 21, 1989.

5. Rosa Livingston, "Our Early Settlers and Farming," *D.A.D. Newsletter, David Ackerman Descendants — 1662* 23, no. 2 (1985): 7.

6. Personal communication with Kevin Wright, May 4, 1989. A photograph album in a private home in River Edge, New Jersey, contains *cartes d'visite* of Tom Thumb and of General Grant.

7. *The Genealogical Magazine of New Jersey* 10 (1935): 46–47.

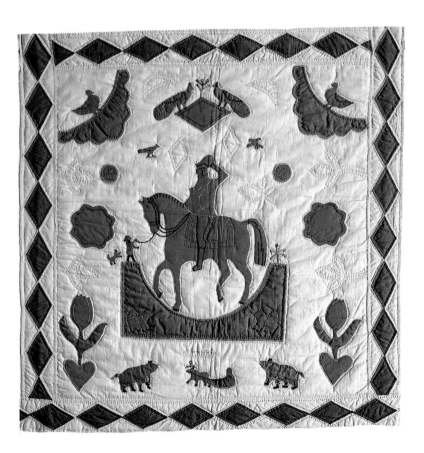

FIG. 6 *The Ackerman Quilt* (detail)

20

The Old Maid Quilt

United States (Canandaigua, New York),
dated 1871
Made for Susan Elizabeth Daggett by
her friends in the Young Ladies
Sewing (or Aid) Society
of the First Congregational Church
Cotton; pieced, appliquéd,
and quilted; ink
76 x 68 in. (193 x 172.7 cm)
Collection of Shelly Zegart's Quilts,
Louisville, Kentucky

FIG. 1 Caroline Cowles Richards, 1860, from *Village Life in America 1852–1872* (Williamstown, Massachusetts: Corner House Publishers, 1972), frontispiece

FIG. 2 Susan Elizabeth Daggett, c. 1859, the Ontario County Historical Society, Canandaigua, New York

IN THE DIARY she kept from her tenth year to her thirtieth (1852–72), Caroline Cowles Richards (fig. 1) told of girls growing into women in the small lakeside town of Canandaigua, New York, and recorded the events and emotions that led to the creation of the *Old Maid Quilt*.[1]

In December 1859 the young women of Canandaigua's First Congregational Church met to form a society. Among the group's goals were to develop morally and intellectually, to have "great fun and fine suppers,"[2] and to present each member with an album bed quilt upon her marriage. Susan Daggett (fig. 2) vowed, at age eighteen, never to marry, but the others insisted she would have a quilt just the same.

Two years later the concerns of the society shifted from weddings to war. Following the Confederate firing on Fort Sumter, President Lincoln called for seventy-five thousand volunteers, and the young men of Canandaigua responded. The young ladies of the society donned small flag pins and wore their hair tied with red, white, and blue ribbons. They had earrings made of the buttons soldiers cut from their coats to give as souvenirs to the girls who handed them flowers as they passed through on the train.[3]

"The girls in our society say," Caroline Richards wrote, "that if any of the members do send a soldier to the war they shall have a flag bed quilt, made by the society, and have the girls' names on the stars."[4] On March 26, 1862, she recorded, "I have been up at Laura Chapin's from 10 o'clock in the morning until 10 at night, finishing Jennie Howell's bed quilt, as she is to be married very soon. Almost all of the girls were there. We finished it at 8 p.m. and when we took it off the frames we gave three cheers."[5] In May of 1863: "We were talking about how many of us girls would be entitled to flag bed quilts, and according to the rules, they said that, up to date, Abbie Clark and I were the only ones....Susie Daggett is Secretary and Treasurer of the Society, and she reported that in one year's time we made in our society 133 pairs of

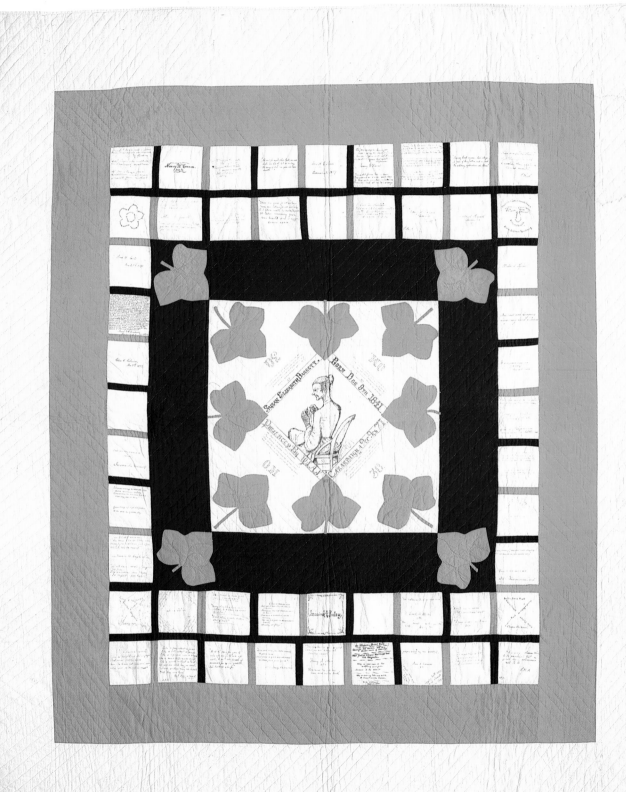

The Old Maid Quilt

FIG. 3 *The Old Maid Quilt* (detail)

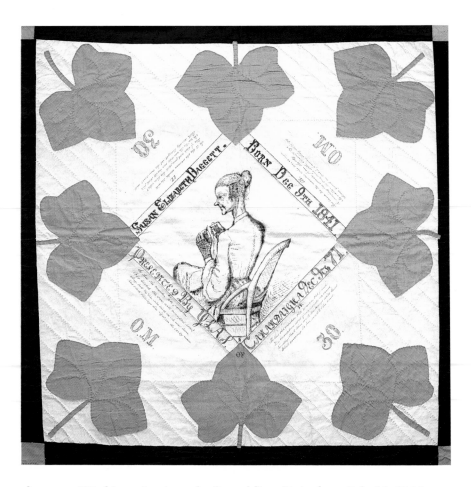

drawers, 101 shirts, 4 pair socks for soldiers."[6] And on July 15, 1866: "The girls of the Society have sent me my flag bed quilt, which they have just finished. It was hard work quilting such hot days but it is done beautifully. Bessie Seymour wrote the names on the stars."[7] Four days later, on July 19, Caroline was married.

In 1871, at age thirty and a dozen years after the Young Ladies Sewing Society first set forth its intentions, an unmarried Susan Daggett, as promised, did receive her quilt. The circumstances surrounding the *Old Maid Quilt* were recounted in a centennial booklet published by the First Congregational Church in June 1899:

> Any member reaching the age of thirty years, being still unmarried, was to receive a quilt. There is, however, a record of only one member, Miss Daggett, being brave enough to acknowledge the attainment of such great age....In all probability the central block was the chief cause of this custom being forever abolished. This block, donated by the pastor, Mr. Allen, consisted of a pen-picture of a spinster with her knitting work [she is in fact threading a needle], her hair done up in a ridiculous little knot. This, by the way, was not intended to be an exact likeness of any member of the society.[8]

The quilt's central image (fig. 3) is indeed stereotypical of a nineteenth-century spinster: a pinch-nosed woman, with dress drawn tight over thin back and shoulders. The style of that "ridiculous little

knot" places the figure in the earlier and therefore unfashionable style of the 1850s, as does the filet work of her mitts. She is surrounded by appliquéd leaves that speak of autumn rather than spring.

Susan Daggett, in reality, was an attractive and accomplished woman. From 1878–80 she held the position of assistant lady principal of Vassar College, but her primary vocation was within the church; she served for fourteen years as the president of a Woman's Board of Missions in New Haven.[9] Mission work provided women with the opportunity for leadership, but it was often considered an unattractive alternative for young girls growing up in an age when marriage and motherhood was considered the highest calling. In 1853 Caroline Richards recorded that in response to a "prophecy" that her younger sister Anna was going to be a missionary, "Anna cried right out loud. I tried to comfort her and told her it might never happen, so she stopped crying."[10]

For Susan the specter of spinsterhood may indeed have held no terror; however, although many of the inscriptions entered on her quilt speak with great fondness of Susan's admirable personal qualities, others show the prevailing attitude toward single women of Susan's age: "An old Maid, / Once a bright and shining light / But now forever dark / Her life burns out unknown, unsung / She dies without a spark."[11]

NOTES

1. Caroline Cowles Richards, *Village Life in America 1852–1872* (Williamstown, Massachusetts: Corner House Publishers, 1972).

2. Ibid., p. 114.

3. Ibid., p. 131.

4. Ibid., p. 132.

5. Ibid., p. 140.

6. Ibid., p. 152.

7. Ibid., pp. 205–6.

8. *100th Anniversary Booklet of the First Congregational Church, Canandaigua, N.Y.*, June 1899, p. 64.

9. Shelly Zegart, "Old Maid–New Woman," *The Quilt Digest* 4 (1986): 63–64.

10. Richards, *Village Life in America*, p. 17.

11. The inscriptions on the quilt, as transcribed by the lender, read:

1a. Your 30th year is well nigh past,
Since first our shy [illegible] outcast
My Susan
Lo! yonder she walketh
in maidenly sweetness.
If you change your
condition and marry
consult your mother!

1b. Nancy W. Corson.
Nov 71

1c. Don't laugh till you're
[illegible] kilt
Where you behold this
gorgeous quilt
Kate B. Antes
1871

1d. "Ah me! for aught that I could ever read,
Could ever hear by tale or historys
The course of true love never did run smooth"

1e. Mrs. A. E. Pierce
December 10, 1857

1f. Oh! dinna say her bonnie face
Is altered by the touch o' time
Nor say her form hath lost the grace
The Matchless grace that marked it's prime:
Fanny W. Pierce
To me she's fairest, lovlier now.
Than crowned [illegible] flowers
o' early days.
For change [illegible] years have only made
More [illegible] all her looks and ways.

1g. A man spits by livin alone they do say
And with women fraid it is much the pain
[illegible]
But though I am always as [illegible]
as can be
Here I'm makin myself yet. Where can the
man be?

1h. "Sure my hearts my own Each villages
Is queen of her affections, and can beset
Her arbitrary sighs where'es she pleases"

1i. Sure cure for "chilblains"
Rub thoroughly with Kerosine
Then apply a lighted match.
L. [or S?] H. A.

2a. Carrie Richards Clark
Mary Paul, Sarah McCabe, Fanny
Nickerson, Carrie Lamport, Fannie Tonsley

2b. "Say this unto your heart
Old friends like old maids
Are trusted [illegible]"
Alice A. Jeneth
"Never put off till tomorrow, what you can
do day after tomorrow just as well."

2c. [illegible]

2d. "There are gains for all our losses
There are balms for all our pain
But when youth the dream departs
It takes something from
our hearts and it *never* comes again."

2e. [blank]

2f. Cure for chilblains
Hold your feet in boiling water
for ten hours then [illegible]
half a mile in the snow.
Sure Cure K. B. A.

2g. Emily Stoneman Candiff[?]
N. G.
L. H. A.

2h. Natalie M. Bennett
November 1871

2i. Fannie Richardson Wilcox
Mary Cay Stevens, Lizzie Gird Harris
Bessie Seymour Hubball
Ella Hildreth, Kate Lapham Spaulding

3a. Sara H. Antes. Nov. 21, 1871

3i. Ritie S. Tyler

4a. As oft as I hear the robin red-breast
chant it as cheerfully in September, the begin-
ning of winter as in March, the approach of
the summer, why should not we (think I) give
as cheerful entertainment to the hoary frosty
hairs of our ages winter, as to the [illegible] of
our youth's spring! I am sent to the ant, to
learn industry; to the dove, to learn inno-
cence; to the serpent, to learn wisdom; and
why not to this bird, to learn [illegible] and
patience; and to keep the same terror of my
mind's quietness, as well at the approach of
calamitys winter as of the spring of happi-
ness? And since the Roman's constancy is so
commended, who changed not his counte-
nance with his change of fortunes, why should
not I with a Christian resolution, hold a
steady course in all weathers, and thought be
forced with cross winds to shift my sails, and
catch at side winds, yet skillfully to steer, and
keep on my course, by the "cape of good
hope," till I arrive at the haven of eternal
happiness!
Sarah V. B. Anderson Anclrisos 11/22/71

4i. Nor Cast one longing lingering look
behind.

5a. Clara G. Coleman Dec. 9th 1871

5i. "It is difficult to grow old gracefully"
Charlotte E. Clark

6a. [blank]

6i. "Her widow's cap" is still hanging in the
corners.
Mary M. Whulen 11/22/71
Oil of [illegible] sure cure for Chilblain

7a. That you may be beloved be amiable.
Susan 'The Matchless!!

7i. [illegible]
And lay the future lashes right
And trust me I will shed no tears
At twice the count of thirty years
And thus she wonders on half and half
blest without a mate for the pure lonely heart

8a. "She dwelt among the untrodden ways
Beside the springs of Dove.
A maid whom there were none to praise
And very few to love."
Your May of life has fallen
to the sere, the yellow leaf.

8i. [illegible]
H. Ella Smith

9a. — Chilblains —
"In vain shalt thou use many [illegible];
for *thou shalt not be cured*."
— Fannie H. Gaylord —
"Of all sad words of tongue or pen.
The saddest are these
It might have been."

9i. Years following years, steal something every day,
At last they steal us from curseless away."
"Learn to labor and to *wait*"
30 — "facts are stubborn things."

10a. Sarah K. Whitney, Jennie Howell Hazard
Mary Field Fiske, Sarah Howell Foster
Laura Chapin, Louisa Benjamin

10b. She neglected her heart — who studies her "glass"
It is difficult to grow old gracefully
Old maids are embers on the [illegible] from which sparks have fled
Her voice, however soft, gentle and [illegible]
An excellent thing in woman. Nettie Palmer

10c. [illegible]
"Many daughters have done virtuously but their excellent them all"
"Wast thou made before the [pills?]?"

10d. "She never told her love
But let concealment, like a worm is the breed.
Fixed outer damask check, she pined in thought;
And with a green and yellow melancholy
She sat (like patience [illegible])
Smiling at grief."

10e. Louise H. Finley

10f. [blank]

10g. "The Melancholy days have come"
Emily H. Wheeler 1871
"Poor canal with umbrella"!
Little boy — no.

10h. "Earth has no sorrow that heaven cannot heal"
"A more darker day I never saw" !!

10i. Lucilla Field Pratt, Mary Jewett, Cornelia Richards, Julia Phelps
Clara Dickson, Fannie Paul

11a. "[illegible] an old Maid,"
Once a bright and shining light
But now forever dark
Her life burns out unknown, unsung
She dies without a spark

11b. "Like a ring without a finger
like a bell without a ringer
like a ship which ne'er is rigged
Or a mine that's never digged
Like a mound without a trent
Or civet box which has no scent;
Just such as these may she be said
That lives, ne'er loves,
but dies a maid A. B. R.

11c. "It is in vain for you to rise up early, to sit up late, to eat the bread of sorrows for so he giveth his beloved [illegible]."

11d. "Time still, as he flies, adds increase to your truth.
And gives to your mind what he steals from your youth."
Abby Stanley Clark Williams

11e. "They wondered at me who had known me once
a cheerful, careless damsel."
Fanny A. Palmer 1871
"How much the heart can bear and yet not break."

11f. [illegible] — Bridal Veils
Cheerful Old Maids are the brides maids of society.
The [illegible] singer that "*draws*" best, the Mosqueto
Why is your nose in the middle of your face? Because its the *scenter*.
Why is dancing like new milk, it strengthens the Calves.

11g. "A ball *came* and struck him *there*!!"
"*Another* ball *came* and struck him *there*!!"
Anna B. Richards 1871
"Blessed are the piece-makers"

11h. We made this quilt for our dear Sue.
May her joys be many and her sorrows few!
K. B. O.

11i. Tis a very solemn thing to be married, but a great deal solemner not to be.
L. [or S?] H.A.

And around the central design:

I. Is this the maiden all forlorn
Who tended the cow, with crumpled horn?
Nay but 'tis she, who since ere she was born,
Has shed blessings like light, in the early morn.
O. M.

II. Is it the old woman under the hill,
Who, if she's not gone, doth live there still?
No, no! 'tis the one who our hearts doth fill
With kindly thought at her own sweet will.
30

III. Perchance 'tis the woman who ever so high,
Is sweeping the cobwebs from the sky,
No rather, 'tis one, who with pleasant eye,
Some good in each passing thing doth spy.
O. M.

IV. To this old maiden, old woman, old friend, This marvelous work of our hands we send,
Trusting that time with his wings will lend
Blest covering to her until the end.

21

The Phoebe Cook Quilt

United States (Gilead Township,
Morrow County, Ohio), dated 1872
Made by Phoebe Cook
Cotton and silk; appliquéd, pieced,
embroidered, and quilted
94 x 75 in. (238.8 x 190.5 cm)
The Ohio Historical Society

On December 12, 1822, in her nineteenth year, Phebe[1] Cooper married Abel Cook. Thirty years later they moved to a farm near West Gilead (its name was changed to Edison in 1882), Ohio, and twenty years after that, in 1872, Phebe entered the date and her initials (fig. 1) in the corner of this quilt, which is a record of that small midwestern town and the people who were her neighbors.[2]

There are almost one hundred figures in this calico community, of which the women in particular are a very stylish group. The woman in block 6a is wearing an informal indoor wrapper, and another, situated below that block, is dressed in a full, loose-fitting jacket called a paletot, more in vogue in the mid-1860s; but the majority of the ladies are attired in primarily cotton versions of the most fashionable styles of 1871–72.

During this period an elaborately draped and embellished skirt was the most predominant feature of a woman's dress. Many of the ladies on this quilt are wearing ruffled dresses, several of a style called the Dolly Varden (fig. 2), named after a character in Charles Dickens's novel *Barnaby Rudge.* The Dolly Varden costume appeared in the summer of 1871, following Dickens's death in 1870. The author was immensely popular with the lower-middle and middle classes, so it is therefore not surprising that the style was most popular among those women. A *Punch* cartoon (fig. 3) of August 24, 1872, suggests it was

Fig. 1 *The Phoebe Cook Quilt* (detail)

embraced by the servant class as well. The Dolly Varden's appearance on this quilt makes it clear that Phebe Cook was not only an astute observer of fashion but also had an excellent understanding of the principles of dressmaking: the ruffled overskirt is correctly depicted drawn up on both sides (with draw strings or stitched), in imitation of the eighteenth-century polonaise. Popular at the time was the type of bias trim seen on the ladies in gray stripes (fig. 4).

In addition to providing her figures with a variety of accessories (for

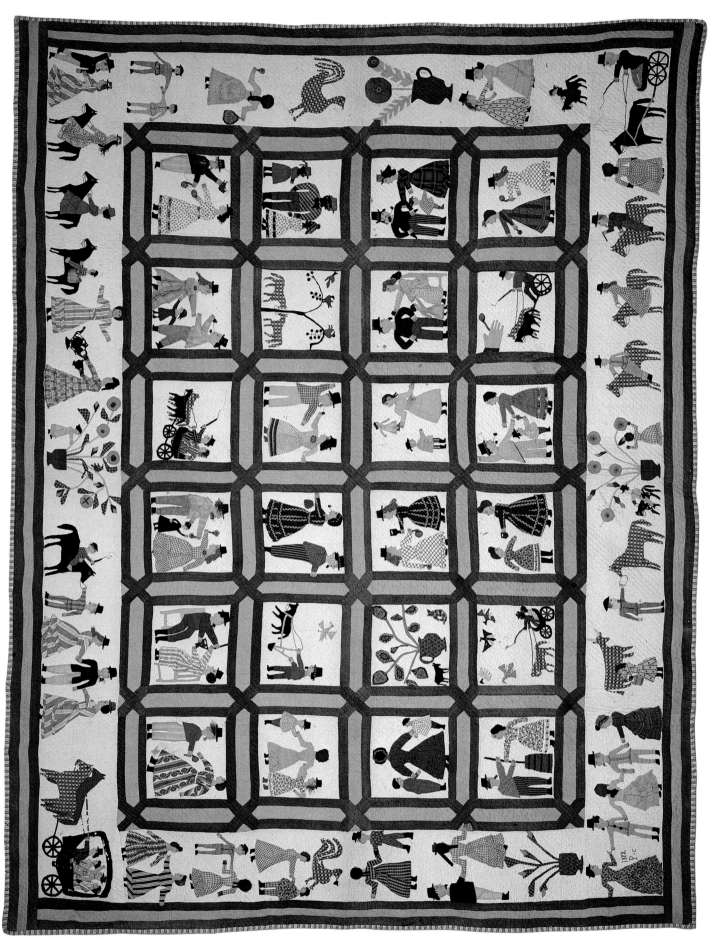

The Phoebe Cook Quilt

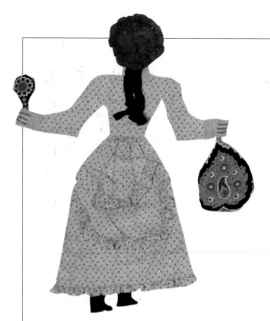

example, the cameo-type brooches worn by the ladies in blocks 2a and 4a), Phebe also furnished them with various head coverings: snoods, tied kerchiefs, and, clearly represented on the lady in brown in figure 1, mob caps. The mob cap originated in the eighteenth century; Phebe quite likely saw the again-fashionable cap illustrated in the June 1872 issue of *Godey's Lady's Book*. The most interesting of these feminine head coverings is what appears to be a version of a man's slightly truncated top hat. Developed from the Eugenie hat of the mid-1860s, its simple, stylized shape (as on this quilt) was frequently illustrated in more elaborate form in 1872 issues of *Peterson's Magazine*. *Peterson's* and *Godey's* were among the publications that influenced the fashions of middle America.

The design of the sashing that separates the figurative blocks may have been selected specifically to suggest railroad tracks; the town was, in fact, built to provide a stop on the Cleveland, Columbus, Cincinnati and Indianapolis Railroad. Two black and white roosters, oversized and placed prominently at the center of each side border, may indicate the commercial importance of the town's two hatcheries and the chicken coop manufacturer located west of the railroad tracks.[3]

The quilt illustrates a variety of commonplace activities: men, women, and children ride in carriages and on horses and ponies; a man plows; a woman milks a cow; butter is churned; tea is offered; and men and women alike smoke pipes, in which red embers are visible. The people interact in a physical sense: they hold hands and link arms, and even when they seem to stand only in conversation their pose is one of animation, their arms almost always extended. But the quilt offers no hint as to what the totality of these scenes might represent unless, perhaps, there is a clue to be found in the object held in what may represent the hand of God (block 2d). That object (a flower, a pinwheel, or possibly a commemorative favor?) also appears in the hands of nine of the quilt's figures (fig. 5) and is worn as a brooch at the neck of one other.

This grand effort was undertaken by Phebe Cook in the year in which she and Abel celebrated their fiftieth wedding anniversary and the year her granddaughter Blanch was born. It was in the small community represented on her quilt that she and Abel lived out the rest of their sixty-nine years together.

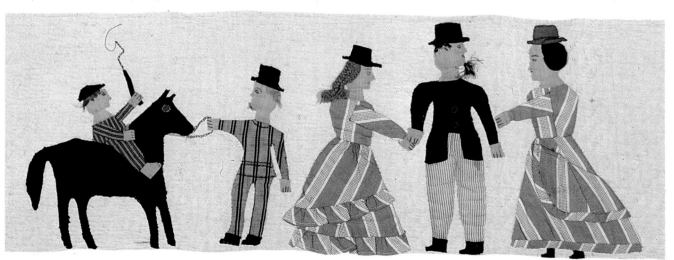

FIG. 5 *The Phoebe Cook Quilt* (detail)

NOTES

1. The quilt is widely known as the *Phoebe Cook Quilt,* and I have retained that spelling for its title. However, Abel Cook's will, his obituary (*Morrow County Sentinel,* July 23, 1891, p. 3), the quilt-maker's obituary (*Union Register,* December 23, 1891), and her gravestone all spell her given name as "Phebe." I have used that spelling throughout the text.

2. The quilt is said to have been made for Phebe Cook's granddaughter Blanch Corwin (Kelly), whose niece, Mrs. Veldren Hartpence, recalls that during family visits "the women would often gather in one room, and so often Aunt Blanch got this quilt out, and one of us would hold a corner then talk about all the things that were depicted on it." Personal communication with Mrs. Veldren Hartpence, March 26, 1990.
 "Blanch, though, could remember who only one of the figures was, that of Dr. S. H. Britton, driving a two-wheeled vehicle [top right-hand corner]. Dr. Britton was the father of Nan Britton of Harding-era fame [in 1919 Nan Britton bore President Warren G. Harding a daughter out of wedlock]." Mr. Walter Moore, the attorney to whom Blanch Kelly gave her grandmother's quilt, as quoted in *The Marion Star,* August 3, 1986.

3. Eleanor Koon, *Edison History from 1882–1982* (1982), unpaginated.

22

The Suffragette Quilt

United States, c. 1875
Possibly made by Emma Civey Stahl
Cotton; appliquéd, embroidered, and
quilted
70 x 69½ in. (177.8 x 176.5 cm)
Dr. and Mrs. John Livingston
and Mrs. Elizabeth Livingston Jaeger

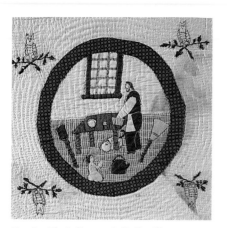

FIG. 1 *The Suffragette Quilt* (detail)

Quilts provided a means of financial support and moral persuasion for two of the great social reform movements of the nineteenth century: temperance and antislavery. Fund-raising quilts were often inscribed with the signatures of those who had contributed to the cause with a donation of ten to fifty cents; the pieces were then sometimes raffled for additional monies. That quilts were used to raise funds for the temperance movement is substantiated by the existence of a red and white, pieced quilt (its pattern, appropriately, is *Drunkard's Path*) bearing multiple embroidered signatures and, at its top, "W.C.T.U. [Woman's Christian Temperance Union] Union Springs."[1] On at least two occasions children's quilts were exhibited at antislavery fairs,[2] bearing moral messages both embroidered ("One curse remains a monstrous, hideous blot....The stain to 'rase that tarnishes the South") and inscribed:

> Mother! when around your child
> You clasp your arms in love,
> And when with grateful joy you raise
> Your eyes to God above,
> Think of the negro mother, when
> Her child is torn away,
> Sold for a little slave — oh then
> For that poor mother pray!

Another great issue of social reform was that of women's suffrage. One might logically have expected quiltmakers to play a supporting role in this cause, but to many of the activists in the suffrage movement, quilts were (indeed as was most needlework) interpreted as symbols of woman's subjugation. They were particularly abhorrent to the very vocal Oregon feminist Abigail Scott Duniway, who categorized them with "tatting, darned netting, silk embroidery, and a thousand other trifles that impecunious women kill themselves over, causing the beholder to sigh for the wasted ingenuity that is so confined to futile nothings in its endeavor for expression that men falsely imagine that the women of the land are content to do nothing else."[3] It seems somehow ironic, therefore, that a quilt would so uniquely chronicle the activities of a suffragette.

The Suffragette Quilt

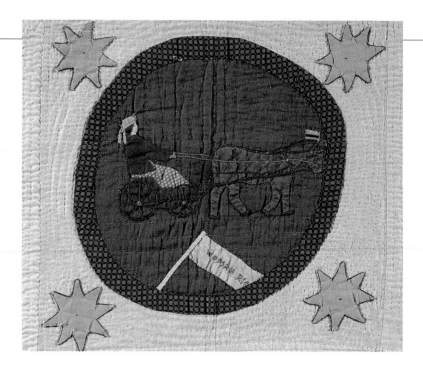

FIG. 2 *The Suffragette Quilt* (detail)

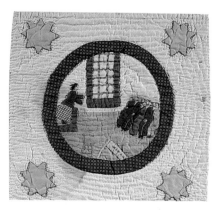

FIG. 3 *The Suffragette Quilt* (detail)

The maker of this important textile was possibly Emma Civey (Mrs. Jacob S.) Stahl, or Mrs. Stahl's mother, and it came to be given to Mrs. Stahl's daughter, Mrs. Marion Gabriel, born in Elgin, Illinois, in 1882. The quilt's narrative elements are enclosed in circular vignettes, a form of design one would find in popular print illustrations of the period and which might indicate a possible source for the scenes themselves.

All too rarely does an explanatory note accompany a quilt, and when it does, it is often the recollections of the quilt's caretaker rather than the quiltmaker herself. But at some point someone, probably Mrs. Gabriel, wrote (or caused to have recorded) a series of comments[4] on the figurative blocks:

Story of Womans Right Quilt in pictures
Made over 100 years ago.
Pictures are numbers as the story goes.

1. Man is in the kitchen doing dishes. He is owlish and cross. Represented by Owls [fig. 1].

2. The woman has gone to lecture on Womans Right. How important she is driving [fig. 2].

3. She is lecturing to all men only 1 woman and that is her Pal [fig. 3].

4. She was told that war has been declared and she comes home and tells the husband he will have to go to war [fig. 4].

5. She gets him allready to go to war and now he is telling her if God spares his life he will return.

6. He does return and this is their meeting. This is all of the story. But in order to fill in the Quilt there is other pictures.

7. The deer under the Oak represents Freedom.

8. Ravens are bringing food to the Grandmother and she is giving a cake to the Grandchild.

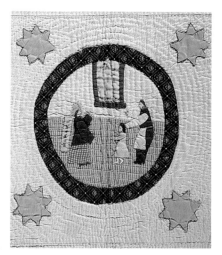

FIG. 4 *The Suffragette Quilt* (detail)

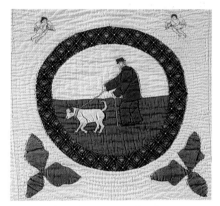

FIG. 5 *The Suffragette Quilt* (detail)

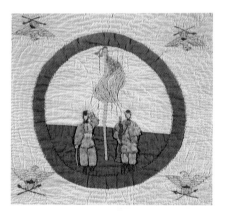

FIG. 6 *The Suffragette Quilt* (detail)

9. Angels are guarding the Blind man and his Dog. Notice how he is groping his way [fig. 5].

10. The School Marm is wondering what is the matter with the Pupil. He can't get the problem on his slate.

11. Is the Soldiers under the Flag of Freedom [fig. 6]. Every other block is Birds, fruit or Flowers. Notice the fine stitches and also how the border is made. There is not another quilt like this.[5]

Mrs. Gabriel's commentary may only be a personal interpretation; we will never know what captions the quiltmaker might herself have offered. We cannot even know if these images of "women's rights" were done in stylish celebration or satirical condemnation of that great cause. Although certain segments of the quilt quite clearly present the activities of a Platform Lady (one who spoke out in public forums) reordering her priorities, the balance of the illustrations seem more sentimental than strident. The blind man, the elderly woman, and the schoolteacher and pupil could each accurately suggest prevailing areas of benevolent concern, and ones in which the quiltmaker may in fact have felt more comfortable. Finally, the commentary does not include an explanation for the twelfth block: could it be a warning of possibly dire consequences that might follow an adventure outside of the traditional women's sphere? A child kneels in prayer in the presence of a chair empty save for a bit of red and white cloth. These are the colors assigned to the mother in the quilt, seen in her skirt and in the sash of her dress. Has the child lost her mother to death — or perhaps to the cause?

Whatever interpretation one might attach to the quilt's images and the quiltmaker's intent, truly "there is not another quilt like this."

N O T E S

1. This quilt is in the collection of the Los Angeles County Museum of Art and is a gift of Betty Horton.

2. The first quilt was made by Maria Theresa Baldwin Hollander and exhibited in the 1860s in New York. A reference to the second appears in the January 2, 1837, issue of *The Liberator*, an abolitionist paper published by Boston reformer William Lloyd Garrison; the article in which the quilt is mentioned reported on a Ladies Fair held on December 22 and is one of the earliest known instances of a quilt's journalistic documentation. Both quilts are illustrated, and the full article is included, in Sandi Fox, *Small Endearments: 19th-Century Quilts for Children* (New York: Charles Scribner's Sons, 1985), pp. 102–8.

3. As quoted in Ruth Barnes Moynihan, *Rebel for Rights: Abigail Scott Duniway* (New Haven: Yale University Press, 1938), p. 153.

4. Until several years ago, there was attached to each story block a tag with a number corresponding to Mrs. Gabriel's commentary.

5. Mrs. Gabriel entered the quilt in the 1929 Chicago Evening American Quilt Contest. A blue ribbon indicates the quilt was one of the finalists in the competition.

23

The Scenes of Childhood Quilt

United States, c. 1875
Quiltmaker unknown
Cotton; appliquéd, embroidered, and
quilted; ink
37 x 35 in. (94 x 88.9 cm)
Joel and Kate Kopp,
America Hurrah Antiques

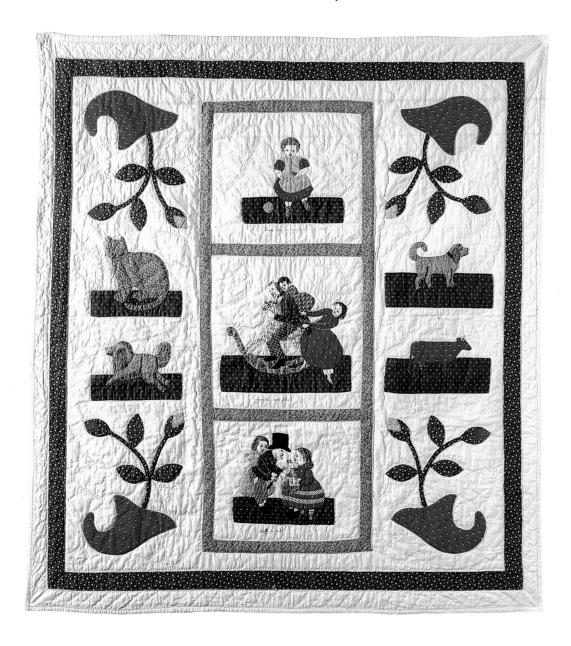

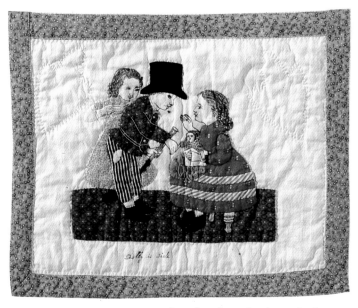

FIG. 2 *The Scenes of Childhood Quilt* (detail)

FIG. 1 From *La Mode illustrée* (1871), unpaginated, Los Angeles County Museum of Art

Nineteenth-century quilts for children were, almost without exception, adult quilts made small: in their construction no technique was too sophisticated, nor any textile too dear. Quilts worked with such refined methods as *broderie perse* and all-white stuffed work and in such intricate patterns as *Star of Bethlehem* joined common, calico four-patch quilts in covering the most fortunate of sleeping children.

By the second half of the nineteenth century a number of extremely successful children's monthly periodicals were being published, including *Chatterbox, The Youth's Companion,* and *St. Nicholas.* Filled with stories, riddles, and puzzles, they were a source of great pleasure for their young readers. On this quilt the children's features, exquisitely and expressively rendered in ink, probably derive from one of those periodicals. Depicted with the classic accouterments of the nursery, the children are all dressed in costume of the early 1870s. The young girl in the top block (beneath which is inscribed, "Here's some more sins in my pocket") has set aside her ball. She is wearing a pinafore (cf. fig. 1), a simple cover open at the back, intended to keep her dress clean as she plays. The middle block ("Grandpa ride first") features a rocking horse,[1] and the older girl, holding on to slender, tangled reins, wears pantalets and the flat-heeled type of slippers very popular during the Civil War. In the bottom block (fig. 2) "Dolly is sick." The young doctor is wearing a boy's jacket almost identical to a boy's flannel sacque — also trimmed in white braid — illustrated in an 1872 issue of *Peterson's Magazine.*[2] He is playing "dress up" in an adult's top hat and carries what appears to be a knobby walking stick with a silver handle.

NOTES

1. The first type of hobbyhorse used by American children was a simple horse's head on a stick, with or without wheels. An advertisement in the *Pennsylvania Packet* for September 10, 1785, announced, "Rocking-Horses in the neatest and best manner, to teach children to ride and give them a wholesome and pleasing exercise," and pictured a horse, complete with saddle and bridle, set on a pair of double rockers. Similar horses could be had in the 1850s from Brown and Eggleston in New York and Bradford Kingman in Boston. Katharine Morrison McClinton, *Antiques of Childhood* (New York: Clarkson N. Potter, 1970), p. 156.

2. *Peterson's Magazine* 61, no. 4 (April 1872): 295.

24

The Burdick-Childs Bedcover

United States (possibly North Adams,
Massachusetts), c. 1876
Probably made by members of the
Burdick-Childs family
Cotton; appliquéd and embroidered
79 x 79 in. (200.7 x 200.7 cm)
Shelburne Museum, Shelburne, Vermont

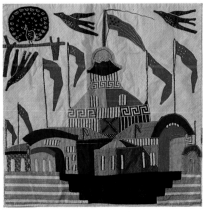

FIG. 1 *The Burdick-Childs Bedcover* (detail)

T HAT CERTAIN of the blocks on this bedcover may depict the grand
structures built in Philadelphia to house the 1876 Centennial Exhibition
is suggested by the inscriptions on the banners on block 4e, "Declarara-
tion [sic] of Independence" and "Centennial Anniversary," that flutter
from two flagpoles also flying the Stars and Stripes and a 1776 Pine Tree
Flag. Within the gatelike structure formed by the flagpoles a cracked
Liberty Bell hovers, flanked in the sky by two shields bearing the dates
1776 and 1876. Set in the center of this patriotic tableau is a building that
bears a certain resemblance to the Agricultural Hall of the exhibition.
On block 3b (fig. 1) we find absolute confirmation of the quiltmaker's
intention to record the centennial event: that block accurately depicts
the Women's Pavilion (cf. fig. 2). As described in one of the many illus-
trated histories of the exhibition, that building owed its existence
"entirely to the efforts of a number of ladies known as the 'Women's Cen-
tennial Committee.' It is devoted exclusively to the exhibition of the

FIG. 2 Women's Pavilion, International
Centennial Exhibition, from James D.
McCabe, *The Illustrated History of the Centennial
Exhibition* (Philadelphia: Jones Brothers &
Co., 1876), p. 590

The Burdick-Childs Bedcover

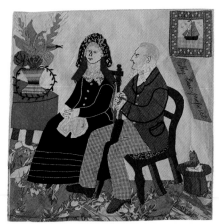

FIG. 3 *The Burdick-Childs Bedcover* (detail)

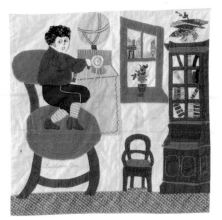

FIG. 4 *The Burdick-Childs Bedcover* (detail)

results of woman's labor, and thus constitutes an altogether unique feature of the great fair."[1] The exhibition of the "results of woman's labor" included machinery invented by women (for the most part, household laborsaving devices); embroidery from a number of nations, including pieces from England's Royal School of Art Needlework; and photographs of American institutions that were established or directed by women, including the New York Lying-In Asylum, the Shelter for Colored Orphans in West Philadelphia, and the Home for Friendless Women in Indianapolis.[2] In the light of that period's heightened public and private benevolence it is interesting to note that two of the blocks (1e and 2f) seem to illustrate the less fortunate, this on a bedcover that otherwise depicts a prosperous and joyful Victorian-era America.

The popular art of the Victorian period was rich with images of America and American life, including those subjects dearest to the Victorian heart: the family and the home. The domestic scenes worked on this bedcover provide us with an invaluable record of the decorative arts of the period. In evidence, for example, are various picture frames (fig. 3) containing portraits, mirrors, and lithographs; rococo revival side chairs, also called balloon-back chairs; a carefully rendered secretary holding books (with the volume numbers clearly visible on their spines); and a stuffed bird, acknowledgment of the craze for taxidermy (chairs, secretary, and bird can be seen in fig. 4).[3]

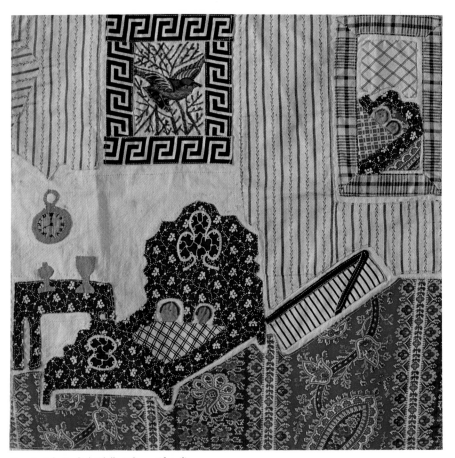

FIG. 5 *The Burdick-Childs Bedcover* (detail)

The use of architectural perspective was a popular illustrative device and one taught to Victorian ladies in Lesson 19 of "Godey's Course of Lessons in Drawing."[4] In addition to the buildings depicted on 1b, perspective is integral to the design of most of those blocks depicting interiors, particularly 3a (fig. 5), in which mother and father sleep in an ornately carved bed (probably also rococo revival); a mirror at the top right reflects a smaller bed holding two children. The blocks on this bedcover have been applied both by hand and by sewing machine, several in a manner that leaves white ground visible between adjoining images. This is a technique seen on at least a few other quilts of the period, and it is used on this block, on the at-home scene in block 1d, and on the banks of the waterway on block 4f.

This bedcover can also be said to constitute a catalogue of illustrative conventions popular at the time: fruits and flowers (5b); religion (on 2b, Moses is set adrift beside an immense cross embellished with chintz flowers done in *broderie perse*); transportation (2a); comic scenes (2e); mischievous children such as the young boy being reprimanded in 5d (fig. 6).

In the top right-hand block two women stand beneath a large red frame, which contains faint architectural images drawn but not embroidered. The woman on the right wears a fitted dress, circa 1876, with a slight train and fullness behind the knees; the one on the left wears a gown with huge pagoda sleeves, a costume fashionable almost twenty years earlier. They are dwarfed by a cat sitting on a dog's back, two of the numerous animals both domestic and exotic that wander across this quilt.

FIG. 6 *The Burdick-Childs Bedcover* (detail)

N O T E S

1. James McCabe, *The Illustrated History of the Centennial Exhibition* (Philadelphia: Jones Brothers & Co., 1876), p. 589.

2. Ibid., p. 592.

3. An inscription identifies the boy on this block as "Meddlesome Tom." Six other blocks bear inscriptions worked in embroidered cotton: the sign on the wall of block 2d, "Teas, Silks / China / Carvings"; on 2e, "What D'Yer Say" and "Terrible Struggle"; on 3c and 3d, "My last proposal" and "My first proposal"; on 4d, "The Globe Theatre / Built / A.D. 1593"; and above the door of the house on the right side of 6d, "C. Starr."

4. *Godey's Lady's Book* (August 1871): 158–59.

25

The Couples Quilt

United States, c. 1880
Attributed to Mary Jane Batson and her
granddaughter Mariah Chapman
Cotton; appliquéd, embroidered,
embellished, and quilted; ink (or paint)
80 x 74 in. (203.2 x 188 cm)
Marcia and Ronald Spark

THE ORAL HISTORY accompanying this quilt places it within the intriguing body of work done by nineteenth-century African-American quiltmakers. Tradition holds that it was begun in the 1850s by Mary Jane Batson while she was still a slave and that following the Civil War she remained on a plantation in Richmond, Virginia. She is said to have completed the quilt blocks in the late 1870s and to have given them to her granddaughter Mariah Chapman, who later set them together and constructed the quilt. In 1922 the *Couples Quilt* was given to Mariah's niece Mrs. Malinda Spain and in 1933 given to Mr. William Kern. Mr. Kern, then the principal of a school outside Detroit, Michigan, had helped to feed and clothe Mrs. Spain's children during the Depression.[1] The reverse of the quilt bears three inked inscriptions that substantiate it was once in the hands of the Spain family (fig. 1).

Contrary to what oral tradition suggests about the quilt's provenance, the surface of the piece provides evidence (in detail and design) that the blocks could not have been worked in the antebellum period. Beneath one small foot the background fabric (a handwoven linen, slightly foxed) reveals that a small line of sewing machine stitching has been removed from what may have been an old garment.[2] The most telling evidence, however, is in the silhouette of the costumed ladies, who all wear bustles and hats datable to the late 1870s or 80s.

The costumes worn by the couples are all quite detailed. On block 1a (fig. 2, left side) the woman's garb is similar to that found on most of the other blocks. The tabbed bands of decoration on the skirt were popular through the 1870s; the round objects on the bands may represent large, covered buttons, and the belt would have had a button closure or a steel buckle. She wears a bow at her neck. Her partner's tie is from the 1870s, and he wears a peaked cap. Their faces are blank, unlike the simplistic features embroidered on the couple on block 1b (fig. 2, right side), on which it is interesting to note that the man's pants were painted after the piece was quilted.[3]

The women on the quilt carry a variety of objects, in most cases some type of fan or handkerchief, a lace-edged version of which is seen

FIG. 1 *The Couples Quilt* (detail, reverse)

The Couples Quilt

FIG. 2 *The Couples Quilt* (detail)

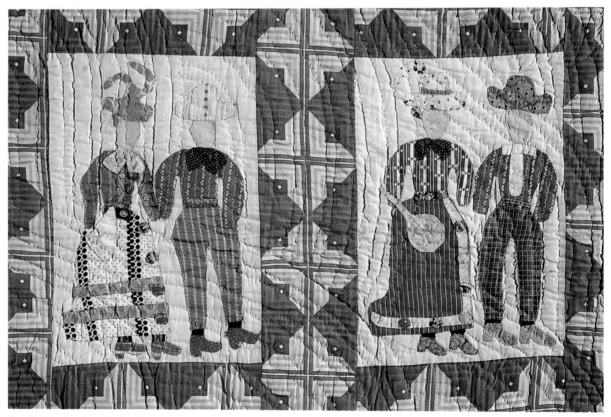

FIG. 3 *The Couples Quilt* (detail)

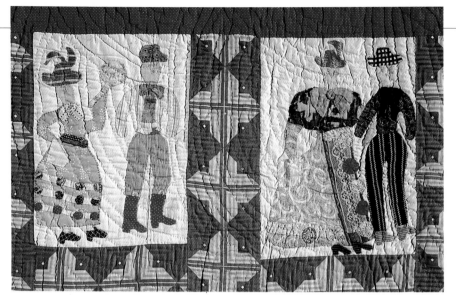

tucked into the belt of the lady on block 2a (fig. 3, left side). The gentleman with whom she holds hands is distinguished by the knit-fabric stockings he wears. On block 2b (fig. 3, right side) the man wears a bow that is actually tied (the neckwear on the other men is only vaguely gathered); almost all of the articles of clothing on this quilt were available from 1870s mail-order catalogues, and this tied bow may represent a commercially available cravat.

On most of the women's costumes the dress comes to the top of the shoe (with a bit of ankle showing on some), indicating a more formal or walking attire. On block 1c (fig. 4, left side) the woman wears white stockings, and the shoes are very clearly seen to be an 1870s style with tongues. The tabs by which her partner would pull on his red boots are clearly visible. On block 1d (fig. 4, right side), on the arm of an escort wearing a large silk bow, a woman presents herself in especially elegant attire. She wears a cape similar to those popular in the 1880s, with a brooch on the large bow at her neck. The striped satin ribbon down the front of her dress is overlaid with machine-made, single-color dress lace festooned with rosettes. This longer dress, with the suggestion of a train, would have had a dust ruffle petticoat, whose flounce protector (which was removable and washable) is clearly depicted.

Block 3c features the only couple not wearing hats; theirs are stacked on a hat rack to the left of the woman. An elegant bit of lace embellishes the lady's bodice and a panel of her skirt; she wears a necklace of tiny glass beads.

The blocks were eventually set together with strips of a type of fabric (usually referred to as "cheater cloth") intended to simulate the look of pieced work or appliqué. It is somehow ironic that the results of the blockmaker's meticulous labors should eventually have been joined together by a printed fabric used to avoid labor.

N O T E S

1. Personal correspondence with Marcia Spark, June 14, 1988.

2. The earliest American patent on a sewing machine was issued to John J. Greenough on February 21, 1842, but the machine was not in common family use until the 1860s. Grace Rogers Cooper, *The Sewing Machine: Its Invention and Development* (Washington, D.C.: Smithsonian Institution Press, 1976), p. 13.

3. In most instances any quilting on these figurative pieces in some manner outlines rather than crosses over the appliquéd forms. On this quilt, however, an *Ocean Wave* quilting pattern, crudely and unevenly done, simply covers the entire surface of the quilt, surely by a hand other than the one that created the dresses' intricate embellishments.

26

The Constitution Bedcover

United States, c. 1880
Quiltmaker unknown
Cotton; appliquéd, pieced, embroidered,
and quilted
66 x 73 in. (167.6 x 185.4 cm)
Joel and Kate Kopp,
America Hurrah Antiques

F ${}$ IG. 1 *The Constitution Bedcover* (detail)

MOST OF THE images on this busy bedcover are common to the period. Flora and fauna appear on numerous blocks, which are unique only in the intricate and imaginative embroidery that covers many of the wide variety of animals and birds. There are conventional patriotic images: eagles and shields are depicted on blocks 40 and 41; flags appear on crossed standards on block 95 and stream from the hot-air balloon on block 51[1]; the portraits in blocks 26 and 108 may be of President Garfield and General Ulysses S. Grant; on block 67 a figure that bears an obvious resemblance to Abraham Lincoln stands next to a bride and groom (fig. 1).[2] Just left of this last block is another Abraham, the biblical patriarch of the Hebrew people, about to sacrifice his only son Isaac; the bedcover bears several other biblical characters, a favored subject for quiltmakers throughout the nineteenth century.

Intermingled with these straightforward images, however, are more than thirty appliquéd and embroidered blocks that illustrate the once-secret symbols and legend-laden rituals of America's fraternal organizations. During his 1831 tour of America Alexis de Tocqueville recognized a national propensity toward the forming of associations: "If it is proposed to inculcate some truth or to foster some feeling by the encouragement of a great example, they form a society."[3] Such societies proliferated in nineteenth-century America, and they developed and often shared in common a sometimes bewildering assortment of regalia, rites, and symbols.[4]

Elaborate regalia such as sashes, collars, swords, and a variety of jewels symbolic of rank heightened the dramatic effect of the societies' rituals. An advertising broadside printed circa 1855 by Baker, Godwin, and Company in New York announced Elias Combs to

The Constitution Bedcover

FIG. 2 *The Constitution Bedcover* (detail)

FIG. 3 From Jeremy Cross, *Masonic Chart* (New Haven, 1819), frontispiece

be a purveyor of regalia to Odd Fellows, Masons, and other associations; its illustration prominently features a collar such as that on block 25, on which are entered the initials I.O.G.T. (Independent Order of Good Templars).[5]

Among the most fascinating and elaborate items of fraternal regalia are Masonic aprons, one of which is illustrated on block 85 (fig. 2). The earliest of these aprons, in England, were similar to the plain leather, knee-length, protective garment worn by stonemasons,[6] but they evolved into elaborately printed, painted, and embroidered objects, sometimes designed and executed by amateurs and at other times by professional artists. The symbols of Freemasonry appear on these aprons in a variety of arrangements. Fraternal symbols appeared on a wide range of objects: on clocks and candlesticks; on handkerchiefs and hooked rugs; on china mugs and stoneware jugs. Following the War for Independence, these symbols entered the iconography of America's decorative arts, and in the second half of the nineteenth century many appeared as single images or primary subjects on American quilts and bedcovers.

One of the most important of Masonic images, the masters carpet, was illustrated on the frontispiece of Jeremy Cross's *Masonic Chart*, published in New Haven, Connecticut, in 1819 (fig. 3); the engraver is

FIG. 5 *The Constitution Bedcover* (detail)

FIG. 7 *The Constitution Bedcover* (detail)

identified as Amos Doolittle (himself a Mason),[7] who had contributed a less solemn image to the *Boo-Hoo Bedcover* six years earlier (see p. 41). The masters carpet, appearing in variations on a large number of Masonic aprons (fig. 4), is illustrated on block 42 (fig. 5) of this bedcover, where several individual Masonic symbols are clearly visible, including the acacia sprig, the anchor, the all-seeing eye, the celestial and terrestrial globes appearing atop the pillars, the sword pointing to a naked heart, the beehive, and the ark. The last three are illustrated again, individually, on blocks 86, 23, and 103 respectively, but since the ark is one of those symbols shared with other fraternal organizations,[8] that may well be among those blocks not specifically Masonic.

Certain of the symbols found on an Irish Masonic apron of 1796 (fig. 6) appear almost a century later on several of this bedcover's individual blocks: a cock appears on block 82, a skull-topped coffin on block 85 (fig. 2), and a pitcher on block 44, which depicts Temperance (one of the three Masonic cardinal virtues) as a figure measuring from a pitcher. The two men atop pedestals in the lower corners of the apron each wear an apron; their counterpart on block 5 (fig. 7) does not, but resting on the base of the pedestal on which he stands are three female figures that may be depictions of the symbols faith, hope, and charity. Jacob's Ladder appears on block 36 in more complete symbolic imagery than on the apron. The bedcover is in a reconstructed form, and the block's original positioning was probably as illustrated in figure 8, showing a sleeping Jacob, who in his dream sees angels ascending and descending a ladder to heaven (Gen. 28:12). The Adam and Eve embroidered in wool on the handwoven cotton apron are much less discreetly dressed than those on the bedcover (fig. 9), whose substantial appliquéd fig leaves are more appropriate to Victorian modesty.

The hand-and-heart motif on block 28 is occasionally found on nineteenth-century quilts and bedcovers, though it has not generally

FIG. 6 Masonic apron, Ireland, 1796, embroidered cotton, 21¼ x 16¼ in. (54 x 41.3 cm), Museum of Our National Heritage

FIG. 4 Attributed to R. B. Crafft (United States), Masonic apron, c. 1850, oil on leather, 12⅞ x 13 in. (32.7 x 33 cm), Museum of Our National Heritage

been recognized by the modern observer as a symbol associated with the Independent Order of Odd Fellows. Although the quiltmaker in this case clearly intended that block to be another of her fraternal segments, other quiltmakers of the period may have adopted the motif not as a sign of fraternal affiliation but simply as a symbol of affection. The original symbolism attached to many of America's most traditional and enduring quilt motifs faded over time, and design became the primary reason for the motif's continued use. It is extremely doubtful, for example, that every tulip appliquéd on a Pennsylvania quilt of the nineteenth century was meant to represent the Trinity, as it generally did in its earlier applications on the decorative arts of Palatinate Germany.

If block 33 is also a fraternal segment, then the building on it could certainly represent the location of lodge activities. By the middle of the nineteenth century lodge rooms in which members met to conduct their rituals were often decorative fantasies based on Egyptian, Gothic, or Greek architecture. The interior scene on block 83 is similar to one illustrated in another manual by Jeremy Cross, undated, but probably of mid-century.[9]

One of the most intriguing sections of the bedcover is a group of four blocks (54, 55, 60, and 61) (fig. 10). Three of the blocks suggest the "steps" that are a part of Masonic symbolism, the three stages of life (youth, manhood, and age) that also represent the first three Masonic degrees: a young boy poses with a hoop and stick; a soldier in full uniform sits on a chair, his sword's point resting on the floor next to what appears to be a penny rug; two men enjoy the fruits of old age — time for leisurely conversation with two jugs at their feet. The fourth in this series of blocks completes the universal stages of life: a coffin rests beneath an immense weeping willow tree in view of tombstones and monuments. That final block, one particularly suggestive of the type of mutual assistance assured by many of the fraternal organizations, is in the tradition of America's mourning arts (see the *Maria Hanks Quilt*, p. 88). The 1876 *Odd Fellows Text Book and Manual* describes the misery of a lonely, impoverished death and suggests "how different would be the condition of such a person, if in the days of his health and strength he had become a member of our Noble Order! A competency would have smiled round his hearth-stone; sympathizing friends would have watched round his sick-bed; and he would close his eyes in death with the sweet assurance that his family was left in the care of brothers."[10]

The popularity of sailing vessels as a subject among quiltmakers is evidenced by a number of American quilts, such as the *Charleston Battery Scene* (ill. pp. 54–55) and the *Trade and Commerce Bedcover* (ill. p. 49). A sailing ship dominates this bedcover's large central block; its stern clearly bears the name *Constitution*. The quiltmaker may have wanted to honor the American frigate whose performance in the War of 1812 earned her the nickname of "Old Ironsides." Worked after the Civil War, the image might have been intended to affirm that the United States Constitution had survived intact and victorious. Finally, the "Book of Constitutions Guarded by the Tiler's Sword" is a Masonic symbol of the fraternity's watchfulness and constancy. The ship sails on a calm sea.

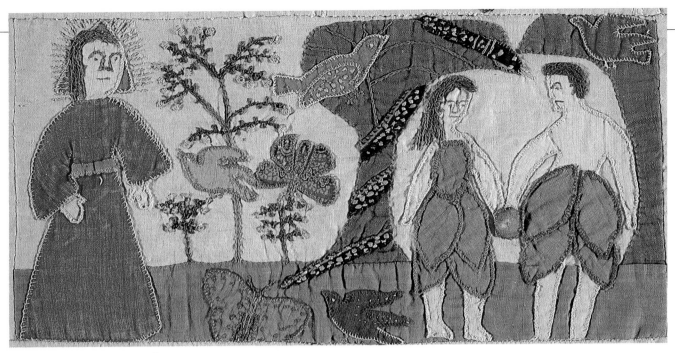

FIG. 9 *The Constitution Bedcover* (detail)

NOTES

1. The Montgolfier brothers' 1783 ascension in a hot-air balloon was an event that aroused a great and continuing public interest in these immense objects. They occasionally appear on quilts and bedcovers through the use of a textile such as *Baloon de Gonesse* (a copper-plate print, rose on white linen, Jouy, 1785) or as an appliquéd image such as the one presented on this piece.

2. If this figure does indeed represent Lincoln, the particular event he is attending and the nuptial couple next to him remain unknown.

3. Alexis de Tocqueville, *Democracy in America* (New York: Vintage Books, 1945), pp. 114–15.

4. The Scottish Rite Masonic Museum of Our National Heritage in Lexington, Massachusetts, has published three catalogues invaluable to the author in this preliminary interpretation of the images on this bedcover: *Masonic Symbols in American Decorative Arts* (1976), *Bespangled Painted & Embroidered: Decorative Masonic Aprons in America 1790–1850* (1980), and *Fraternally Yours: A Decade of Collecting* (1986). For her exemplary texts, her important research on the effect of Masonic symbolism on American decorative arts, and her generosity in the discussion of both during numerous conversations and communications, I am very grateful to Barbara Franco, who was, at the time this book was being written, that museum's assistant director.

5. The broadside is illustrated in Franco, *Fraternally Yours*, p. 43; additional illustrations show daguerreotypes and photographs in which such collars are being worn by Freemasons and by members of the Order of United American Mechanics posing in 1880 beside a Pennsylvania train station. The Independent Order of Good Templars was organized in 1850 and, unlike the earlier (1842) Sons of Temperance, admitted women on an equal basis.

6. Pictorial evidence is the principal method of tracing the stylistic development of these aprons, one of the earliest examples being a satirical print, *Night*, engraved by William Hogarth in 1738.

7. There are several extant Masonic objects engraved by Amos Doolittle, a member of the Hiram Lodge in New Haven, Connecticut, from 1792 until his death in 1832. An engraved Grand Lodge of Connecticut certificate (circa 1799), a "diploma of the third degree" (circa 1819), and three engraved Masonic aprons (circa 1799, 1818, and 1819 respectively) are illustrated in Franco, *Bespangled Painted & Embroidered*, pp. 88–90.

8. *Odd Fellows Monitor and Guide Containing History of the Degree of Rebekah and Its Teachings, Emblems of the Order, According to Present Classification and Teachings of Ritual, As Understood by Obligated Odd Fellows and Their Wives* (Indianapolis: Robert Douglass, 1878), p. 72.

9. Jeremy L. Cross, *The True Masonic Chart or Hieroglyphic Monitor: Improved Stereotype Edition with the History of Free Masonry by a Brother* (New York: A. S. Barnes & Co., n.d.), p. 17.

10. As quoted and cited in Franco, *Fraternally Yours*, p. 73.

27

The Caroline Jones Quilt

United States
c. 1885
Made by Caroline Kountz Jones
Primarily silk and velvet; pressed,
appliquéd, and embroidered
72 x 65 in. (182.9 x 165.1 cm)
Mr. and Mrs. Nelson Dorrington Jones

THE PREDOMINANT style of American quilts changed drastically during the last quarter of the nineteenth century. The earlier preference for plain and printed cottons worked in the clearly defined lines of geometric, pieced patterns or curvilinear appliqué now gave way to silks and velvets in asymmetrical shapes, whose edges were characterized by an often intricate combination of embroidered stitches and whose surfaces bore a fanciful variety of painted, appliquéd, embroidered, and embellished images.

The embellishment found on costume of the period continued to be appropriated for use on quilts, but now, rather than such subtle elements as tiny piping or bits of soutache (a narrow braid), those shared embellishments became more flamboyant. Decoration such as the chenille flowers, pom-poms, and corded braiding that appeared on wraps and evening gowns of the 1880s was also used on crazy quilts; indeed, actual costume accessories, such as evening bags and gloves, were sometimes appliquéd to those already ornate surfaces. One of the more memorable fashion trends of the 1880s was the decorative use of dead animals. The number of stuffed birds seen on women's hats was sufficient to prompt *Harper's Bazar* to decry the "world-wide slaughter of the innocents."[1] Stuffed hummingbirds, owl's heads, even an entire kitten, were seen on muffs, and this bizarre fad led Mrs. David McWilliams to add stuffed birds and chipmunks to the crazy quilt she made to be raffled for charity in 1882 (fig. 1).

The principal influences on the development of crazy quilts, however, were the popularity of Japanese motifs and interest in England's Aesthetic art movement. Images drawn from both appear on the crazy quilt worked by Caroline Kountz Jones.[2] Japanese prints entering the European market in the 1850s had already influenced the work of a few artists, including those paintings done by James Abbott McNeill Whistler in the early 1860s. *Japonisme*, however, did not profoundly affect American quilts until more than a decade later, following the overwhelmingly popular response to the Japanese exhibits at the 1876

FIG. 1 Mrs. David McWilliams (United States), quilt (detail), 1882, primarily silk and velvet with chipmunks, Missouri Historical Society

The Caroline Jones Quilt

FIG. 3 *The Caroline Jones Quilt* (detail)

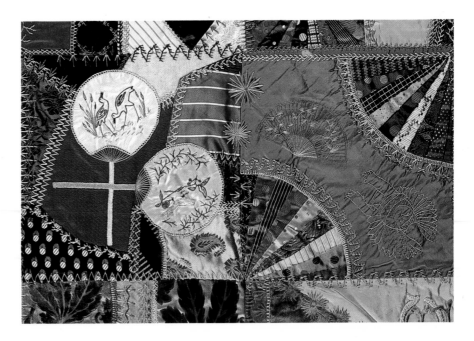

FIG. 2 From James D. McCabe, *The Illustrated History of the Centennial Exhibition* (Philadelphia: Jones Brothers & Co., 1876), opposite p. 28

FIG. 4 Quilt (detail), c. 1885, primarily silk and velvet, collection of Adele Millard

Centennial Exhibition. During this period it was said, "Japanese confusion, which is at heart the highest artistic order, reigns."[3] The asymmetrical aspects of Japanese design were soon primary to the construction of American quilts, and traditional Japanese motifs were incorporated into a vocabulary of images that appeared consistently and profusely on newly fashionable silk and velvet surfaces. The sculpted cranes that appeared in the Japanese gardens at the exhibition (fig. 2) were seldom absent from the surface of crazy quilts. An Aesthetic interest in insects traditional to Japanese design led to a veritable mania for applying them to crazy quilts and costume: bonnets were trimmed with beetles and dragonflies; silver spiders appeared on the bodices of evening gowns; and in 1879 *Godey's Lady's Book* reported that "a fly is the fanciful ornament of the day; a pretty little fly, so skillfully and perfectly imitated that it looks like life."[4]

One of the many histories describing the Centennial Exhibition tells of the fan motif in the Japanese display within the Woman's Building: "Several large screens ornamented with numberless fans, which in turn are ornamented with figures of various kinds, are also in this collection. Some of the figures are painted, while others are worked in wool, or made of cloth raised high from the surface."[5] Fans had already become, like blue china, a decorative craze for English Aesthetes (the first drawing in *Punch* of an "Aesthetic room" in which fans are mounted on a screen appeared in 1875, although Whistler had used fans on his walls in the late 1860s), and they now became the most persistent image on this new type of quilt. They appear on Caroline Jones's quilt in two principal shapes: the folding fan and the bamboo hand-screen (fig. 3).

The illustrations in Kate Greenaway's popular children's books portrayed very young girls in Aesthetic dress. Figures based on those illustrations were among the most popular images for crazy quilts — indeed, the *Caroline Jones Quilt* includes several. But the depiction on

FIG. 5 *The Caroline Jones Quilt* (detail)

crazy quilts of adult figures in Aesthetic dress is quite rare. One such example painted on an unfinished crazy quilt wears the knee-breeches, jacket, and loose tie that characterized Aesthetic dress for men (fig. 4); he strikes an affected pose almost identical to that of the character Bunthorne on a poster for a New York performance of *Patience,* an 1881 comic opera by Gilbert and Sullivan that satirized the Aesthetic movement and shaped the middle class's perception of it. Aesthetic dress proved to be a particularly attractive satirical subject for artists such as George du Maurier. On her crazy quilt Caroline Jones includes an Aesthetic woman (fig. 5) similar to that illustrated by du Maurier in an 1881 issue of *Punch* (fig. 6) (an appearance in *Punch* was a sure sign that a motif or fashion had achieved popular currency). The delicate coloring of her costume is of particular importance, as stories appeared in London that Aesthetes would refuse to go to dinner with any woman dressed in the garish colors achieved through the use of aniline dyes;[6] the skirt of her gown is decorated with cattails, which shared popular favor with sunflowers and lilies during the 1880s, especially on the embroideries worked by the Royal School of Art Needlework; and she holds herself in a fashionable slouch, the "S" shape of a kimono-clad Japanese woman worked elsewhere on this elegant quilt.

NOTES

1. *Harper's Bazar* (September 16, 1882): 579.

2. Caroline Virginia Kountz was born in Pittsburgh, Pennsylvania, in 1858. Her father owned the trolley lines in that city, as well as a number of riverboats providing passenger and freight service on the Mississippi River. In 1878 she married Thaddeus Crane Jones of Somer, Westchester County, New York, and moved to St. Paul, Minnesota, where her two children were born. Personal correspondence with Nelson D. Jones, 1989.

3. *Harper's Bazar* (July 25, 1885): 475.

4. *Godey's Lady's Book* (September 1879): 286.

5. James D. McCabe, *The Illustrated History of the Centennial Exhibition* (Philadelphia: Jones Brothers & Co., 1876), p. 594.

6. James Laver, *Taste and Fashion* (London: George G. Harrap and Co., 1945), p. 67.

FIG. 6 From *Punch* (April 9, 1881): 162, private collection

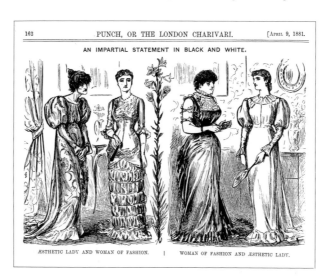

28

The Hardman Quilt

United States, c. 1885
Possibly made by Mrs. Edwin Hardman
Silk and velvet; appliquéd, embroidered,
and embellished
82 x 70 in. (208.3 x 177.8 cm)
Courtesy of the Haggin Museum,
Stockton, California, gift of
Nora Le Quellec and Marie Freeman

IN THE LATE nineteenth century a quiltmaker thought to be Mrs. Edwin Hardman appliquéd, embroidered, and embellished a series of evocative figurative and pictorial blocks. These were then joined together with several rectangular segments of asymmetrical patches bearing traditional crazy quilt motifs such as owls, cranes, and butterflies. Those large segments were then affixed to the outer edges of a central medallion, whose principal element is a rather stately home: its chandeliers are visible through the windows; its roof is topped with a weather vane; and birds guard a nest in one of the two trees that flank it.

Many of the blocks feature the theme of horse and rider: a European-style hunting scene; a jockey astride a thoroughbred; an equestrienne; a young girl on a pony (or donkey?) next to a boy flying a kite; a yellow-haired cowboy, with a slender golden mustache, lassoing a steer (fig. 1). Two other horses on the *Hardman Quilt* suggest those that appeared on the lithographed posters announcing the arrival of the circus. Feats such as those presented on this quilt (and those seen on a segment of fabric contained in a child's comforter [fig. 2]) amazed and astounded children and adults alike, from America's rural areas to its great urban arenas; however, many clergyman and educators, in what

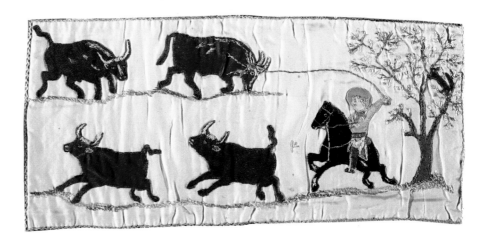

FIG. 1 *The Hardman Quilt* (detail)

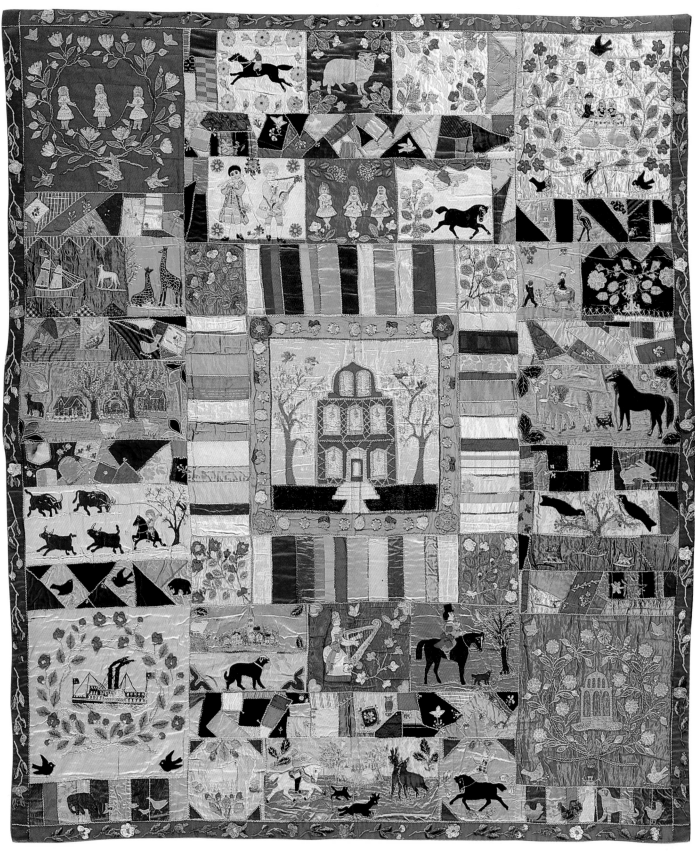

The Hardman Quilt

FIG. 2 Child's comforter, United States,
c. 1875, 53 x 50 in. (134.6 x 127 cm), the
Baltimore Museum of Art, gift of Irwin and
Linda Berman, St. Simons Island, Georgia

FIG. 3 *The Hardman Quilt* (detail)

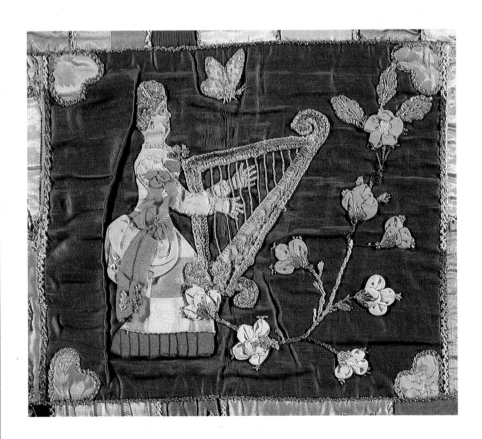

FIG. 5 From *Harper's Bazar* (February
23, 1884): 125, Los Angeles County
Museum of Art

FIG. 4 *The Hardman Quilt* (detail)

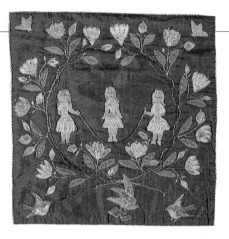

Fig. 6 *The Hardman Quilt* (detail)

was still a strongly puritanical environment, saw the circus as a sure road to moral ruination. Caroline Cowles Richards (see the *Old Maid Quilt*, p. 98) noted in her diary the appearance of the circus in Canandaigua, New York, on July 4, 1857, and her grandmother's thoughts on young women leaping through a hoop (fig. 3):

Barnum's circus was in town to-day and if Grandmother had not seen the pictures on the handbills I think she would have let us go. She said it was all right to look at the creatures God had made but she did not think He ever intended that women should go only half dressed and stand up and ride on horses bare back, or jump through hoops in the air.[1]

On a velvet block, its four corners embellished with golden hearts, a woman plays a harp (fig. 4). Her elegant formal gown is in the asymmetrical style of the period (cf. fig. 5), its elaborate decoration down one side only. Unlike the illustration, however, the dress on the quilt extends more modestly to the harpist's neck. Two other musicians represented on the quilt, young boys playing a guitar and flute, are incongruously dressed in eighteenth-century costume: although the quiltmaker may have intended the figures to represent performers in period costume, she may also have been depicting automata, a type of mechanical toy extremely popular during this period.

Three young girls (sisters? triplets?) are apparently central to the quilt's narrative. They are depicted in one scene wearing similar lace dresses and skipping rope within a crossed floral spray (fig. 6). In a second scene (fig. 7) they wear the same type of lace-caped dresses, but ribbons have been added to their pinched waists; their small feet are crossed as in pirouettes; and each carries a small bouquet, tributes perhaps from an enchanted audience for whom they have performed. The three girls appear in a third scene (fig. 8), wherein two are seated motionless in a boat moving across a lake. They now wear black dresses, and their embroidered features are solemn. The third has been transformed and appears as the winged figurehead on that vessel: she smiles and holds above her head a long floral garland. On one other block three possibly analogous figures appear: small winged angels bearing arms full of flowers.

Fig. 7 *The Hardman Quilt* (detail)

Fig. 8 *The Hardman Quilt* (detail)

N O T E

1. Caroline Cowles Richards, *Village Life in America 1852–1872* (Williamstown, Massachusetts: Corner House Publishers, 1972), p. 88.

29

The Bible Quilt

United States (Athens, Georgia), c. 1886
Made by Harriet Powers (1837–1911)
Cotton; pieced, appliquéd, and quilted
73¾ x 88½ in. (187.3 x 224.8 cm)
Smithsonian Institution

IN 1886, while attending a cotton fair in Athens, Georgia, a young artist named Jennie Smith came upon an extraordinary quilt in the corner of an exhibition of farm products and initiated a series of events that saved for America one of its greatest textile legacies:

After much difficulty I found the owner, a negro woman [Harriet Powers, fig. 1], who lives in the country on a little farm whereon she and her husband make a respectable living. She is about sixty-five years old [Powers was actually only forty-nine at the time], of a burnt ginger cake color, and is a very clean and interesting woman, who loves to talk of her "ole miss" and her life "fo de war." The scenes on the quilt were biblical and I was fascinated. I offered to buy it, but it was not for sale at any price. After four years, Harriet sent me word that I could buy it if I wanted it. Alas! my financial affairs were at a low ebb and I could not purchase. Last year I sent her word I would buy it if she still wanted to dispose of it. She arrived one afternoon in front of my door in an ox-cart with the precious burden in her lap encased in a clean flour sack, which was still further enveloped in a crocus sack. She offered it for ten dollars but I only had five to give. After going out and consulting her husband, she returned and said "owin ter de hardness of de times, my ole man he 'lows I'd better teck hit" and not being a new woman, she obeyed. After giving me a full description of each scene with great earnestness and deep piety, she departed, but has been back several times to visit the darling off spring of her brain. She was only in a measure consoled for its loss when I promised to save her all my scraps.[1]

With remarkable forethought Jennie Smith also set down Mrs. Powers's verbal description of each block, adding comments of her own:

No. 1 represents Adam and Eve in the Garden of Eden, naming the animals, and listening to the subtle whisper of the "Sarpent which is degiling Eve." It will be noticed that the only animal represented with feet is the only animal that has no feet. The elephant, camel, leviathan, and ostrich appear in this scene.

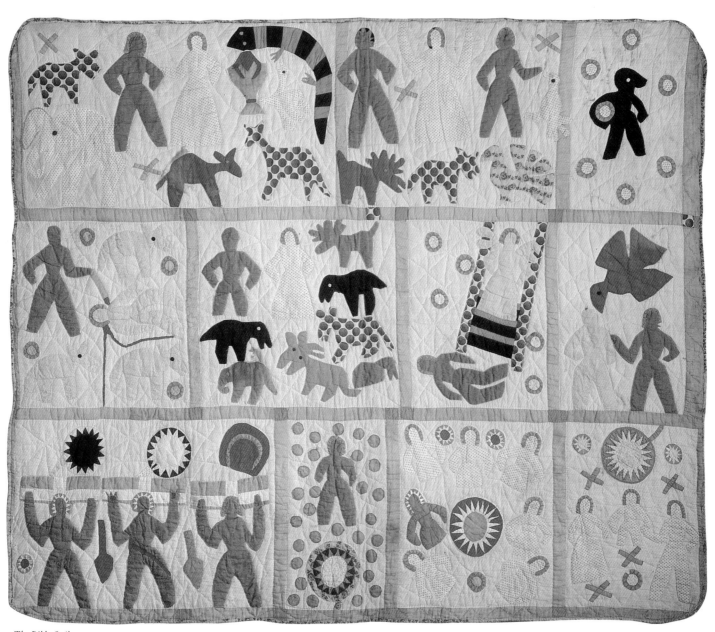

The Bible Quilt

No. 2 is a continuation of Paradise but this time Eve has "conceived and bared a son" though he seems to have made his appearance in pantaloons, and has made a pet of the fowl. The bird of Paradise in the right lower corner is resplendent in green and red calico.

No. 3 [fig. 3] is "Satan amidst the seven stars," whatever that may mean, and is not as I first thought a football player. I am sure I have never seen a jauntier devil.

No. 4 is where Cain "is killing his brother Abrel, and the stream of blood which flew over the earth" is plainly discernible. Cain being a shepherd is accompanied by sheep.

No. 5 [fig. 2, left side] Cain here goes into the land of Nod to get him a wife. There are bears, leopards, elks and a "kangaroo hog" but the gem of the scene is an orange colored calico lion in the center, who has a white tooth sticking prominently from his lower lip. The leading characteristic of the animal is its large neck and fierce manner. This lion has a tiny neck and a very meek manner and coy expression.

No. 6 [fig. 2, right side] is Jacob's dream "when he lied on the ground" with the angel ascending or descending the ladder. She has a rather stylish appearance.

No. 7 is the baptism of Christ. The bat-like creature swooping down is "the Holy Sperret extending in the likeness of a dove."

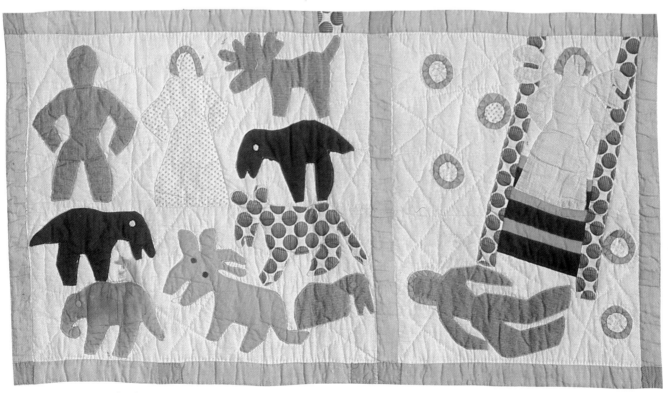

FIG. 2 *The Bible Quilt* (detail)

FIG. 3 *The Bible Quilt* (detail)

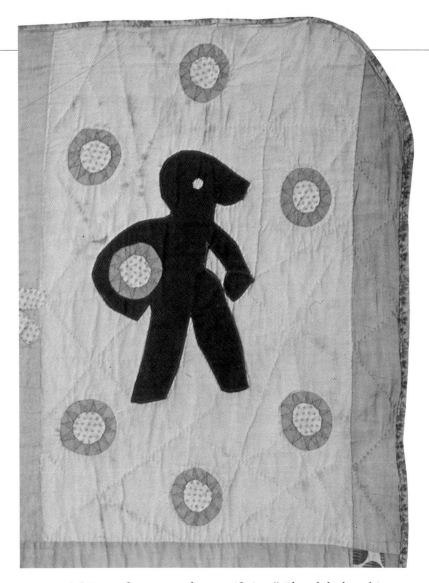

No. 8 "Has reference to the crucifixion." The globular objects attached to the crosses like balloons by a string represent the darkness over the earth and the moon turning into blood and is stitched in red and black calico.

No. 9 This is Judas Ascariot and the thirty pieces of silver! The silver is done in green calico. The large disc at his feet is "the stare that appeared in 1886 for the first time in three hundred years."

No. 10 is the last Supper, but the number of disciples is curtailed by five. They are all robed in white spotted cloth, but Judas is clothed in drab, being a little off-color in character.

No. 11 "The next history is the Holy Family; Joseph, the Vargint and the infant Jesus with the stare of Bethlehem over his head. Them is the crosses which he had to bear through his undergoing. Anything for wisement. We can't go back no further than the Bible."

N O T E

1. Jennie Smith's handwritten pages preserving the meager facts of Harriet Powers's life and of her creative triumphs are now in the Smithsonian Institution.

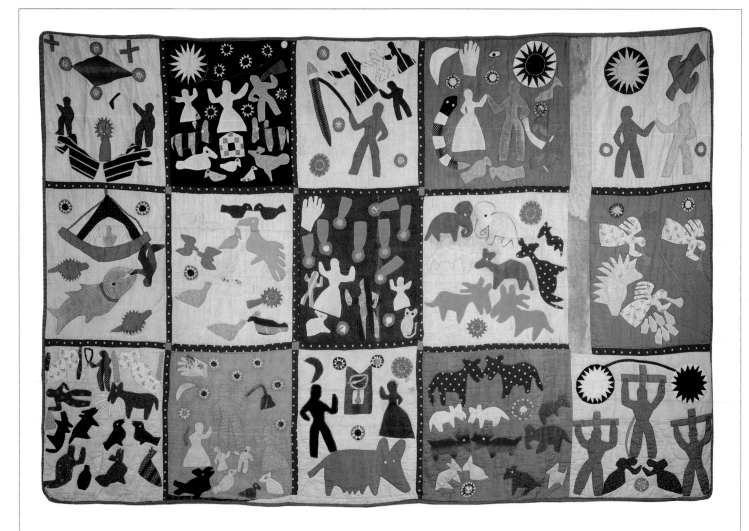

30

The Creation of the Animals Quilt

United States (Athens, Georgia), c. 1898
Made by Harriet Powers (1837–1911)
Cotton; pieced, appliquéd, embroidered,
and quilted;
69 x 105 in. (175.3 x 266.7 cm)
Bequest of Maxim Karolik,
Museum of Fine Arts,
Boston

POWERS'S SECOND Bible quilt, the *Creation of the Animals Quilt,* was either commissioned or purchased (through Jennie Smith's efforts) by the faculty ladies of Atlanta University and given to the Reverend Charles Cuthbert Hall, then chairman of the board of trustees of Atlanta University, about 1898. Again, care was paid to the writing down of Mrs. Powers's descriptions of those events depicted on the quilt:

1. Job praying for his enemies. Jobs crosses. Jobs coffin.

2. The dark day of May 19, 1780. The seven stars were seen 12.N. in the day. The cattle all went to bed, chickens to roost and the trumpet was blown. The sun went off to a small spot and then to darkness.

3. The serpent lifted up by Mosses and women bringing their children to look upon it to be healed.

4. Adam and Eve in the garden. Eve tempted by the serpent. Adam's rib by which Eve was made. The *sun* and *moon.* God's all seeing *eye* and God's merciful hand.

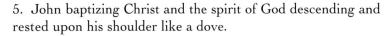

5. John baptizing Christ and the spirit of God descending and rested upon his shoulder like a dove.

6. Jonah casted over board of the ship and swallowed by a whale. Turtles.

7. God created two of every kind, Male and female.

8. The falling of the stars on Nov. 13, 1833. The people were frighten and thought that the end of time had come. God's hand staid the stars. The varmints rushed out of their beds.

9. Two of every kind of animals continued. Camels, elephants, "gheraffs" lions, etc.

10. The angels of wrath and the seven vials. The blood of fornications. Seven headed beast and 10 horns which arose out of the water.

11. Cold Thursday, 10. of Feb. 1895. A woman frozen while at prayer. A woman frozen at a gateway. A man with a sack of meal frozen. Isicles formed from the breath of a mule. All blue birds killed. A man frozen at his jug of liquor.

12. [fig. 1] The red light night of 1846. A man tolling the bell to notify the people of the wonder. Women, children and fowls frightened but Gods merciful hand caused no harm to them.

13. Rich people who were taught nothing of God. Bob Johnson and Kate Bell of Virginia. They told their parents to stop the clock at one and so it did. This was the signal that they had entered everlasting punishment. The independent hog which ran 500 miles from Ga. to Va. her name was Betts.

14. The creation of animals continues.

15. The crucifixtion of Christ between the two thieves. The sun went into darkness. Mary and Martha weeping at his feet. The blood and water run from his right side.

The written descriptions accompanying both quilts indicate the extent of biblical knowledge Mrs. Powers had acquired, the influence of folklore and legend on many of the symbols she included (such as that of the footed snake that appears in both quilts), and her abiding interest in astronomical and seasonal occurrences of great magnitude. Technically, both quilts are crudely constructed, but on the strength of their astounding aesthetic and narrative qualities, they stand as two of America's greatest figurative quilts. A faded photograph of Harriet Powers, circa 1890, survives (see fig. 1, p. 136). Our eyes are drawn to her hands and to the corner of her apron embellished with the comet figure worked in such profusion on those "darling off spring of her brain."

FIG. 1 *The Creation of the Animals Quilt* (detail)

31

The Equestrian Quilt

United States, c. 1890
Quiltmaker unknown
Silk, velvet, and taffeta; pressed,
appliquéd, embroidered, and embellished
88 x 57 in. (223.5 x 144.8 cm)
Museum of American Folk Art, gift of
Mr. and Mrs. James D. Clokey III

FIG. 1 From *Harper's Bazar* (June 28, 1884):
409, Los Angeles County Museum of Art

FIG. 2 From *Godey's Lady's Book* (May 1885):
598, Los Angeles County Museum of Art

Dᴜʀɪɴɢ ᴛʜᴇ 1880s riding became the sport of choice among the cosmopolitan upper class and, through articles in such publications as *Harper's*, of great interest to the middle class as well. For a fashionable turn in Central Park or participation in a horse show (fig. 1) the appropriately attired equestrienne would have appeared as she does on the central medallion of this elegant and vibrant quilt. She is formally dressed and rides sidesaddle atop a horse in full stride. Her riding habit is conservatively styled in a very sturdy fabric. Habits varied (as fashion required) in such details as the length of the skirt or the width of the lapel.[1] Gauze veils, streamers, or silk bands were secured around the crown of the high silk hats (fig. 2). All these details are visible on the central appliquéd figure; in addition, we see a riding crop in her hand and buttons on the front of her boned and padded black bodice.

This equestrienne, however, may represent not an eastern urban rider but rather a participant in an American spectacle: several of the quilt's figurative elements, when considered together, suggest activities of a Wild West show. Three equestriennes galloping around the central rider are joined by a fourth in a gray riding habit, holding aloft a streaming flag. (Another standard bearer [fig. 3], complete with hanging saber, perhaps portrays a cavalry rider.) The costumes on the equestriennes would seem more appropriate to a horse show; though, Emma Lake Thatcher, Wild Bill Hickok's stepdaughter, did appear with Buffalo Bill Cody in Europe in 1887–89 billed as "Emma Hickok, the Champion Equestrienne of the World."[2] Also, an undated program from a Wild West show lists a "Grand Equestrian Entree" following the "Grand Parade."

Equestrian acrobats, common to both Wild West shows and circuses, are substantially represented on this quilt (fig. 4). Two other figures are

The Equestrian Quilt

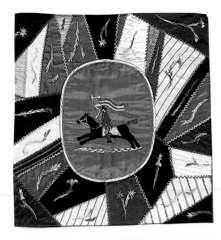

FIG. 3 *The Equestrian Quilt* (detail)

FIG. 5 *The Equestrian Quilt* (detail)

ethnic caricatures (figs. 5–6); Cody took great pride in the ethnographic aspects of his events, as evidenced in an 1893 program that announces, "a Group of Syrian and Arabian Horsemen will illustrate their style of Horsemanship, with Native Sports and Pastimes" and "Cossacks…in Feats of Horsemanship, Native Dances, etc." The presence of jockeys on the quilt does not negate the possibility that the figures are those of a Wild West show. We know, for example, that in England Cody arranged races between thoroughbreds and his broncos and often pitted one of his Western riders against a leading jockey of the area.

NOTES

1. Juliana Albrecht, Jane Farrell-Beck, and Geitel Winakor, "Function, Fashion, and Convention in American Women's Riding Costume, 1880–1930," *Dress* 14 (1988): 57.

2. Her horse rearing up, Emma Hickok appears in riding habit and Western hat on an 1889 English stereoscope. Illustrated in Joseph G. Rosa and Robin May, *Buffalo Bill and His Wild West: A Pictorial Biography* (Lawrence, Kansas: University Press of Kansas, 1989), p. 134.

FIG. 6 *The Equestrian Quilt* (detail)

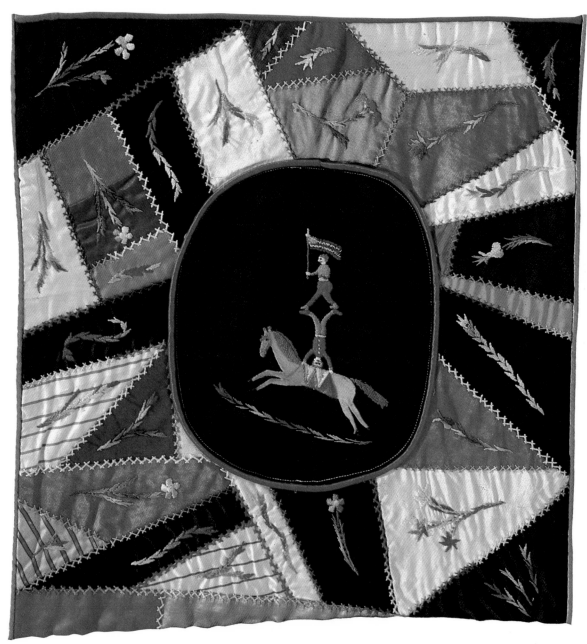

FIG. 4 *The Equestrian Quilt* (detail)

32

The Storybook Quilt

United States (possibly Utica,
New York), c. 1895
Eudotia Sturgis Wilcox
Primarily silk and velvet; pressed,
appliquéd, and embroidered; glove
leather; paint, watercolors, and ink
78¼ x 68 in. (198.8 x 172.7 cm)
Natural History Museum of
Los Angeles County

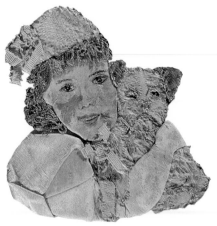

FIG. 1 *The Storybook Quilt* (detail)

THE NAMES FOR a number of traditional American quilt patterns were drawn from literary sources. *Delectable Mountains*, for example, is from John Bunyan's *The Pilgrim's Progress* (1678, 1684) and *Lady of the Lake* is from Sir Walter Scott's popular epic poem (1810) of the same name. These patterns, abstract in nature and constructed from small geometric pieces of fabric (squares, rectangles, and triangles), represent an idea rather than an identifiable image. These were inspired by works written for adults; for the *Storybook Quilt* that Eudotia Sturgis Wilcox created as a treasured legacy for her grandchildren, she turned to those

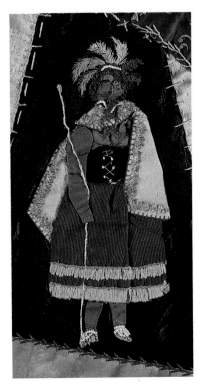

FIG. 2 *The Storybook Quilt* (detail)

books written for a child's pleasure, books that were an integral part of the Victorian nursery. Though several of the illustrations are quite identifiable, others such as the girl with her dog (fig. 1) or an Indian figure (fig. 2) are so general as to require the original print source for a more positive identification. Nevertheless, most of the appliquéd illustrations on the Wilcox quilt were probably drawn directly from those classic books produced during the golden age of children's literature.

This quiltmaker proved herself to be an extraordinarily skilled and confident needlewoman in the construction and embellishment of the figures' costumes. Illustrations based on Kate Greenaway's charming depictions of young girls in Victorian dress were a popular motif on crazy quilts but were

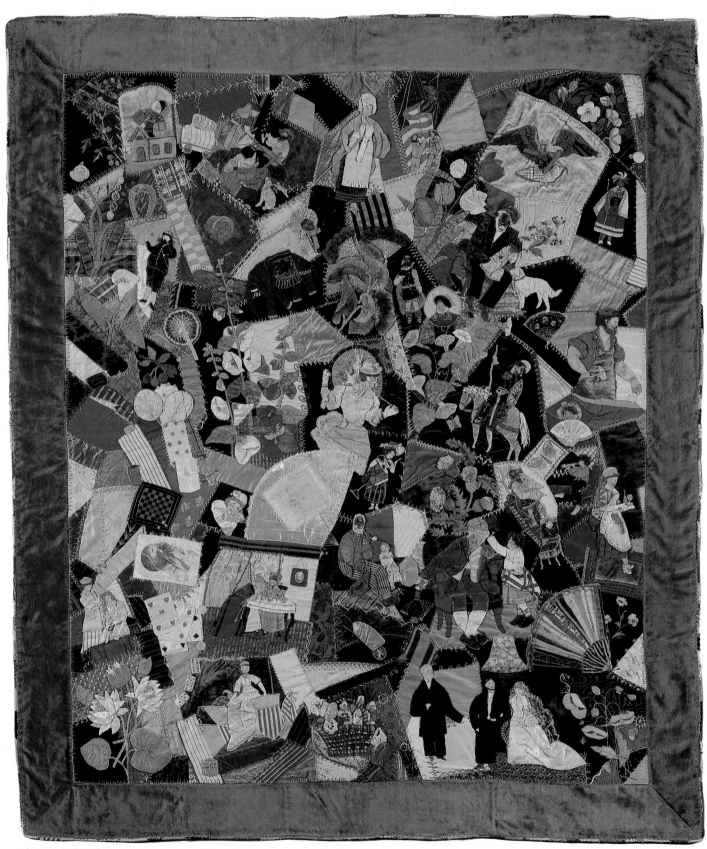

The Storybook Quilt

FIG. 3 Quilt (detail), United States, c. 1890, primarily silk and velvet, Los Angeles County Museum of Art, gift of Mrs. S. G. Milligan and Mrs. Margaret Milligan

usually rendered only in a simple, embroidered, outline stitch (fig. 3). The garments on the *Storybook Quilt,* however, are made quite dimensional by the type of careful folding and layering seen on the illustration of Heidi and her grandfather (fig. 4), particularly on Heidi's skirt. The smallest details appear on the grandfather's costume: the small tassel on his cap; the delineation of the soles on his slippers; five white buttons formed by French knots at each side of his knee breeches; a bit of cuff showing beneath the sleeve of his brown velvet jacket; metallic thread forming a watch chain; a tiny piece of green ribbon constituting a tie above his white vest. Similar attention to detailed costume is apparent on one of the scenes from Louisa May Alcott's *Little Women* (1868–69)[1]: the hostess wears a wrapper tied with a tasseled cord (fig. 5).

During the last quarter of the nineteenth century American literature often contained elements of local character, mannerisms, and speech. This interest in regionalism is illustrated on this work in the detail of Uncle Remus (fig. 6). Joel Chandler Harris's *Uncle Remus, His Songs and His Sayings: The Folk-Lore of the Old Plantation* (1881) was immensely popular during the period in which this quilt was made.

Throughout the quilt the faces of the figures have been constructed of soft glove leather, upon which features have been delicately painted. Hands have also been constructed of this material, allowing for the realistic contouring seen on the hand in which grandfather holds his pipe.[2]

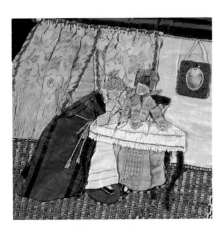

FIG. 5 *The Storybook Quilt* (detail)

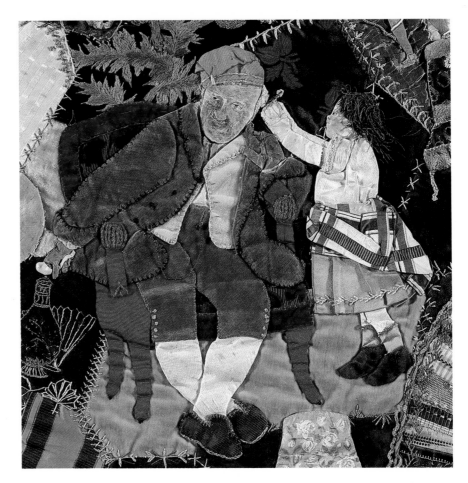

FIG. 4 *The Storybook Quilt* (detail)

FIG. 6 *The Storybook Quilt* (detail)

Although Harriet Beecher Stowe's *Uncle Tom's Cabin* (1852) was written for adults, the message was wrapped in adventures sufficient to satisfy younger readers. Mrs. Stowe also condensed its contents in *Pictures and Stories from Uncle Tom's Cabin* (1853): to emphasize the moral significance of the sentimental illustrations, the preface to that small book read, "This little work / Is designed to adapt Mrs. Stowe's touching narrative / To the understandings of the youngest readers / And to foster in their hearts / A generous sympathy for the / Wronged negro race of America."[3] By the time this quilt was begun, the Civil War had been fought, and the issues this book addressed had been decided. The images here are of Uncle Tom and the sweet blonde child that was little Eva (fig. 7), recreated in bits of silk and sentimentality.

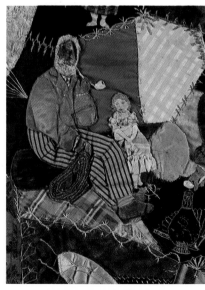

FIG. 7 *The Storybook Quilt* (detail)

NOTES

1. The influence of *The Pilgrim's Progress* is pervasive throughout *Little Women*. Chapter titles are drawn from Bunyan's prose ("Beth Finds the Palace Beautiful," "Meg Goes to Vanity Fair," and "The Valley of the Shadow"), and his words enter into conversations ("We were in the Slough of Despond tonight, and Mother came and pulled us out as Help did in the book. We ought to have our Roll of Direction, like Christian."). It is appropriate that scenes from *Little Women* should appear on this quilt because the book's text contains several references to quiltmaking. For example, in the first chapter Mrs. March (Marmee) asks,

> "Do you remember how you used to play *Pilgrim's Progress* when you were little things? Nothing delighted you more than to have me tie my piece-bags on your backs for burdens, give you hats and sticks and rolls of paper, and let you travel through the house from the cellar, which was the City of Destruction, up, up to the housetop, where you had all the lovely things you could collect to make a Celestial City." Louisa May Alcott, *Little Women* (New York: World Publishing Co., 1969), p. 23.

2. The Japanese motif of vase and fan just below grandfather's hand is taken directly from a set of "Transfer Designs for Doilies in Etching" illustrated in *Godey's Lady's Book* (July 1885): 111.

3. Harriet Beecher Stowe, *Pictures and Stories from Uncle Tom's Cabin* (Boston: John P. Jewett and Co., 1853), unpaginated.

33

The "Sacret Bibel" Quilt

United States (possibly West Chester,
Pennsylvania), c. 1895
Possibly made by Susan Arrowood
Cotton; appliquéd, embroidered,
and tied; ink
90 x 72 in. (228.6 x 182.9 cm)
Museum of American Folk Art, gift of
Amicus Foundation Inc. and Evelyn and
Leonard Lauder

THIS QUILT'S exuberant surface arrangement and the rudimentary quality of its workmanship stand in sharp contrast to the more formal elegance and flawless techniques shown on Lutheria Converse's *Noah's Ark Quilt* (ill. p. 85), worked more than four decades earlier. It is impossible to determine whether the quality of her stitches brought one moment of concern to the maker of the *"Sacret Bibel" Quilt*; her technical deficiencies may simply represent a personal indifference to that aspect of her efforts. What is important is that both pieces represent uniquely creative expressions of personal religious convictions.

On the *"Sacret Bibel" Quilt* figures of men and women (purported to represent members of an as-yet-unidentified church congregation in West Chester, Pennsylvania) have been appliquéd to squares and rectangles of plain and printed fabric, which have, in turn, been arranged symmetrically over a light, printed background cloth. Crudely written, misspelled captions have been stitched precariously to the quilt's surface. In design and demeanor, the figures are much less individualized than those on the Converse quilt; though each basic outfit on the *"Sacret Bibel" Quilt* is embellished with elaborate accessories at the neck, the silhouetted figures are simple in shape and alike.

Under a blue "sky" there is a compartment of thirteen men, themselves further compartmentalized by red chain-stitched floss. They all wear hats, but the central figure is bareheaded, and below him the caption identifies "Jesus on the monn / tain sending his de / siples threw the / world to preach." They are in formal dress, with starched white fronts, and the cravats they wear are consistent with the period, as is the asymmetrical bolero-type bodice worn by the woman in red at the far left of the white rectangle just below them. On each side of the "monntain" there is a building identified as a "church house." From each roof sprout blooming (or burning?) yellow, rose, and red floral chintz segments.

The "Sacret Bibel" Quilt

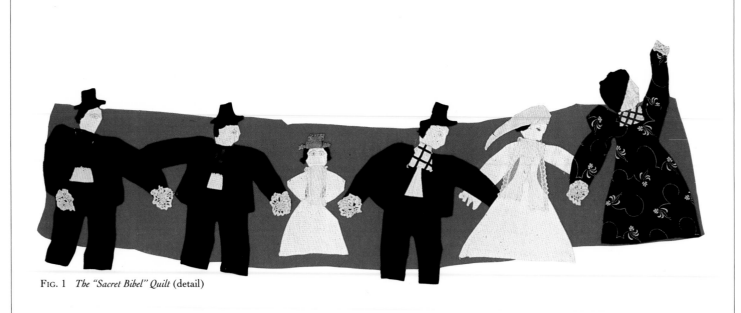

FIG. 1 *The "Sacret Bibel" Quilt* (detail)

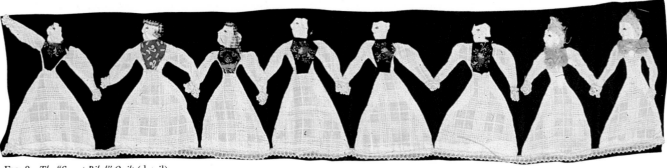

FIG. 2 *The "Sacret Bibel" Quilt* (detail)

FIG. 3 *The "Sacret Bibel" Quilt* (detail)

The figures in the left-hand corner "going to the tree of life" may represent a bridal couple, suggested by the young woman in white and veil, the entire party led firmly by the hand of a rather matronly and determined-looking woman (fig. 1). They move toward a chintz block bearing the figure of another formally dressed man, whose left hand is raised and whose right holds a Bible. The inscription below him reads, "Preacher preach the gospel / the same on ether sid / of the river." He is flanked on his left side by eight women cut paper-doll fashion, wearing identical white dresses with lace hems but with individual bodice treatments and hairstyles (fig. 2). They are also "going to tree off life."

The tan cotton river runs down from the mountain through the center to the bottom of the quilt. Near the top, a small "pocket" holds two figures: "John baptizing Jesus / in the river off / Jorden." Among other groups "at the baptizing of Jesus on ether [side?] of the river," "twelv desipls si[t?] on each sid of the river." At the top-right corner of the river, blood flows from his wounds as "Jesus [is] crucif[ied] on the cross."[1] At the bottom, left of the river, amid a bower of small appliquéd floral motifs, we see "Adam an eav in / the Garden" and to the right of the river, "Noh Ark."[2] Along the right side of the bedcover, paralleling the arrangement on the left, the "preacher prea / ching the gospel" is flanked by seventeen women, those on the left having been joined by two mustachioed gentlemen. An inscription runs between the two groups: "On either side of the river was the tree of life bare twelve months / of fruit the leaves of the tree [illegible] of the nation means teaching / of the gospel." Mid-center on the left side we find "Jesus in the garden [balance of the inscription is torn away]" and on the right, "The angel guarding / the sleeping man" (fig. 3).

In the lower third of the river, on a vertical inscription, one line to be read from the right side of the river, one line from the left: "Susan Arrowood / Sacret bibel quilt." Although not sufficient to confirm Susan's authorship of this piece, the inscription on this fragile, unofficial document at least affirms her existence.

N O T E S

1. Compare with block 3e on Harriet Powers's *Creation of the Animals Quilt* (ill. p. 140).

2. In addition to the elaborately detailed ark on Lutheria Converse's quilt, Noah's Ark appears as a Masonic symbol on the *Constitution Bedcover* (ill. p. 123).

34

The Leila Butts Utter Quilt

United States (New York), dated 1898
Attributed to Leila Butts Utter
Wool and cotton; pressed, appliquéd,
embroidered, embellished, and tied;
paper
84 x 76 in. (213.4 x 193 cm)
Dr. and Mrs. Fred Epstein

THIS STURDY crazy quilt was in all probability worked by Leila[1] Utter on her husband's 168-acre farm in central New York State.[2] The disparate sizes of the forty-one intricately detailed figures indicate they were copied directly from a variety of sources, such as book illustrations or photographs. But the complexity of the costumes on more than one third of the blocks further suggests that those were copied from fashion plates,[3] an assumption additionally supported by the stance of individual figures; for example, a middle-class woman posing for a personal photograph would generally not hold out her arm to indicate the fullness of the sleeve (fig. 1).

That the figure on the block in the lower left-hand corner (fig. 2) is taken from a fashion plate of the late 1860s is indicated by the painstaking duplication of a costume from that time; also by the raised position of the arm, typical of the fashion plates of that period; and by the lady's complex and detailed coiffure. Such elaborate hairstyles could be seen on the fashion plates in ladies' magazines; in addition, these periodicals often devoted entire pages to very specific illustrations of the latest in hairstyles (fig. 3). The women's costumes on the quilt range from this late-1860s garment to those of the late 1890s (such as that worn by a young girl wearing black stockings and a schoolgirl braid [fig. 4]), but the men's and boys' costumes are all from the 1890s (figs. 5–6).

Although Leila would probably not have realized it, her elaborate figures were

FIG. 1 *The Leila Butts Utter Quilt* (detail)

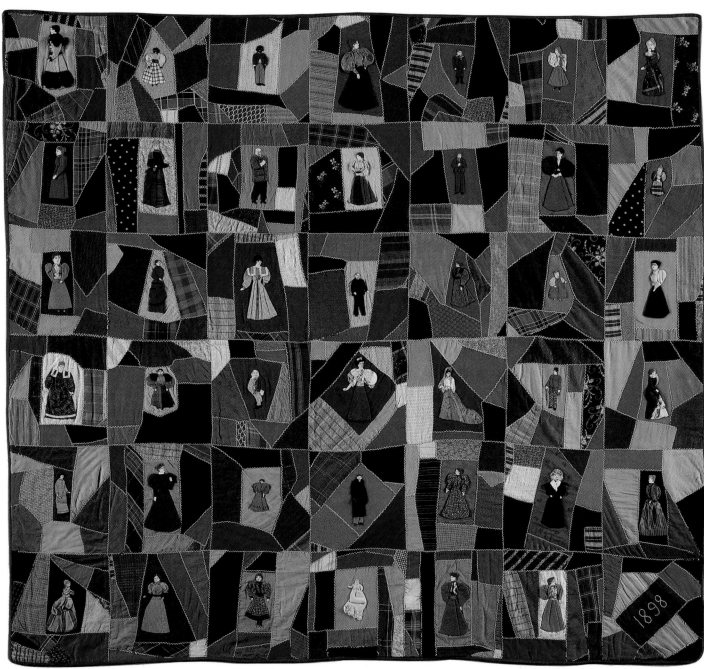

The Leila Butts Utter Quilt

FIG. 2 *The Leila Butts Utter Quilt* (detail)

in the tradition of the "dressed pictures" constructed in the eighteenth century. In the creation of those earlier works the body was cut from a stiff paper, to which folded and draped fabric was then glued. After embellishment of the costume, face and hands were cut from vellum, painted with watercolors, and inserted in place. The whole figure was then affixed to a background often representing an interior scene.[4] Leila's costumes, worked a century later, were sewn to wool and cotton blocks, the watercolored vellum replaced by a rather stiff fabric pulled around paper cut in the shape of head and hands, on which the features were then rendered in single strands of thread.

We know little of the quiltmaker's life. We do know that Leila was an adopted child and that she and her husband, James, took Elizabeth Munson into their home when she was only two years old; and although Elizabeth was never legally adopted, they cared for her, educated her, and regarded her as their daughter. It is likely Leila was a Methodist, for in 1883 the name of James Utter was among subscribers to a fund for the Methodist Church in nearby Davenport, and it was to that church that he bequeathed $200. Whether Leila intended these figures to represent certain members of her community is not known. It seems more likely that these paperdoll-like figures were merely the splendid result of an ambitious diversion.

FIG. 3 From *Harper's Bazar* (October 3, 1868): cover, Los Angeles County Museum of Art

NOTES

1. Although authorship of the piece has been attributed to Lelia Butts Utter, that given name seems to reflect an inadvertent transposition of two letters, the quiltmaker in fact being Leila Johnson Butts Utter.

2. Tradition has held the provenance of this quilt to be the "Worchester-South Mountain area of Delaware County," but in his will James Utter geographically places his farm "on South Hill" in Maryland, Otsego County. There is and was no Worchester (town or village) in New York, but there is a town of Worcester adjacent to (east of) the town of Maryland. Both Maryland and Worcester abut on Delaware County. The author is grateful to Mr. Fred Bowman for the extensive genealogical research undertaken on behalf of this entry.

3. Blocks 1d, 1f, 2b (c. 1888), 2d, 2f, 3b (c. 1880), 3c, 3e, 4d, 4e (c. 1867–68), 4f, 5b, 5e, 6a (c. 1868), 6b, 6c, 6e, 6f. Personal correspondence with Nancy Rexford, January 1990.

4. Jerome Irving Smith, "Dressed Pictures," *Antiques* (December 1963): 694.

FIG. 4 *The Leila Butts Utter Quilt* (detail)

FIG. 5 *The Leila Butts Utter Quilt* (detail)

FIG. 6 *The Leila Butts Utter Quilt* (detail)

35

The John L. Sullivan Quilt

United States (possibly Illinois), c. 1900
Quiltmaker unknown
Primarily silk and velvet; pressed
and embroidered
76 x 76 in. (193 x 193 cm)
Dr. and Mrs. Fred Epstein

JOHN L. SULLIVAN won his heavyweight championship in a bare-knuckle battle with Paddy Ryan in 1882 and lost it ten years later in a gloved match with Jim Corbett. In those ten years Sullivan became an American hero, the darling of the sports page and idol of the working class. He is depicted in the center of this quilt, surrounded by embroidered reminders of his glory days.

By 1860 almost half the population of the Northern states lived in cities or towns, and, not surprisingly, the number of people working sedentary occupations increased significantly during that period. This situation gave rise to a national concern over the softening of the middle and upper classes, which in turn helped trigger the athletic revival that swept the United States (particularly the Northeast) following the Civil War. Many Americans looked with renewed interest at the "Muscular Christianity" movement begun in England during the first half of the century and began to regard the perfection of one's body as a moral obligation.[1] Calisthenics, gymnastics, and sports became a national preoccupation (baseball players in uniform, a cricket player, and a detached but muscular arm holding what is perhaps a medicine ball all appear as peripheral embroidered figures on this tribute to the great John L.). It was at this time that boxing gained enthusiastic acceptance in the increasing number of public gymnasiums, the Y.M.C.A., and colleges.

One of the sport's earliest and most influential promoters, Richard Kyle Fox, arrived in New York in 1874 as a penniless immigrant from Dublin, but within two years he purchased a floundering periodical, the *National Police Gazette.* He added his name to the masthead and introduced a sports page (fig. 1), the success of which led other papers to follow suit. Through the wide circulation of his *Police Gazette* and his own promotional genius Fox determined the direction that professional prizefighting would take: sport became spectacle. The names of several of the papers that carried the exploits of John L. Sullivan are among the more than sixty inscriptions on this quilt (fig. 2).

By 1887 Sullivan was an internationally lionized figure, giving a command performance sparring match before the Prince of Wales, who

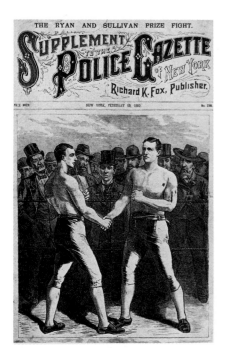

FIG. 1 From the *Police Gazette of New York* (February 18, 1882), private collection

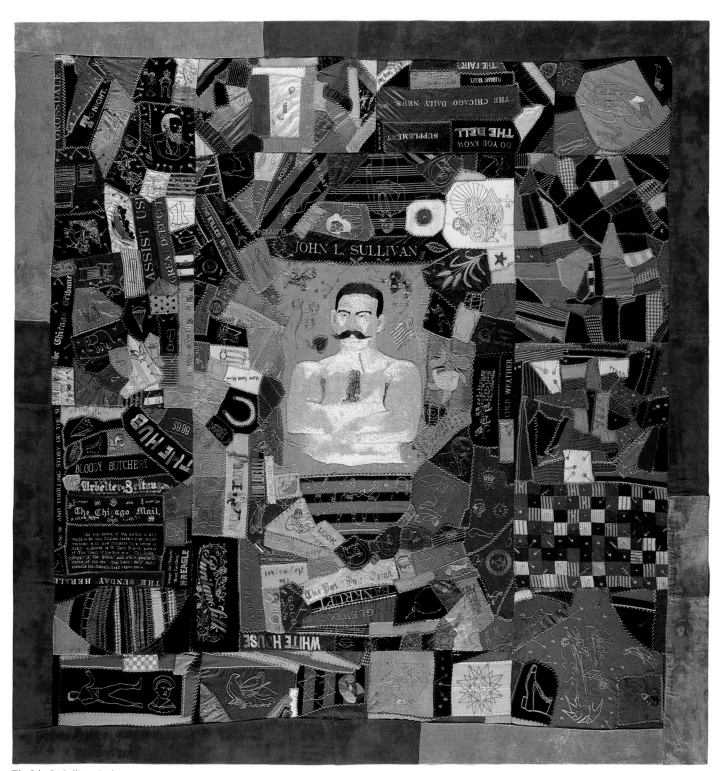

The John L. Sullivan Quilt

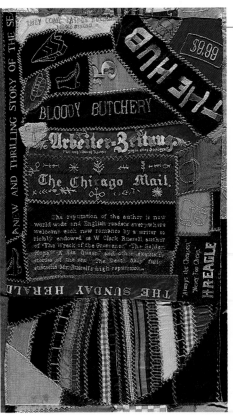

FIG. 2 *The John L. Sullivan Quilt* (detail)

would become King Edward VII. Following the exhibition he greeted his host with a firm handshake and a loud "Hello, Prince. Howdy!" and the two men became friends.[2]

Sullivan appears on the quilt in full formal dress (fig. 3); and the quiltmaker has worked a number of embroidered accessories (such as a hat, shoe, slipper, and shirtfront) throughout the quilt. It is, however, in the costume of the ring that he is most often depicted. The Boston Strong Boy wore emerald green knee breeches, flesh-colored stockings, and high-topped, black fighting boots; those green breeches and one flesh-colored stocking appear on the quilt (fig. 4, bottom right-hand corner).

The last bare-knuckle championship fight was held in New Orleans in 1889 between Sullivan and Jake Kilrain. The fight was, as usual, promoted in and extensively covered by the print media, and the images that appeared on paper were transferred onto the surface of this quilt (fig. 4). To the right of the two figures, a vignette shows the opponents locked in a wrestling hold, a moment that was also set down in a *Police Gazette* illustration of Sullivan's seventy-fifth-round knockout of Kilrain. A single figure to their left is in the classic stance so often assumed by Sullivan and duplicated by the young men and boys who worshipped him.

On the right side of the quilt, one segment is incongruously constructed in small one-patch squares rather than in the random arrangements that compose the balance of the quilt's surface. Other than the traditional embroidery stitches, this block and two adjoining "crazy" blocks are unembellished. Perhaps the quiltmaker tired of her labors; perhaps her unfinished blocks were assembled by another; perhaps there were simply no more grand events or headlines to record. The great John L. Sullivan lost his title to Jim Corbett in 1892. A passionate and public patriot (in the ring, in addition to his own colors of green and white, he usually encircled his waist with an American flag), Sullivan rose from the canvas and addressed the crowd: "I fought once too often. But, thank God, I lost to an American."

N O T E S

1. Harvey Green, *Fit for America: Health, Fitness, Sport and American Society* (New York: Pantheon Books, 1986), pp. 181–215.

2. John D. McCallum, *The World Heavyweight Boxing Championship: A History* (Radnor, Pennsylvania: Chilton Book Co., 1974), p. 12.

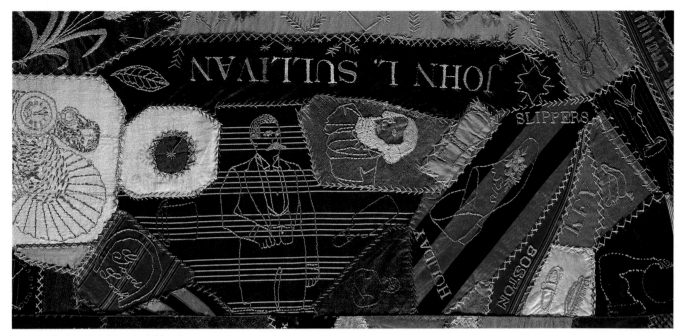

FIG. 3 *The John L. Sullivan Quilt* (detail)

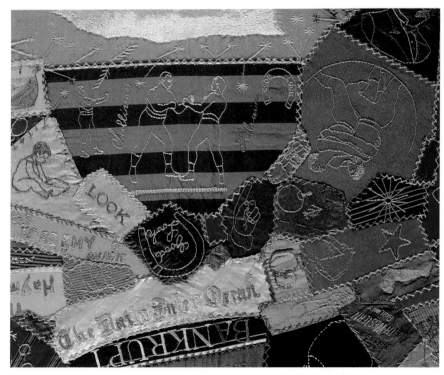

FIG. 4 *The John L. Sullivan Quilt* (detail)

36

The Rachel Grant Quilt

United States (Salt Lake City, Utah),
c. 1900
Made by Rachel Grant
Primarily velvet; pressed
and embroidered
80¼ x 67 in. (203.8 x 170.2 cm)
Pioneer Village, Farmington, Utah

FIG. 2 A. F. Tait dressed in Western garb, c. 1851, courtesy of the Adirondack Museum

BY THE 1830s frontiersmen, explorers, trappers, and mountain men had become America's romantic heroes. American writers such as James Fenimore Cooper and Washington Irving linked the country's national identity to a variety of Western themes. To the stereotypical interpretations of the mountain man as a romantic hero of legendary proportions set down in Irving's *The Adventures of Captain Bonneville, U.S.A., in the Rocky Mountains and the Far West* (1837) were added George F. Ruxton's *Adventures in Mexico and the Rocky Mountains* (1847) and Francis Parkman's *The California and Oregon Trail* (1849).[1]

The public concept of the "American West" was formed primarily between 1830 and 1860 by written accounts and the visual imagery of narrative paintings and prints. Currier and Ives began issuing lithographs with frontier themes in the 1850s. Their principal artist in that field was Arthur F. Tait; sets of lithographs transposed from his images were viewed by more people than was the work of any other mid-nineteenth-century painter.[2] Tait, however, had never seen the prairie nor even traveled west of Chicago. His first Western painting, *On the Warpath* (1851), depicts a trapper, long rifle held to his shoulder, wearing buckskin tunic and leggings with fringed seams (in activity and costume not unlike a figure [fig. 1] worked on this velvet crazy quilt forty years

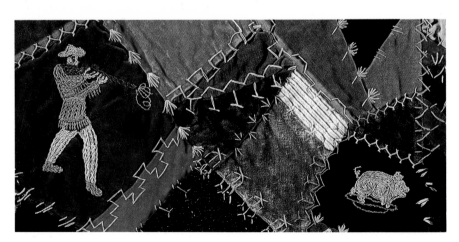

FIG. 1 *The Rachel Grant Quilt* (detail)

162

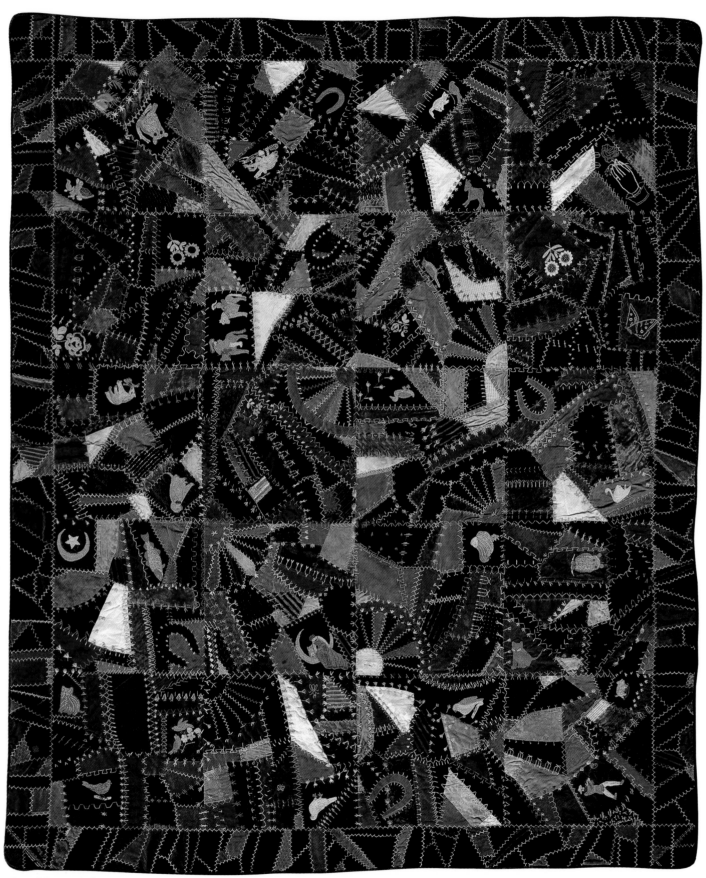

The Rachel Grant Quilt

FIG. 5 *The Rachel Grant Quilt* (detail)

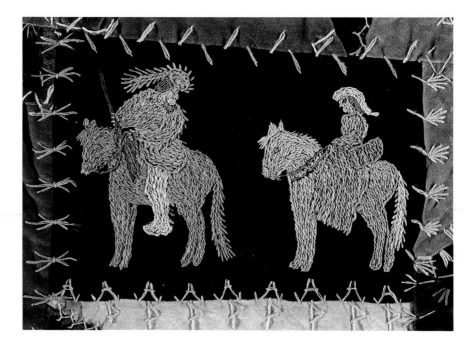

later). The costume and accessories in the painting were in fact borrowed from a New York collection of Western gear. Tait had himself photographed in the outfit, and the resulting studio picture was gridded (fig. 2) and transferred onto canvas.[3]

Rachel Grant[4] would have had an abundance of printed sources — novels, biographies, popular magazines, advertisements for Wild West shows, photographs of men in Western garb (fig. 3), and the illustrations of Frederic Remington (fig. 4) — from which to select the Western figures that appear on her quilt.

Beside a depiction of a mountain man in a coonskin cap, she worked the image of a Western woman sitting astride a horse, a basket on her arm (fig. 5); the figure's stereotypical dress would certainly have been homespun. In addition to its practicality, the wearing of home manufacture has, through the course of American history, been a social and political statement.[5] In Utah, where this quilt was made, the wearing of home manufacture was a religious directive as well. When in 1847 Brigham Young led a group of pioneers into the Great Salt Lake Basin, self-sufficiency was established as both a religious and economic imperative. Young decreed, for example, that men ought not to dance with any woman wearing other than a homespun dress. Years later, Emma Seegmiller, describing the clothing she wore as a youth in the United Order of Orderville in Kane County, Utah, recalled that wool was scoured, carded, and spun into yarn for her dress; her handmade shoes were tanned in the Order's tannery out of the hides from their own cattle; her straw hat was handmade.

But thrift, politics, and faith were sometimes insufficient to withstand the lure of current fashion and printed fabric. Emma wrote that "the figured calicoes in varied colors and designs, ginghams, unbleached for underwear and for beds, seemed so sheer compared with our usual homespun. And the 'shiny' buttons, the neatly folded papers of pins and

FIG. 3 "Antelope Ernst" Bauman, c. 1877, courtesy Gene Autry Western Heritage Museum

FIG. 4 From the *Century Magazine,* c. 1890

cases of needles, the spools of thread, and best of all the 'store smell' that went with it!"[6]

The depiction of women's frontier costume was often as stereotyped as that of the mountain man: she was often portrayed as a plain and unstylish toil-weary figure in a sunbonnet. Those frontier women, however, were linked to the most current fashions through descriptive letters and patterns from friends and family in the East. Also, they had access to *Godey's Lady's Book,* and the latest styles contained therein were adapted to whatever available materials and circumstances allowed. As confirmed by the illustrations posted on the wall of a Colorado school house (fig. 6), fashion was an integral part of the Western frontier.

FIG. 6 Colorado classroom, late nineteenth century, the Denver Public Library, Western History Department

N O T E S

1. Harvey L. Carter and Marcia C. Spencer, "Stereotypes of the Mountain Man," *Western Historical Quarterly* 6, no. 1 (January 1975): 17–32. A short written sketch of Daniel Boone in John Filson, *The Discovery, Settlement, and Present State of Kentucke, with an Appendix containing the Adventures of Col. Daniel Boon* (1784), established that Kentuckian as the prototypical Western hero.

2. Peter H. Hassrick, "Introduction," in Ron Tyler, et al., *American Frontier Life: Early Western Painting and Prints* (New York: Abbeville Press, 1987).

3. Warder H. Cadbury, "Arthur F. Tait," in Tyler, et al., *American Frontier Life,* pp. 112–14.

4. When Jedediah Grant (the first mayor of Salt Lake City and a significant leader in the Church of Jesus Christ of Latter-day Saints) died, he was barely forty years old. Rachel, one of his three living wives, had nine days earlier given birth to her first son, Heber (who would become the seventh president of the Church). The wives later assisted in their mutual support in part through their sewing skills.

5. Home manufacture was for some an expensive point of honor: South Carolinians had long taken pride in living on their own resources, and the ladies often paid twice as much for silks grown and manufactured at home. During the Civil War the commonest goods were worn out of both necessity and pride. The commonest sort of calico commanded twenty-five dollars a yard, "and we women of the Confederacy cultivated such an indifference to Paris fashions as would have astonished our former competitors in the Federal capital." As quoted in Elisabeth McClellan, *Historic Dress in America: 1800–1870* (Philadelphia: George W. Jacobs & Co., 1910), p. 273.

6. Emma Seegmiller, "Personal Memories of the United Order of Orderville, Utah," *Utah Historical Quarterly* 7 (1939): 174.

PHOTOGRAPHY CREDITS & SOURCES

Unless otherwise indicated, all photographs are reproduced courtesy of the lenders.

Quilts and/or bedcovers numbers 1–3, 5, 9–11, 14–15, 18–19, 22, 25, 26 (details only), 27–28, 32, and 34–36 photographed by Steve Oliver, Los Angeles County Museum of Art; number 4 © the Metropolitan Museum of Art 1989/1990, photographed by John Bigelow Taylor; number 6 courtesy of Joel and Kate Kopp, America Hurrah Antiques; number 20 courtesy of *The Quilt Digest Press*, San Francisco, first published in *The Quilt Digest* 4.

167

Edited by Chris Keledjian
Designed by Sandy Bell
Photography supervised by Steve Oliver
Text type set in Cochin
by Continental Typographics, Inc.,
Chatsworth, California.
Display type set in Greco Adornado
by M & H Type,
San Francisco, California.
Printed by Dai Nippon Printing Co., Ltd.,
Tokyo, Japan.